COMMONSENSE PHOTOGRAPHY

COMMONSENSE PHOTOGRAPHY

Leonard Gaunt

THE FOCAL PRESS

LONDON and NEW YORK

First published 1969
Second Impression 1970
Second Edition, Revised 1972
Fourth Impression 1973

Printed by Biddles Limited Guildford
and bound by W & J Mackay Limited Chatham

Contents

1: PHOTOGRAPHERS TODAY

2: THE CAMERA FOR YOU

3: BUILT-IN FEATURES

4: FILMS AND FILM SPEED

5: LENSES AND THEIR USES

6: FOCUSING AND SHARPNESS

7: BEATING EXPOSURE PROBLEMS

8: LIGHT IN A FLASH

9: FLASH IN PRACTICE

10: LAMPS AND LIGHTING

11 : WATCH YOUR COLOURS

12 : WHAT FILTERS CAN DO

13 : CLOSE UP AND CLOSER

14: PHOTOGRAPHY WITHOUT LIGHT

15: DEVELOP THEM YOURSELF

16: MAKING THE PRINT

17: PROCESSING COLOUR

18: DARKROOM ACCESSORIES

GLOSSARY 287

INDEX 300

Introduction

Henry Ford's famous dictum that all history is bunk could be paralleled by the statement that all photographic theory is bunk. Both statements are patently absurd but perhaps Henry Ford meant that we should not expect history to repeat itself when the conditions are changed.

This, too, has its parallel in photography, with the added difficulty that photographic theory is based on a rather shaky foundation. Its innumerable precisely stated formulae and equations make assumptions that just are not tenable.

Nobody yet fully understands the whole process from light-struck emulsion to developed image.

No photographic image is ever completely sharp. Methods have been devised of measuring the degree of sharpness but they are applied to the image produced by the taking lens. They cannot be applied to the final presentation without making, again often untenable, assumptions about viewing distance.

No lens is perfect, but optical formulae and calculations must assume that such a phenomenon exists. These calculations are often only accurate when applied to the on-axis rays of light, but they are

frequently used to forecast the effect of oblique rays striking the very edge of the lens.

Shutters vary in their efficiency both as regards marked speeds and according to their position relative to the film plane.

Film sensitivities are arbitrarily decided by quite elaborate formulae built up on a foundation of human assessment of picture quality. They depend on carefully controlled processing under laboratory conditions.

There are innumerable other factors but these are enough to demonstrate that theory should be treated with extreme caution. This book does that. It is a book setting out one man's attitude to the theory of photography and expressing opinions that may well aggravate those with an unshakable faith in scientific methods.

But this is a personal book. It is deliberately opinionated without aiming to be dogmatic. The author has no wish to assert that his are the only beliefs worth holding. They are opinions arising out of long practice and, as such, are arguable. The aim is to arouse a healthy scepticism, and to encourage the reader always to relate theory to the shortcomings of the equipment and materials with which he works.

The worship of equipment and gadgets and theoretical calculation for their own sakes is incompatible with the taking of pictures—and that, after all, is what photography is all about. Pictures can take many forms, from the simple snapshot printed straight to the creation in the darkroom of a complicated colour pattern. They are good or bad, interesting or incomprehensible, according to personal taste and opinion.

Some will tell you that this is good photography and that is bad. This book offers no such judgments. Its pictures cover a wide range of styles and subjects. They are used to illustrate, not specific parts of the text, but the main theme that photography is about pictures.

Formularized calculations are essential for the backroom boys who produce the equipment and materials. For the photographer they are merely incidental and must always be related to what actually happens in practice.

1: Photographers Today

There are many types of camera user
and they put their cameras to a variety of uses.
We are more concerned with those
who want to take good pictures
than those who drown themselves in technicalities.
But what is a good picture?

The basically simple business of using a camera has become ridiculously complicated in recent years, despite the fact that designers and manufacturers have been producing equipment supposedly aimed at simplification. There was a time when a photographer's results depended to a great extent on his skill in compounding his own emulsion and coating it on his glass plates. It often depended on techniques of posing his subjects so that they looked as if they were moving, because his emulsion was much too slow to allow any movement in the subject whatever. His camera—a gigantic affair by modern standards—was poised on a stout wooden tripod while he gave exposures lasting for several seconds. Naturally, he had no colour facilities.

Now we have cameras with which you almost literally "point and shoot". They can produce good colour pictures with no more effort from the photographer than lining the subject up in the viewfinder and pressing the button.

For the more discriminating, we have films of many speeds and sizes, varying colour response, etc., small cameras that can take a wide range of lenses and accessories, exposure meters that can see in

the dark, simple processing methods for both black-and-white and colour, and so on.

What technicalities are for

Yet, or perhaps because of all the facilities available, photography has become a mysterious process that the average person finds difficult to understand. He is given extraordinarily conflicting advice about the type of camera he should use, exposure factors, f-numbers, filters, colour rendering, lenses for colour, shutter speeds and a host of other matters.

We have reached the stage where innumerable would-be photographers are getting worse results with their modern 35 mm single lens reflexes than were obtained with Box Brownies thirty years ago. And most of this is due to an unnecessary preoccupation with what is known as the technical side.

It is true that a study of the photographic process, the intricacies of the modern camera, the chemistry of photography and related subjects can be fascinating in itself, but if the object is to take photographs, only the most superficial knowledge of these subjects is necessary. J. Allan Cash, whose photography is the envy of a good many people, put it very succinctly. "I don't know a lot about technicalities", he said, "just how to use them."

That is the aim of this book—to explain just enough about the technicalities to enable you to use them properly. To do this, we have to range over the whole field to separate the essential from the inessential and to lay our real emphasis on those matters that will help the photographer to produce better pictures.

Photographers and others

Who, after all, are the real camera users and what do they want to know? Have you ever asked a top-flight photographer, for example, to tell you the gamma to which he develops his films? The chances are that he will laugh. He will probably not even know what you are talking about—and the chances are that you won't either. Ask him to set his lens to $f11$ without looking at it and you will get a more positive reaction.

The modern successful photographer may or may not have learnt the basic theory of the photographic process. But what he will have

learnt is how to use his equipment—and he will have learnt it by taking pictures. He knows from experience and usually with only a smattering of theory what his cameras, lenses and films will do. He is not concerned with the A to Z of increased grain size and lower contrast with fast films. He is concerned with the Ps and Qs of how these films behave in practice. He doesn't read books on photographic theory and he is not likely to be reading this.

He is not necessarily a professional either. Many amateurs work in a similar way, but the amateur's interests often range wider than the professional's. The professional tends to specialize. The amateur is more inclined to tackle a variety of subjects and to take pictures for himself rather than for a client or with a particular market in mind. He may do his own processing and therefore be a little more concerned with "what goes on" as well as with "what comes out". But he is still primarily interested in results and leaves the abstruse theorizing to that well-known breed—the "keen amateur".

This is the man who would like to sell some of his pictures, largely to convince himself that his work is worth looking at. He never gives up, even if he does not sell a single picture. Photography is his hobby, sometimes his passion, and he studies every aspect of it that he possibly can. *He* will tell you what gamma is all about. He will have tried most developers on the market and still will not have found the one he is looking for. He will have rigid views on whether or not a reflex is better than a rangefinder camera, or the full frame format better than the half frame, and whether or not photography is an art.

The keen amateur's equipment is often elaborate—generally far more so than that of the average professional. He frequently trades it in for the latest product. He reads everything he can lay his hands on and, with luck, he will be reading this. We hope so because we would like to induce him to change his ways.

The average amateur
Chiefly, however, we are aiming at the largest category of photographers in the world—the average amateur. This man (or woman, of course; there are many and we hope there will be more) may be on his way to join one of the other categories. Or he may become so disheartened that he soon packs in photography altogether.

We are not trying to push him into any particular category. In fact, we would rather like to head him off from the "keen amateur" class. We simply want to help him to take better pictures. We can stop him studying theory too deeply and guide him into the far more rewarding field of practice, where he can teach himself how to take pictures rather than learn from others how they think he ought to do it.

Our average amateurs are a mixed bag. They range from those who are quite at home with camera controls and the basic differences between various films, filters, lenses, camera designs and so on to those who are all fingers and thumbs when it comes to deciding on aperture and shutter speed combinations and who find close-up exposure factors, depth of field, reversal processing, etc., rather difficult to understand. We would like to explain to them just how little of such matters and many others they really need to concern themselves with.

Perhaps we have categorized photographers a little rigidly, so that some feel they cannot fit themselves into any of our definitions. That is understandable. It is a healthy sign, too. The photographer should be an individual. And he should have his own approach to the fascinating business of trying to reproduce in a photograph the things that he sees.

Photography is individual

If two people look out of a window on an ordinary scene, it is virtually certain that their individual eyes will transmit to their individual brains, quite individual impressions. The young mother will see the child playing in the street. The man might see his next-door neighbour's new car.

That is the essence of the type of photography we are concerned with: to produce an impression of a subject that is entirely the work of the photographer concerned—not just the one-eyed view of a camera pointed indiscriminately at the general scene. Nor, for that matter, the view that stereotyped rules tell us makes a good picture. After all, what is a good picture? Is it a beautifully-composed landscape, with the centre of interest on an intersection of the thirds and every line leading into the picture? Is it a classical portrait, finger to cheek, single catchlights in the eyes and a touch of rimlighting? Is it a

nude, tastefully posed, completely impersonal, every line a curve with never an awkward bend against the joint? Is it a "modern" arrangement of tones and masses, an imaginative interpretation of the bull fight, a granulated blur of impressionistic movement, an ultra close-up kaleidoscope of form and shape, a ploughed field of soot and whitewash?

It depends on the purpose

What is a good picture? There is no answer unless the purpose is stated. On holiday, you might produce some superb renderings of sea or landscape, mountains, local characters, buildings and the like that would delight your camera club members. Your wife might remember Johnny's woebegone expression when he dropped his ice-cream in the rockpool and berate you because you were busy at the time sizing up the exhibition-print possibilities of a bedraggled-looking hunk of seaweed.

As a press photographer, you might present your editor with a superbly pictorial print of footballers in ballet-like postures. He would be slow to congratulate you if somebody else came up with a blurred picture grabbed a split second later when two of the "dancers" were having a punch-up.

An advertising shot of a beautiful girl drinking "Whizzo" might look marvellous to you. The advertiser might not be so enthusiastic if it were a product he habitually publicized as the "he-man's drink"

Shoot for pleasure

Why do you take pictures? For pleasure? For profit? For exhibition? Or what?

As an amateur—a true amateur—your first aim should be your own pleasure and the expression of your own ideas. You should not be scouring the photographic magazines for hints on how to produce creative masterpieces that will please nobody but another photographer on the same bent.

You have a family, friends and acquaintances. You travel, even if only to work and back. You have some hobby or interest other than photography. You live somewhere. All these can produce pictures that will interest *you* and may well interest others.

There is a limited satisfaction to be gained from pictures that will

hang on an exhibition wall. Once hung and adorned with their little sticker, they are dead. There are thousands like them. Are there thousands of the little pub that used to stand on the corner now occupied by the supermarket? Of that quaint little road bridge now "improved"? Of the really interesting, as opposed to pictorial things you encountered on numerous holidays or day trips? Of your children or friends actually doing things that will bring back memories? Or of your own home and garden and your various activities in and around it?

What have you to show for your photography to date? Innumerable attempts at art in photography? Experiments with new techniques? Have you any pictures which really please you? Do they arouse much interest in others? If you can answer yes to the last two questions, these pictures are probably straightforward shots of people or places. Pictures that you can associate with particular events or occasions and that other people find interesting and pleasant in themselves to look at.

Waning interest

How often do you find that you are losing interest in photography? There seems to be nothing to photograph. You go out full of hope and determination. But the light is wrong. There are no clouds in the sky. The road, river, stream, footpath or what-have-you runs straight out of the picture instead of describing a delicate S-bend. Nothing pleases your artistic nature. You are looking for a picture, not a subject.

But if you are in a new locality, there is always a picture. A street, building or monument does not have to be of outstanding architectural merit or a thousand years old to be worth an exposure. Anything that attracts more than a casual glance is worth a picture.

This may sound like encouragement for mediocrity—but why not face it? The camera in most people's hands is purely a means of recording experiences, places visited, family and friends, social occasions and so on. Not one in a million of us is going to become famous as wizards of photography. And most of us really wouldn't want to anyway. There are other jobs we like much better when it comes to *working* at them. And the successful photographer works as hard as anybody.

A rule or two

Nevertheless, mediocrity is not the aim. Even if you forsake commercial success, you should still strive to make your pictures good for their purpose and in their field.

The rules for that are relatively few. You have to expose with reasonable accuracy, focus sharply, process cleanly and carefully and print to get the utmost out of the negative.

That is the technical side and the more often you use your camera, the easier the technique becomes.

Other considerations might be called artistic, if it were not too pretentious a word. But you want your pictures to be worth looking at, to show the subject clearly and to best advantage and not be cluttered with too much irrelevant detail.

This is not art; it is common sense. If, for example, you want to picture that pub on the corner, don't take it from halfway up the street, so that you have a mass of empty foreground and a tiny structure in the top, left-hand corner.

Go as close as you can. Frame the building carefully in your viewfinder, trying various viewpoints. If possible, show two adjacent sides, not a flat frontal view. But if the frontal view has something interesting in it, by all means take that too. Or perhaps go right in close and concentrate on the interesting features. Watch out for such awkward items as lamp-posts cutting through the name board or vehicles parked awkwardly in the picture area. Come back another day.

Watch out for detail all the time. Try to make the picture as attractive as possible, whatever the subject. Viewpoint is always important. You might think a particular type of street lamp worth a record. Should you take it in the day-time or when alight? Perhaps both. Shoot from the position that shows its outlines clearly. That need not be against the sky. Silver coloured lamps, for example, might well show up better against a darker background—if available. If not, then there might be a genuine reason for waiting for a really blue sky and using an orange filter to separate the tones.

Isolate your subject

Simplify your shot as much as you reasonably can. Think about it. Isolate your main subject and cut out anything that does not fit in with your reason for taking the photograph. If you can't cut it out

try a change of viewpoint. Simplification has two results. It concentrates interest on the main subject and it improves quality by minimizing the degree of enlargement required.

Look at the pictures you have taken. How many of them could have been improved if only you had moved in closer on your subject?

This is a point that cannot be over-emphasized. For every picture you take, get as close to your subject as you possibly can—short of going so close that you cause unpleasant distortion. It is the one thing above all others that can help to lift your pictures out of the casual snapshot class.

Study your picture very carefully through the viewfinder before you release the shutter. Take your time. It is truly amazing how even experienced photographers can overlook the most glaring faults: things like the model's cast-off topcoat showing in one corner of the picture area; or the shadow of a near-by object across her legs; an empty ice-cream carton in the foreground, an obtrusive patch of colour in the background, and so on.

Shooting action

Naturally you cannot watch all these things when you are grabbing a once-in-a-lifetime shot. The rule then is to shoot first and try for a better one afterwards if there is time. If it is a question of a news-type picture, quality is very much a secondary consideration. Even the most shaken, out-of-focus shot of the actual event is preferable to a beautifully produced picture of the static aftermath.

Similar considerations apply to any shots of action and even then there is often enough time to give attention to certain details in the picture. When shooting children playing on the sands you can get to landward of them to avoid too fussy a background. If you are then facing the sun you might make good use of fill-in flash. When taking any kind of group, you can usually choose a viewpoint that at least shows more faces than backs—unless the backs happen to be more interesting. If the group is line abreast, shoot them from an angle where they form a diagonal in the picture. This adds life, saves space and looks generally more interesting.

You should, in fact, avoid straight lines across the picture whenever possible. Few landscapes look attractive with a completely

unbroken horizon. Buildings look better in three-quarter view than flat-on.

Pictures with a reason

Think about your pictures all the time. Think what you are really trying to do. Why do you want to take that picture of mother and child? Because they look alike? Because of the way they look at each other? Then you don't need a full-length shot. Go in close and get head and shoulders or even faces only.

Why do you want to photograph the wardrobe you made? To show how well you have blended it with the rest of the furniture? To demonstrate the stages of production? Or the details of the jointing? The method of applying the veneer? Each makes a different picture. Each needs a different approach. The general photograph might include a large part of the room with the wardrobe relatively small in the picture area. You need plenty of lighting. For the detail pictures you might close right in and show an area only a few inches square. Flash could be the most suitable lighting and close-up equipment would be useful.

Work out exactly how to present your real intention in a thoroughly competent photograph.

You will remember that we have said you should choose subjects to suit yourself. You should not just go out vaguely looking for pictures that will hang on the exhibition wall or make your fortune. Yet what have you got now? Shots of children on the sands. A line of happy faces or a group of active people. An attractive building. A mother and child shot. An example of home woodworking. If you have applied yourself completely to making these good pictures, you have, in fact, produced pictures that *could* hang on an exhibition wall or be sold to magazines, books, greeting card manufacturers and so on.

In other words, you have produced pictures to interest others as well as yourself because, although you were shooting for your own pleasure, you gave the pictures a purpose and a meaning. You concentrated on the main subject. You set out to photograph something to the best of your ability. You did not set out merely to make a picture.

Picture making with no regard to subject or purpose produces

ephemera. The results appear in photographic magazines—often announced as a new art form which is derided or even forgotten when the next style is perpetrated.

Your pictures, your ideas

But when you put some purpose into a picture, when you take it for a reason, you cannot be alone. You are expressing your own interest and no man is such an island that his genuine interest cannot be shared. No matter if you do try to convey impressions rather than produce records, if you are really involved with the subject rather than involuted in the creation of something different, you will arouse the interest of others.

As a true amateur, you should not care what other people think of your pictures. You take them purely for your own pleasure. But we are all human and like some appreciation of our efforts. This is not only vainglory. There is common sense in it, too. If we are appreciated only by ourselves or by an introverted clique, we are smaller men than we think—and that is not healthy.

So apply common sense to your photography. The camera is a recording instrument of extreme simplicity. Use it so. Let it record facts or impressions as you will. But let the impressions be yours. Let the art be yours, if art there be. Your particular brand of genius will evolve naturally. You can't force it.

2: The Camera For You

These are the cameras,
their advantages and disadvantages.
You probably already have a camera,
but you will change it some day.
See which one is best for you.

It has been said that books and magazines on motoring are bought mainly by those who have not yet acquired a car. This may or may not be applicable to books on photography but no doubt some readers of this book are faced with the problem of choosing a camera —either for the first time or because they feel it is time they made a change. Let us examine the basic types.

Nobody can choose an ideal camera for you. The ultimate choice is yours and yours alone. A knowledgeable friend may tell you that the best type of camera available today is the 35 mm single lens reflex. For his purpose, that may well be true. But a surprising number of people find this type of camera difficult to focus, and many more find it too bulky and heavy.

When it comes to choosing an actual model, some may extol the virtues of a particular camera that, nevertheless, does not feel right in your hands. You may find the shutter release too heavy or too light to operate. If you are a spectacle-wearer, the corners of the picture area in the viewfinder may be difficult to see. That, in fact, applies to many cameras. Again, a large-format camera that is recommended to you may prove too heavy and bulky for the type of work you

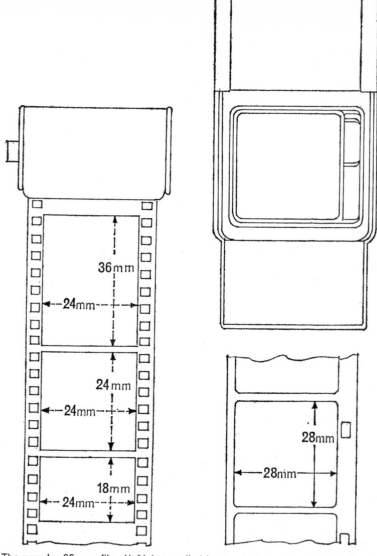

The popular 35 mm film (*left*) is supplied in standard lengths of either 40 or 65 in. in light-tight cassettes, 35 mm film gives 20 or 36 exposures of 36 × 24 mm, up to 25 or 50 exposures 24 mm square or up to 40 or 72 exposures of 18 × 24 mm. No. 126 film (*right*), for instant-loading cameras is the same width as 35 mm film but generally supplied in lengths of about 18½ in. giving 12 exposures 28 mm square.

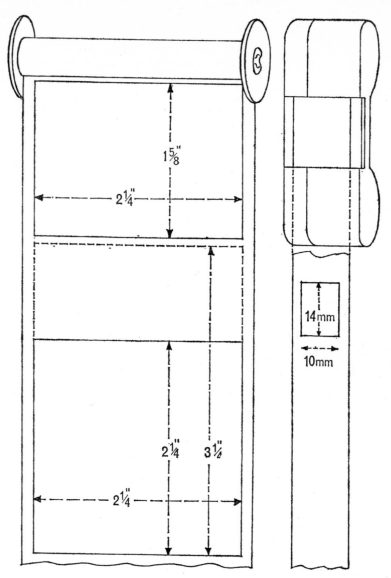

No. 120 film (*left*), is $2\frac{1}{2}$ in. wide and usually $32\frac{1}{2}$ in. long, now generally used to provide 12 pictures $2\frac{1}{4}$ in. square. The film is supplied wound on to a spool together with a protective paper backing. No. 220 is a professional size giving 24 pictures $2\frac{1}{4}$ in. square. Ultra miniature cameras (*right*) use various sizes of film but most have now standardized on a 16 mm width. A popular length is about $16\frac{1}{4}$ in., giving 20 exposures of 10 × 14 mm.

want to do. Ease of handling is very important and you should try to handle the camera of your choice before finally making up your mind to buy it.

The main types of amateur cameras are these:

1. The 120 or 2¼ in. square single lens reflex
2. The 120 or 2¼ in. square twin lens reflex
3. The 35 mm non-reflex and "compact" range
4. The 35 mm single lens reflex
5. The half-frame (or single-frame)
6. The ultraminiature (or subminiature)
7. Popular cartridge-loading cameras

There are also studio, technical and press cameras but their uses are specialized and are not within the scope of this book.

Nor are the Polaroid Land cameras for "instant" photography. The print is produced inside the camera by a special process differing considerably from orthodox photography. The cameras and films are designed for one another and neither can be used with other amateur equipment or materials. The system precludes certain photographic techniques which are available in the normal process. Pictures cannot, for example, be taken in rapid succession and the image size cannot be altered by changing lenses. But against these factors are simplicity of operation, immediate reassurance of a successful result and the relative ruggedness of the equipment. The price of Polaroid photography is greater than the normal process, but there is usually less wastage.

The system camera

A system camera is one which forms the central unit of a wide range of accessories which adapts it for many uses beyond day to day photography.

The accessories are usually manufactured by the firm that makes the cameras. But some models will accept accessories from standard ranges available separately. Cameras which will accept the full range of accessories designed for a system camera may themselves be regarded as system cameras. A camera which merely accepts a range of short and long focus lenses is *not* a system camera. Most of these cameras are 35 mm single lens reflex models.

THE 120 SINGLE LENS REFLEX

The figure 120 is the code number for the film size this type of camera uses. It is the standard rollfilm and has been in use for a great many years. The film used to give eight $2\frac{1}{4} \times 3\frac{1}{4}$ in. pictures in some older cameras but now it is nearly always used to obtain 12 pictures $2\frac{1}{4}$ in. square.

The single lens reflex in this size is generally an expensive camera. For viewfinding it uses the simple reflex principle. A mirror is placed at an angle in the light path between the lens and the film. The image of the object to be photographed is deflected at right angles via this mirror to the viewing screen above. Some of these cameras are primarily designed for waist-level use, but they can take pentaprism attachments to permit eye-level viewing and focusing. Others are specifically designed for eye-level use and are similar in shape to the 35 mm single-lens reflex (see page 36), but, naturally, are bulkier and heavier.

Viewing and focusing

The viewfinder screen in this type of camera serves also as a focusing screen, and usually consists of a translucent finely ground surface in contact with a fresnel screen. The fresnel screen is a special form of condenser lens designed to provide even illumination all over the focusing screen. Without it, the image tends to be darker in the corners.

The viewfinder image in the reflex camera appears the right way up, owing to the presence of the mirror. If it passed straight through the camera to a focusing screen at the back—as it did on many older cameras and still does on some studio cameras—the image would be upside down, because that is the way a lens forms an image. It would also be reversed left to right, and that reversal remains in the simple reflex, as with any other mirror image. The pentaprism attachment, however, and the viewing system of the eye-level cameras, present a laterally-correct image.

While you are viewing and composing your picture, the mirror stands between the lens and the film. It has to get out of the way before the picture can be taken. In the modern camera this is effected automatically as you press the shutter release. The mirror flips away,

obscuring the viewfinder image, the shutter opens and closes and, usually, the mirror drops down again into the viewing position.

High-quality results

That, basically, is the 120 single lens reflex. It is a design particularly suitable for the use of interchangeable lenses so that it can be used for all purposes from close range copying or wide-angle work to tele-photography. It is, as we have said, an expensive camera and is usually fitted with first class lenses. It gives what is, for these days, a fairly large picture. The quality of the lenses and the moderate degree of enlargement required enable it to provide prints and transparencies of superb quality.

THE 120 TWIN LENS REFLEX

This design uses the same reflex principle as the single lens reflex with the important difference that the viewfinder image is seen through a separate lens which plays no part in the actual taking of the picture. There are two lenses, one situated immediately above the other, the upper one viewing the picture, the lower one taking it.

These two lenses are carefully matched to provide the same size image and angle of view and are mounted on a single panel so that they can be moved forward or backward in concert to focus the picture simultaneously on the focusing screen and on the plane in which the film, protected by the shutter, is located.

There are obvious advantages in this arrangement. The mirror does not impede the passage of the image-forming rays to the film, so it can be in a fixed position. No special blind is necessary to protect the film while the viewing and focusing are effected—the shutter can do this. The mirror remains stationary and so rules out any possibility of mechanical trouble. Also it never blocks the viewfinder image.

Limitations on lens changing

But there are disadvantages, too. First, most cameras of this design have fixed lenses. There is no provision, with the notable exception of the Japanese Mamiyaflex, for fully interchangeable telephoto and wide-angle lenses. Attachment lenses designed to overcome this are sometimes available, but their scope is limited and they are

frighteningly expensive. The focusing travel of the lens panel is also restricted (again except in the Mamiyaflex) so close range work is impossible without a supplementary lens (see page 214).

Supplementary lenses, for convenience, have to be a matched pair. In close up work further difficulty arises. The separation between viewing and taking lenses means that each views the subject from a slightly different angle. When the subject is nearer than about 6 ft from the camera, the higher viewpoint of the viewing lens causes it to look over the top of the subject, thus showing rather more at the top of the viewfinder and rather less at the bottom than will actually appear on the film.

The best of the twin lens reflexes use various methods to correct automatically this parallax discrepancy but it remains a significant disadvantage of the twin lens reflex design. No parallax correcting method can simultaneously provide the lenses with the same viewpoint.

A practical design

The twin lens design is, theoretically, outdated and, logically, it should have passed into history years ago. The fact that it has survived is very largely due to the simplicity of operation, mechanical reliability, the structural toughness of the design, and particularly to the relatively modest price for a large-format camera.

The twin lens is one of the great classic camera designs which—like the bumble bee—stands for the triumph of the practical over the theoretical.

35 mm NON-REFLEX

This is the type of camera which sells in the greatest numbers and of which there are by far the most models available. That does not mean, of course, that it is the best. The design includes, after all, some of the cheapest cameras made, even if it does also include some of the most expensive.

The design can be traced back to one model—the Leica. This was the camera which first made the photographic world sit up and take notice of what was then called "miniature photography". That term now has no meaning. The $1 \times 1\frac{1}{2}$ in. pictures provided by the 35 mm camera can be considered small only if regarded as contact prints.

With modern films and optical equipment, they are quite large enough to produce enlargements of first-class quality.

Wide range of models

The 35 mm camera was, for some years, comparatively rare and quite expensive. Today, it is commonplace and the cheaper versions compare very favourably in price with the old box cameras. The principle, of course, is still the same. It is only the size that has changed. That became possible as soon as the Leica was taken seriously and manufacturers set about improving their films so that they could easily withstand the necessary high degrees of enlargement without noticeable loss of quality.

Then, the small size and simple design, coupled with other improvements in miniaturization techniques, enabled a variety of additional features to be built into the camera. Double exposure prevention, interconnected film transport and shutter tensioning, built-in exposure meters, coupled rangefinders, etc., were all advantages to add to the extra load of film and ease of handling.

For these and many other reasons, the 35 mm camera is now the choice of very many camera users—both amateur and professional.

An illogical popularity

The popularity of the 35 mm camera was not a very logical development. It undoubtedly stemmed from the prestige Leitz bestowed on the format and owed something, too, to the convenient extra features that its small size made practicable. It was not, however, the ideal camera for the casual, few films a year photographer, who found eight or a dozen exposures quite enough to get through.

Once launched, however, the 35 mm camera, so comparatively easy to make in its cheaper versions, rapidly displaced all eye-level 120 size cameras and prevented, much to the regret of many, further development of such superb cameras as the Super Ikonta and many others. Who knows what developments these models might have undergone had not all manufacturers so avidly seized on the new 35 mm market?

Instead, the $2\frac{1}{4}$ in. square format was left for a decade or more almost exclusively to the twin-lens reflex and is only now beginning to come back to the eye-level camera in the form of single-lens reflexes. The rangefinder 120-size camera is a rarity.

It can be argued that 35 mm film encourages extravagance and that more pictures mean more enlargements to be made and so more expense. Conversely, it would be argued that more pictures also means a greater chance of a good one, and only the good ones need be enlarged.

Whatever the truth, the 35 mm reigns supreme over the whole range of users from the holiday snapshotter to the advanced amateur and now even has a large following in the professional world. For many of these users, it is the ideal camera. It is comparatively small and easy to handle. The more advanced models can take a variety of lenses and auxiliary equipment to enable them to tackle almost any photographic task. It is at least superficially economical in running costs, black-and-white film costing very little indeed per shot and even colour film encouraging reasonably prolific shooting.

Its practical disadvantages

The best of these cameras are of excellent design and manufacture and they have few disadvantages. Inevitably, however, they are not perfect. They have the parallax troubles that beset the twin lens reflex, because the picture is viewed through a separate optical system. Those that can take interchangeable lenses need separate viewfinding facilities for each lens. The range of lenses that they can use is limited because built-in rangefinders cannot be made to work on lenses much over 135 mm in focal length. Similarly, rangefinders cannot work at extremely close range and all focusing of close-ups has to be done by careful measurement and often by means of complex calculations that are not easily applied to practical problems.

Compact 35 mm cameras

Compared with early models, however, all 35 mm cameras gradually increased in bulk and weight. Whether this was intentional or merely a lack of attention to detail by manufacturers is not too clear. There was no real reason, despite the addition of rangefinder and exposure meters, for the 35 mm non-reflex to become quite as large as it did.

The 35 mm reflex, meanwhile, was becoming even larger and it soon occurred to manufacturers that there was room for yet another range of cameras. Perhaps remembering the near-popularity of the midget half-frame (see page 39), they began to bring out very small

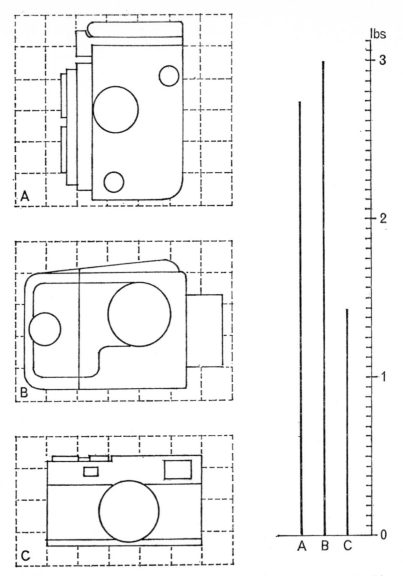

Comparative shapes, sizes and weights of the cameras mentioned in this chapter.

A, Twin-lens reflex. B, 120 single-lens reflex. C, 35 mm non-reflex. D, 35 mm single-lens reflex. E, Instant-loading type. F, Half-frame. G, Ultra miniature.

There are variations in each group, particularly in the 35 mm models. Some of

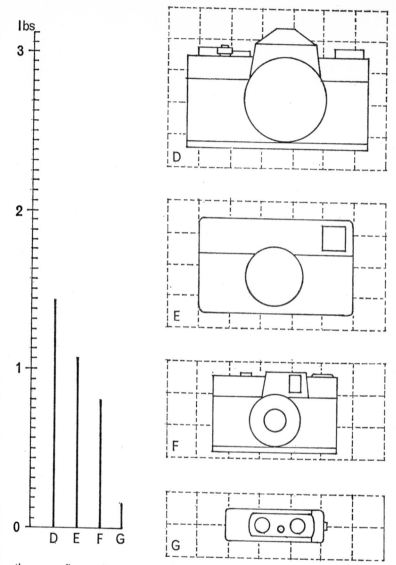

the non-reflex types are much lighter than is indicated here, while the single-lens reflexes can be much heavier. Models of comparable quality and versatility, however, are now of about equal weight in both types. The instant loading model shown is the simple form. There are also more advanced models and versions of standard cameras taking the instant-loading cartridge. These are generally much heavier.

full frame cameras. These have been dubbed "compact" cameras and are proving very popular indeed. Invariably of the fixed-lens type, they are sophisticated cameras in every other respect, with good shutters, sometimes with automatic exposure control, rangefinder, semi-automatic flash setting, etc. They are generally in the middle price range and are eminently suitable as second "carry-everywhere" cameras for real enthusiasts.

35 mm SINGLE LENS REFLEX

This is the "modern" camera. Its design improved so rapidly in the 1950s that innumerable amateurs and not a few professionals were soon hailing it as the best. Certainly it is the most versatile.

The design is by no means new. Even in the 35 mm size it dates back to the 1930s. At first, however, the viewfinder image was shown in the top of the camera. It was very small, it suffered from lateral reversal and was decidedly difficult to use for pictures in the vertical format.

The mirror blacked out the viewfinder at the instant of exposure and had to be wound down again for the next shot. The lens had to be opened wide to focus and manually closed down to the shooting aperture. In short, the design had some advantages in long-focus and close-range work but the camera (there was only one) was decidedly slow and cumbersome in use.

It was not until the 1950s that the basic idea (which had been improved but little in that time) was really turned into a first-class design. The modern 35 mm single lens reflex presents the viewfinder image at eye-level just as the non-reflex does. But it is a much brighter and larger image and, owing to the inclusion of a specially-shaped prism above the focusing screen, it is both right way up and right way round. It is a replica image, that is to say when using the standard lens it is similar in size and appearance to the scene before the unaided eye. The rangefinder camera, on the other hand, presents a miniaturized view.

The mirror blacks out the viewfinder only at the instant of the exposure, flipping up and down automatically before and after the shutter opens and closes. The majority of standard, wide-angle and moderately long-focus lenses are fitted with automatic iris control so that the lens is always wide open for focusing and viewing and

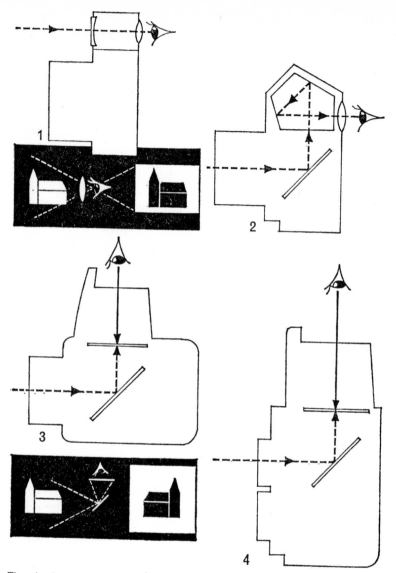

The viewing system of the non-reflex camera (1) cannot show exactly the same view as the taking lens. That is parallax error. The eye-level reflex (2) overcomes this problem. Both types show a correctly orientated image. The waist-level single-lens reflex (3) has no parallax error but its screen image is laterally reversed. The twin-lens reflex (4) has both parallax error and laterally-reversed image.

automatically closes down to the preselected shooting aperture when the shutter is released.

Thus, the disadvantages of the reflex that made the non-reflex so much easier and quicker to use have been almost entirely eliminated. Not entirely, perhaps, because there are still many people who find the coupled rangefinder easier to use than the focusing screen.

Unique advantage

But the reflex has indisputable advantages of its own. It has no parallax troubles, it needs no separate viewfinders and it can use very long-focus lenses without running into insurmountable difficulties with focusing. Some models do have focusing troubles with very short-focus lenses because the mirror has to be locked out of the way but, in practice, this is relatively unimportant.

The single lens reflex is more expensive than the non-reflex type and there are no really cheap models. On the other hand, there are some that are fantastically expensive and for these there is generally a range of lenses and ancillary equipment that would fill a good-sized cupboard. Motor-drive mechanisms with remote control operation, either mechanical or by radio, together with automatic aperture adjustment by servo motor as the light changes, can allow unmanned photography over a period of hours. In that time, the camera might take 250 or more shots without attention.

The relative advantages of the reflex and non-reflex have provided food for innumerable arguments. The benefits of the reflex are too obvious to need stressing. The real point is whether these advantages are of any value to the person concerned. No figures are available but it is a reasonable guess that the majority of those who buy an interchangeable-lens camera never, in fact, buy another lens—let alone an expensive, extremely long-focus lens. Few of them are much concerned with close-up photography either. The parallax problem rarely troubles them.

To these, the special merits of the reflex are confined to the replica viewfinder image and the fact that it might be easier to focus.

It has disadvantages, too

Then the disadvantages of the reflex take over. It is bulkier, making it awkward to carry and sometimes less easy to handle. It has a

much more complicated mechanism. There is no real evidence that it is more prone to breakdowns than the non-reflex but it is a reasonable assumption and it is certainly less easy and more expensive to repair.

To give a really bright viewfinder image, the reflex has to have a large-aperture lens and a fresnel screen, which can add up to additional unnecessary expense. Moreover there are many who do not, in fact, find the screen image easy to focus and who are irritated by the ubiquitous rangefinder spot slap in the middle of the image. Very few models can be provided with screens without this aid to focusing.

On most models the image on the film covers a fractionally wider field than can be seen in the viewfinder. With colour transparencies this extra margin area is taken back again by the mounting frame which slightly overlaps the image all round, so in this case the finder "inaccuracy" can hardly be considered a disadvantage. Even with black-and-white, many enlarger negative carriers similarly encroach upon the image area.

Choose for yourself

So the final choice is an individual one. For the average user, who has no intention of ever buying another lens but simply wants a camera for general photography, holiday records, etc., the reflex is largely a waste of money. He can get extremely good results from a simple rangefinder camera at half the price or less.

Only those who intend to do a fair amount of both close-range and long-range work really need a reflex. Even they should remember that the rangefinder can cope perfectly well with most wide-angle and long-focus work using lenses of up to at least 135 mm focal length.

HALF-FRAME

This is a type of camera that was confidently expected some years ago to capture a large part of the market. It is rather surprising that it did not do so.

The half-frame, which some prefer to call the single-frame because it uses the same image area as a single 35 mm cine frame, is a very simple adaptation of the standard 35 mm camera. Whereas the

normal 35 mm camera uses a horizontal image area of $1\frac{1}{2} \times 1$ in. the half-frame uses an upright area about half that size, i.e. $\frac{3}{4} \times 1$ in. Thus, it can take up to 72 pictures on a standard 36-exposure length of 35 mm film. It can also be made a good deal smaller than the normal 35 mm camera.

Compact and easy to use

Most half-frames are, in fact, extremely small, genuinely pocketable cameras which are quite simple to use. Their film image area can be covered by small, short-focus lenses which, even at moderately large apertures, give sufficient depth of field to make scale focusing a practical proposition. None of them have, in fact, rangefinders or other aids to focusing except the one and only reflex model.

Shortcomings

Nearly all half-frames have fixed lenses. That limits their appeal for the person who feels that he must have a choice of lenses.

Second, the advantage of economy in film may actually be a disadvantage for a great many users. As we noted before, many people have difficulty in using up 20 or 36 exposures. But when it comes to 40 or 72, they find themselves with the film still in the camera for months or they shoot off more than half a film simply to use it up.

Third, when the size originally came on to the market in a big way colour processors were very slow to cater for it. They frequently returned half-frame exposures unmounted or charged extra for the additional mounts.

Finally and perhaps most important, the half-frame has been subjected to the usual criticisms levelled at any new format—although the format itself is by no means new.

Ideal for some

The half-frame is an excellent camera. At reasonable degrees of enlargement this small format can give results virtually indistinguishable from those of the normal 35 mm camera. The camera can be carried anywhere with no inconvenience. There are models with built-in exposure meters, automatic exposure control and even

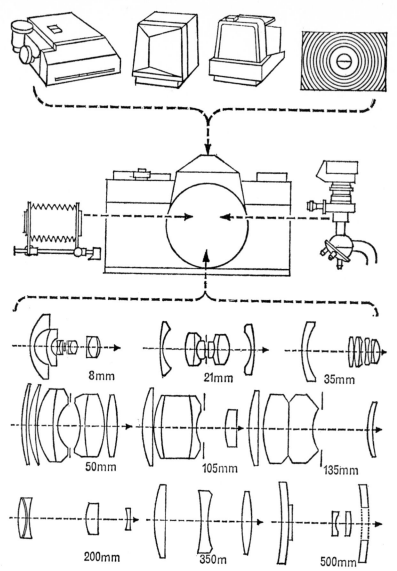

8mm

21mm

35mm

50mm

105mm

135mm

200mm

350m

500mm

Most 35 mm reflex cameras can take a vast range of lenses as well as extension tubes or bellows, microscopes and a variety of other attachments and still show in the viewfinder the exact image that will appear on the film. In some models, the pentaprism and focusing screen can be removed to permit such refinements as through-the-lens exposure control, fast action shooting, waist-level viewing, the use of different screens, etc.

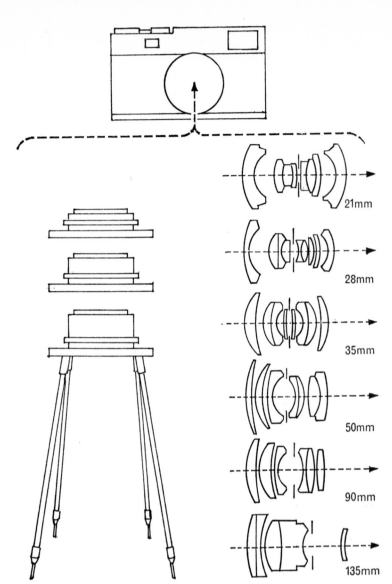

21mm

28mm

35mm

50mm

90mm

135mm

The non-reflex or rangefinder camera has one big limitation as compared with the reflex. It views the scene through an optical system separate from the taking lens. Focusing is effected with a built-in rangefinder which rarely works with lenses of more than 135 mm focal length or at very close range. For close-ups, special equipment is required, such as supplementary lenses and a stand to measure the focused distance.

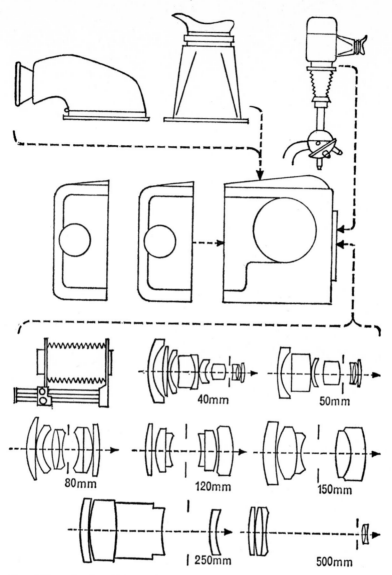

40mm

50mm

80mm

120mm

150mm

250mm

500mm

The rollfilm reflex has all the versatility of its 35 mm counterpart plus advantages of its own. Originally designed for waist-level use, it can take attachments to permit it to be used at eye level as well as magnifiers for critical focusing. Some recent models are primarily intended for eye-level use. Traditional models have interchangeable backs, holding the film magazine in a light-tight container, so that the type of film in use can be changed at will.

powered film transport and rewind. It is, in fact, the ideal camera for the travelling photographer, the occasional snapshotter, the family record type and many others who require straightforward, good quality photographic records. And that includes a sizeable proportion of today's camera users.

Nevertheless, for each of these it has, as we have said, its individual disadvantages. Slight as they are, these drawbacks are apparently enough to prevent it displacing the normal 35 mm camera in popularity and the numbers of half-frame cameras are steadily decreasing.

ULTRAMINIATURE CAMERAS

When 35 mm photography was considered "miniature", the cameras using a smaller format had to find a name denoting something smaller. At first, they used subminiature. Now the generally accepted term appears to be ultraminiature.

These are the cameras giving an image size of about 10 × 14 mm. There have been many versions in a variety of styles and sizes but an attempt is now being made to standardize on the 16 mm gauge. Models have come from Germany, Japan, Italy and others. A unique interchangeable lens model was produced in Russia but still the Minox is undoubtedly the best known. It is smaller than other models and uses a film 9·5 mm wide instead of the usual 16 mm width. This is the camera that has featured in many news stories for its use in unusual and even forbidden locations. It was sent down an air pipe to trapped miners in Germany and was used by Lord Brabazon of Tara to take forbidden pictures in the House of Commons.

This is, of course, the strong point of the ultraminiature. It is inconspicuous, extremely portable and can be used in situations where no ordinary camera could penetrate. Enough film for 1,000 exposures would barely bulge a jacket pocket.

Nevertheless, at the risk of offending its many adherents, we must say that, at present, the tiny image area provided by the ultraminiature is incapable of reproducing extremely fine detail with acceptable quality. In the right hands, it can produce quite staggering results but only with very slow film, meticulous processing, the finest enlarging equipment and exceptional operating and printing skill.

It has no real application for the average user, who may have difficulty in obtaining film and in getting it processed satisfactorily.

CARTRIDGE-LOADING CAMERAS

Kodak have produced two types of cartridge-loading camera system —the now well-established Instamatics using 126-size film and the newer Pocket Instamatics using 110-size film.

The cartridge is really a development of the method the ultra-miniature cameras have used since they were first introduced. It consists of two film containers joined together in a sort of dog bone shape, now commonly known as a cartridge to distinguish it from the 35 mm cassette. The cartridge is loaded with film at the factory and all the user does is drop it into the camera. One container is larger than the other so that the cartridge cannot be put into the camera the wrong way round. A sprocket mechanism pulls the film across the back of the camera and into the empty container frame by frame as the transport mechanism is operated. When all exposures have been made, the camera is opened, the cartridge taken out and another dropped in.

The exposed film is sent away for processing still in its cartridge, which is light-sealed and has to be broken open to get the film out. It uses relatively short lengths of film giving 12 pictures on black-and-white or colour negative film and 20 pictures on colour reversal film. The picture size is about 1 in. square.

The pocket Instamatics use 16 mm film providing an image 13 × 17 mm. They would appear to be aimed primarily at the colour-snapshot market to give enprints from Kodacolor II, introduced with the cameras. Black-and-white and colour reversal materials are also available, however, together with a range of projectors.

These cameras are, of course, ultraminiatures. Although their image size is appreciably larger than that of the early subminiatures, it is practically identical with the later standard. As such the cameras are subject to all the reservations we have already made about the format—with the important proviso that this range is backed by Kodak, who can ensure that film and a comprehensive processing service is always available. The bulk demand for standard enprints

at about seven times enlargement for a largely uncritical market is easily met.

Nevertheless, it must still be said that the ultraminiatures, including the Pocket Instamatics, are cameras for specialized use or for snapshotting. There is still a very definite limit to the quality of the image they can be expected to produce when in normal day-to-day use. Like the larger Instamatics, they have serious limitations for the more-than-occasional photographer who takes his hobby rather seriously, not the least of which is their rather expensive pre-packed film.

3: Built-in Features

Time was when a camera
was little more than a lens on a box.
Now it can have so many built-in features
it hardly needs you at all.
Some of them are useful, some are not.

Miniaturization has played an important part in modern technology and, inevitably, it was soon applied to photographic equipment. Although the 35 mm camera can no longer be considered miniature in any sense of the word, it was for many years too small to take much in the way of built-in accessories. Now, however, greater bulk seems to be acceptable and that, coupled with new materials and methods, has enabled it to contain within its structure additional features designed to simplify its use.

RANGEFINDER

Unless you have a camera with a reflex focusing screen some accessory to aid focusing is a great advantage. Setting the distance by guesswork is adequate when you are working at medium distances and using relatively small apertures. But the 35 mm camera is often used at fairly close range and at wide apertures, when focusing becomes rather critical.

A rangefinder produces two images of the subject in a single eyepiece. These images can be made to coincide by adjusting a wheel

which is engraved with distance footages. When the images coincide, the scale on the wheel indicates the distance.

Coupling

It was a simple matter to build such a rangefinder into the top plate of a 35 mm camera. It was a step further to arrange for the focusing movement of the lens to actuate the viewfinder wheel so that the lens distance scale became also a rangefinder scale. Thus, when the viewfinder images coincided, the lens was focused. That is the coupled rangefinder and it is remarkably swift and accurate in operation.

Early models had separate eyepieces for rangefinder and view-finder but all modern cameras of this design have a single eyepiece which presents the rangefinder image in the centre of the viewing field.

For reasonably serious work, a coupled rangefinder is essential with the non-reflex camera. It is not a complicated mechanism and is very robust. It can be easily adjusted by a camera mechanic if it should happen to get out of alignment.

You can check the accuracy of a rangefinder by setting the lens on infinity, that is, as far as it will go, and looking through the viewfinder to see if infinity subjects coincide. Be certain that your test "infinity" subject is really distant. Probably the surest way is to use the moon on a clear night.

Split image and coincident

There are two basic types of rangefinder—split image and coincident image. The split image type bisects the image, usually horizontally but sometimes diagonally, so that the two halves are laterally displaced when the object is out of focus. A variation of this rangefinder is often found in reflex cameras (see page 58).

With the coincident type, two complete images are presented in a laterally displaced manner. When they are fused into one, the object is correctly focused. This rangefinder is confined to non-reflex cameras, or can be obtained in a separate form suitable for mounting in the accessory shoe.

The split image type is handy where there are straight lines in the picture but is often difficult to use when no such lines are present.

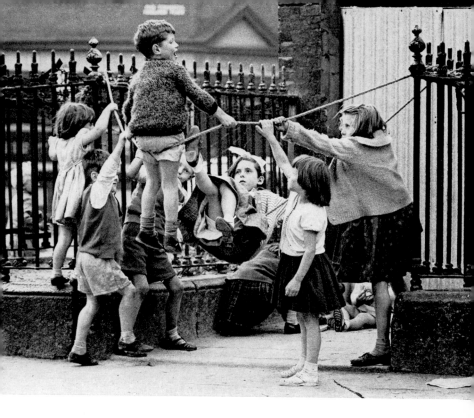

PEOPLE

There are many ways of showing people. You can shoot as you find them, catching the mood of a fleeting moment. You can introduce a little unposed sophistication (p. 50) or pose your characters for impact (p. 51). Lighting and presentation can play their part while, for glamour, the first requirement is a suitable subject.

Each approach has its own aims, technique and adherents. The "snapshot" above needs as much care as the precisely posed and lit studio presentation on page 56. Lighting was used to convey a mood on pages 54 and 55. Each picture appeals to a different photographer and a different audience. What they must have in common, if they are to have individual merit, is an appeal as pictures. Photographs of people should be something more than a map of a face or a diagram of a group.

49

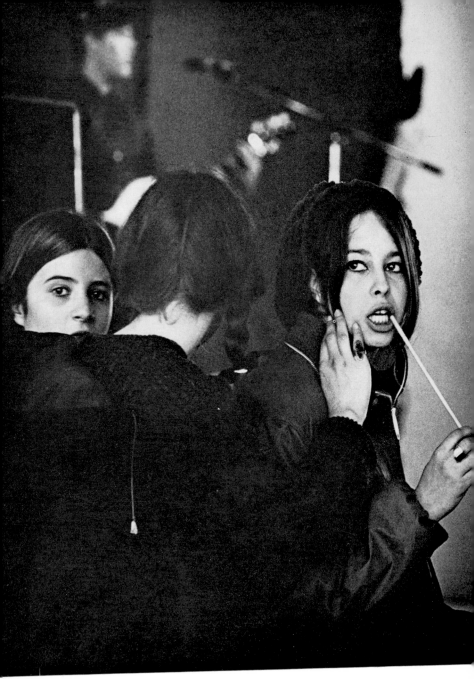

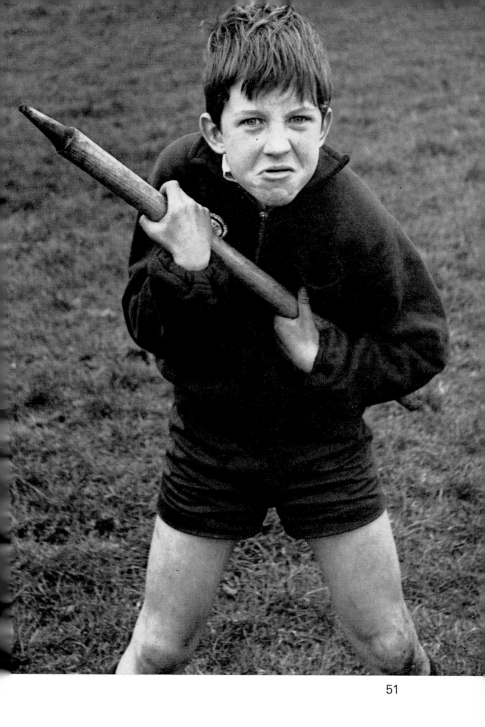

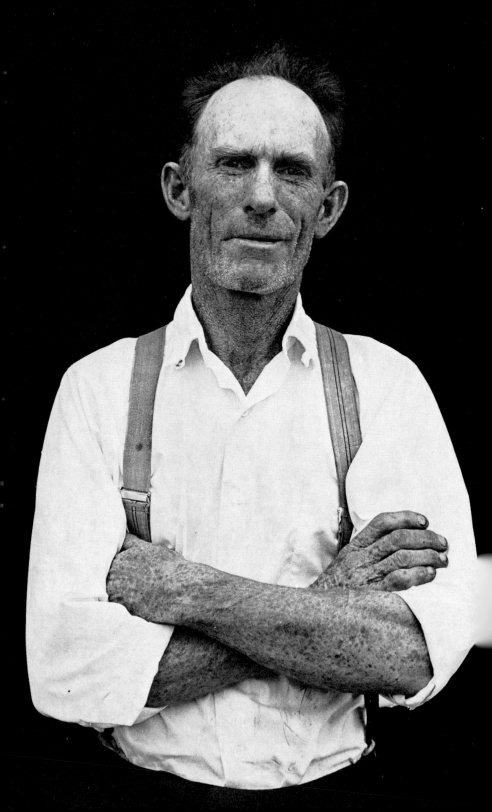

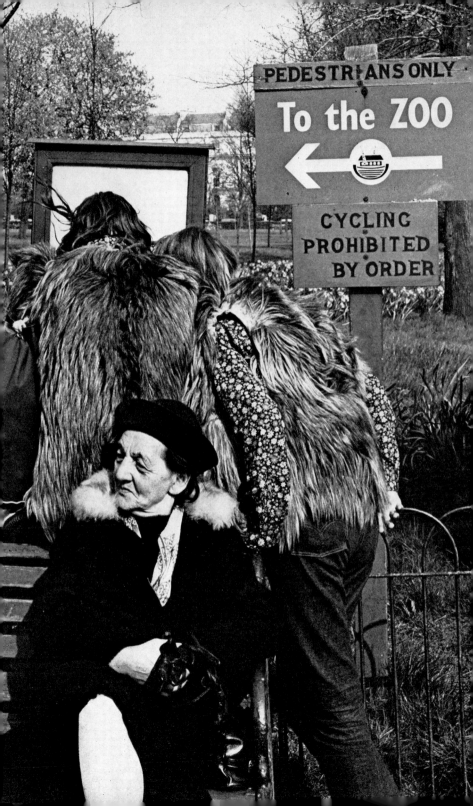

Photos by: Harald Mante (pp. 49 and 52), Nils P. Blix (p.50), R. Owen, Harrow School of Photography (p. 51), I. Rosenberg, Harrow School of Photography (p. 53), Leslie Turtle (pp. 54 and 56), R. Perry, Harrow School of Photography (p. 55).

The coincident image is a better all round version and is swift and accurate with most types of subject.

Sometimes, the coincident image type does not differentiate clearly enough between the two images—or one of the images is rather too dim to see clearly. This can usually be improved considerably by placing a coloured "filter" in one of the rangefinder windows in the front of the camera. This changes the colour of one of the images and shows up any lack of coincidence more clearly.

A suitable material for this purpose is a cut-to-shape piece of one of the colour negative films having an orange or deep yellow masking dye base.

Limitations

The built-in rangefinder has limitations determined by its physical dimensions. Greater accuracy and longer working range are obtained with increased base length, i.e. separation between the two viewpoints, but the base length is obviously limited by the size of the camera. In practice, this generally means that the longest focal length of lens that will couple with the rangefinder is about 135 mm.

The rangefinder is also generally unusable at very close range. Such work often requires extension tubes which have no moving parts to actuate the rangefinder mechanism, or supplementary lenses, for which the rangefinder is not calibrated. Even if the lens is capable of focusing very close without such assistance, the rangefinder mechanism cannot accommodate the long focusing travel of the lens with sufficient accuracy. Thus, the rangefinder camera is virtually unusable with very long focus lenses unless fitted with a reflex housing. At very close range, focusing has to be effected by careful measurement and the field of view calculated or ascertained from published tables, unless the manufacturer supplies special close-up equipment. The camera has to be lined up with the centre of the field without reference to the viewfinder.

Rangefinders for SLRs

The single lens reflex camera has no such problems. You can focus through the taking lens, whatever focal length it might be and regardless of whether supplementary lenses or extension tubes are used. You can focus on any part of the image or observe the focus all

over the image, provided, of course, the camera has a focusing screen.

To the uninitiated, that last provision might seem laughable. What would be the point of a reflex camera without a focusing screen? It might seem too that the reflex camera is the one camera that can happily dispense with the rangefinder. Yet virtually every reflex camera now made has a rangefinder spot in the middle of its screen and several single lens 35 mm reflexes have clear glass screens which do not focus the image.

The clear glass screen, of course, gives a brighter viewing image than the ground glass and that has actually been used as a selling point for one camera. The presence of a rangefinder spot in most reflex cameras is an admission of the inadequacy of the ground glass screen for focusing. The ground glass just is not swift enough in use for many 35 mm users.

The rangefinder in the reflex first took the form of a pair of tiny prisms or wedges cemented into the centre of the focusing screen in such a manner that they crossed in the plane of sharp focus. The effect is to present a split image when the lens is not correctly focused. This and the method of use are exactly the same as with the ordinary split-image rangefinder.

A later variant of this principle is the inclusion of a great number of tiny prisms in the central rangefinder field. The effect then is to present a disintegrated or shimmering image when the lens is not correctly focused. As the image is brought into focus the image becomes steady and clear. The special advantage of this microprism focusing spot is that it is just as easy to focus on bold outlines in the subject as on textured surfaces. The split image is not so good where the bold outlines are horizontal, and very difficult to use on texture, unlike a plain ground glass screen. The microprism is a compromise between rangefinder and ground glass focusing.

For the best of both worlds, either type of rangefinder may be surrounded by a "collar" of finely ground glass (with no fresnel rings) to give a clearer image of fine detail than can be obtained on the rest of the screen. Or the central rangefinder may be a split image type and the surrounding collar a microprism type.

These rangefinders couple, of course, with any lens. They have no moving parts and therefore need no actuating mechanism on the lens. They are limited, however, in the same way as ordinary range-

finders. They will work satisfactorily with most standard lenses and with long-focus lenses up to certain limits. They can only be guaranteed to be accurate when used at reasonably wide apertures—and with many long-focus lenses the maximum aperture just is not great enough. With any lens of maximum aperture smaller than $f4$ the rangefinder cannot be used properly. Whenever there is a discrepancy between the rangefinder and the screen image, the screen image should always be regarded as the more accurate.

It is imperative with the rangefinder in the reflex screen that the eye be centrally placed behind the eyepiece. A fraction off centre and the rangefinder image can be thrown out of line. With the split image type, one half of the image may go dark, just as it does when too small an aperture is used—and for much the same reason, the off-centre eye receiving only a vignetted view. This is a common problem with spectacle wearers, who often find it difficult to position the eye correctly.

Rangefinders in the reflex screen are, in fact, rather a nuisance. They have tended to grow bigger and bigger and to tempt the user to focus by their aid at all times. They overlay quite a large part of the centre of the picture and can interfere with composition and general viewfinding. But with most cameras, the rangefinder is here to stay and you can do nothing about it unless you have one of the few models which allow the screen to be changed for a type more suited to the user's needs.

EXPOSURE METER

Apart from the rangefinder, the most commonly built-in accessory is the exposure meter. In these days when fast films make photography possible in low lighting conditions and accuracy is needed for colour films, correct exposure can be quite a problem. Most people find an exposure meter essential, so it was a natural development to build it into the camera.

It has its uses

Here again, personal preference is the most important factor in deciding whether or not your camera should have a built-in meter. For most day to day photography, the built-in meter is useful and

there is no particular advantage in having a separate meter. On the other hand, the built-in meter is rather clumsy to use for local readings of small areas, for incident light readings and for light-balancing purposes (see page 201). Moreover, it sometimes has a restricted scale. The more versatile separate meters can give much more useful information than the straight reading of the strength of the light offered by a built-in meter. A separate meter has obvious advantages for close range readings when the camera is on a tripod.

Except in these specialized cases, the built-in meter has many advantages. Those which work on a "follow-pointer" basis (see page 65) are particularly easy to use and are even more so where the meter needle is visible in the viewfinder. Such a meter gives a continuous indication of available light levels. Changes in light strength which might not be immediately apparent to the eye are faithfully recorded by the meter and immediately registered in the viewfinder.

We shall return in more detail to the actual construction and use of exposure meters at a later stage. For the moment, we are concerned only with their value as an integral part of the camera.

Through-the-lens meters

The type of built-in meter fitted to most 35 mm reflex cameras takes its reading through the camera lens. The theory—and the publicity blurb—is that such a meter reads the light which actually falls on the film. In practice, it may read the illumination on the screen or at some other point within the camera. In theory, too, it gives a much more accurate reading because its field of view coincides exactly with that of the lens and it will not, therefore, be affected by light from outside the picture area.

With standard lenses, these advantages tend to be somewhat illusory. Most meters are designed to read an area corresponding to the coverage of a standard lens—or even a little less. Readings made by an ordinary built-in meter and a through-the-lens (TTL) meter should be virtually identical when the standard lens is in use.

Moreover, the TTL meter works in exactly the same manner as any other meter. It is designed to give a reading suitable for average subjects, i.e. those with reasonably equal distribution of light and shade. When those conditions do not apply, the TTL meter is misled

in exactly the same manner as any other meter and its reading has to be adjusted to the prevailing conditions.

The TTL meter has more obvious advantages when used with long-focus lenses. Then the meter's angle of view is narrowed in sympathy with that of the lens and a more accurate reading can be obtained. Naturally, adjustments are still necessary for non-average subjects.

Even at close range, the apparent advantages can be illusory. When lenses are used at extremely close range, with extension bellows or tubes, the light has to travel a greater distance from the lens to the film. The ordinary aperture numbers no longer give an accurate assessment of exposure. So careful calculations have to be made to adjust the reading given by the ordinary meter. No such adjustment is necessary with the TTL meter when used with ordinary lenses, but telephoto and retrofocus lenses can cause problems (see page 217).

Some TTL meters give a double reading. They take one reading from a small area suitably marked in the viewfinder and another from the whole picture area, combining the two so as to give emphasis to the small area, which should be placed on the most important tone. The value of this method is at least doubtful.

It's just an ordinary meter

Some TTL meters take all their readings at the full aperture of the lens. Others disconnect the automatic diaphragm control, and so stop down the preset taking aperture, as the meter is switched on. The type of TTL meter that reads through the taking aperture has its drawbacks. When the taking aperture is small and the light not over bright, as might happen in close-range work, it can be very difficult to determine the needle position in the viewfinder.

There is also a psychological factor to be overcome with the TTL meter. Because it reads through the lens and no doubt also because of the nature of the manufacturers' advertising, it tends to be regarded by the inexperienced as infallible. We must emphasize that it is exactly the same in principle as any other meter. It is calibrated in exactly the same way and it may often give readings which have to be adjusted in the light of experience and knowledge of how exposure meters work. You would not get a good result, for example, if you copied a document with the exposure recommended by a TTL meter.

The reading would have to be adjusted in exactly the same manner as if a separate meter were used.

Cadmium-sulphide meters

Most TTL meters are of the cadmium sulphide (CdS) type, whereas some separate and built-in meters are of the selenium type. Whether this is an unqualified advantage is at least open to doubt. One of the reasons for the extraordinary sensitivity of the earlier CdS meters was their tendency to react strongly to light at the red end of the spectrum. This enabled them to give a reading at very low light levels but the readings given were not reliable guides to exposure, because the film is less sensitive to red light. In modern meters of reliable manufacture, this tendency has been corrected.

Nevertheless, no meter is fully reliable at the extreme ends of its scale. Moreover, films tend to react uncharacteristically in very low and very intense light conditions and experience of such conditions is often a better guide to exposure than a straight meter reading.

The CdS meter tends to be unreliable in other respects. Unlike the selenium meter, it has a memory. When taking one reading it may be influenced by a previous reading. This is particularly noticeable in bright-light conditions. If the CdS meter is pointed at a brightly-lit scene and then turned to a low-light scene, it may give too high a reading for the second scene unless given several seconds to settle down. If it is exposed to bright light while set for a low light reading, it can remain affected for hours or even days. In that condition it is quite incapable of giving a correct reading—but there is no indication that it is "out of order".

Some of these troubles could be eliminated if the meter had a zeroing control. Most selenium meters have this facility, so you can check that the needle is in the zero position before taking a reading. Very few CdS meters have a zero control and, in fact, many have no zero mark for the needle at all.

Self-powered

Perhaps the biggest disadvantage of the CdS meter is that it is not self-powered. The light-sensitive part of a selenium meter is a comparatively small piece of selenium which generates an electrical current in proportion to the amount of light falling on it. That current

can be measured and the result presented on a scale calibrated to provide exposure recommendations.

The heart of the CdS meter is a light-sensitive resistor. The normal electrical resistor has a given resistance, according to its structure, to the passage of electrical current. The light sensitive or photo-resistor has a resistance that varies with the amount of light falling on it. When no light falls on the resistor, practically no current can pass through it. As the light increases, so the resistance falls and the more current it will pass. So the current variations can be measured and presented in the form of exposure recommendations as in the selenium meter—with the very important difference that the CdS meter has to have a current fed to it from a battery.

The advantages of the CdS meters apart from their extra sensitivity, size for size, are that they are particularly suitable for TTL metering, and that they can read narrow angles. In selenium meters a narrow angle of view can only be obtained with a baffle over the front, which reduces sensitivity. The value of these advantages to the average photographer is minimal.

FLASH

Built-in flash equipment is a feature of some inexpensive cameras but it is rarely encountered in more advanced models. This is not surprising because a flashgun mounted on the camera does not give particularly good results.

The ordinary flashgun can always be mounted away from the camera by means of an extension lead but if the socket for the bulb is actually in the camera, you are stuck with flash-on-camera work. This is convenient if you are likely to use flash only on rare occasions when you will not be concerned unduly about the quality of the picture. If you think that there may be times when you want to take reasonably good pictures by flash, forget about built-in flash. The only time when it might be said to be a sensible arrangement is when the flash is used as a fill-in—daylight or other lighting forming the main light source.

In the past it was often argued that flat, frontal lighting was necessary for colour. This was true at one time when the contrast of the colour material itself was excessive. But it no longer applies today.

Built-in flash normally uses the tiny, but quite powerful, AG1 type bulb in a midget reflector. The whole unit is less than a cubic inch in size and it sometimes pops up from the camera body at the touch of a button.

A later version is a special socket to take flashcubes. The flashcube is one of those ideas brought out now and then to speed up flash operation. It is a solid block containing four flashbulbs with individual reflectors. The cube fits on to the camera and revolves when the film is wound on to bring a fresh bulb into place automatically. After four, presumably high-speed shots, you remove the flashcube and fit another.

The flashcube costs more than four flashbulbs and is really a rather expensive luxury. It is very rarely indeed that you need to shoot so rapidly that you cannot spare the few seconds it takes to change the bulb.

Some cameras are designed to take special flashguns which dispense with the necessity for a connecting cable. The flash contacts are in the accessory shoe of the camera and in the foot of the flash-gun.

This, too, is just a gimmick. Admittedly it dispenses with that awkward cable, but the whole point of the cable is that it allows you to remove the flashgun from the camera and operate it from the side or such other position as may give a more pleasing lighting arrangement. Of course, you could buy one of those useful little accessories which converts the shoe contacts into the normal co-axial socket.

AUTOMATIC EXPOSURE CONTROL

It seemed, not very long ago, that we were moving into the age of the camera without scales. The built-in exposure meter was developed to the extent that it could control exposure automatically. As you set either shutter speed or aperture, the meter made the appropriate adjustments to ensure that the correct exposure was given.

The snags soon became apparent. Both aperture and shutter speed have other tasks to perform besides exposure control. Aperture, for instance, controls depth of field (see page 121) and the shutter speed is important if there is movement in the subject. The exposure meter could not deal with such things. Yet some cameras were produced

which did not indicate the actual aperture and shutter speed set by the automatic features. You could find yourself trying to shoot a racing car at 1/30 sec. and you would not know until you saw the results.

On some models, a small aperture automatically involved a slow shutter speed. A fast shutter speed could only be obtained with the lens wide open. On others, the shutter speed depended on the film speed setting. A high film speed meant a high shutter speed and so on.

It failed

The fully automatic camera of this type was intended for the user who was seeking trouble-free photography. It was a ghastly failure. The user needed to know a great deal about the mechanism before he could guarantee reasonable results. It was also expensive compared with other designs.

This type of camera is now virtually dead except in the simple versions which have limited aperture and shutter speed ranges. After all, the original automatic was the Box Brownie, with one shutter speed and one aperture for all occasions.

More sensible designs were and are still made. These are the types in which the full aperture and shutter speed range are retained but are linked to the exposure meter in such a way (usually) that the meter sets the aperture required for correct exposure in accordance with the light conditions and the shutter speed you preset. With this type, the automatic aperture control can usually be disconnected so that the camera can be operated in the orthodox manner.

Other models do not actually control the aperture at all. They have a visible indication in the viewfinder or on a separate meter scale when the controls are set to give the correct exposure. With the viewfinder type, for example, there may be a mark in the viewfinder and a needle which moves with the strength of the light and the setting of the film speed, aperture or shutter speed. If you line up the needle with the mark, the controls are set to give correct exposure.

The meter scale type may have two needles or pointers, one manually controlled according to shutter speed and film speed set, the other affected by the aperture control and the strength of the light falling on the meter cell. Lining up the two needles (known as the "follow pointer" system) sets the controls for correct exposure.

These semi-automatic cameras are useful and efficient. They enable you almost to forget about exposure problems and get on with the real job of taking pictures. With most of them, you can get by with very little technical knowledge at all. On the other hand, their automatic facilities do not restrict you from using your own judgment.

Nevertheless, manufacturers still hanker after fully automatic operation, even if the user is not so keen. They have produced some expensive methods of overcoming the difficulty of providing links for this purpose between lens and camera body in cameras with focal plane shutters and fully interchangeable lenses. Electronically-controlled shutters have been pressed into service, special servo mechanisms designed and the Asahi company have even incorporated a memory bank in one of their Pentaxes. All modern systems, however, give the user full control over the automatic operation.

AUTOMATIC IRIS

The automatic iris is a feature of the single lens reflex camera and its function is to make this type of camera almost as fast in use as the rangefinder type. Originally, the SLR lens had to be opened up to full aperture for fine focusing and manually closed down again to the shooting aperture before releasing the shutter. Aperture control of this type is usually called "manual".

A later development was the lens with two aperture control rings. One ring operates a stop without affecting the iris. You preset your shooting aperture with this ring, leaving the lens wide open for focusing. Then, just before shooting, you turn the other ring until it meets the preset stop. This you can do quickly without looking at the lens and you are then stopped down to your shooting aperture.

Sometimes, this type of lens uses only one ring, which can be moved slightly along the barrel against a spring to change its function from the actual aperture control ring to the preset ring. The principle is the same. Both these types are known as "preset" lenses.

The final development was to connect the diaphragm to a pin passing through the lens mount and emerging at the back. When this pin is pushed in by a mechanism in the camera, the diaphragm closes to the aperture set on the aperture control ring. The ring itself

has no effect on the diaphragm, which closes when you press the release fractionally before the shutter opens.

With early models of such lenses, you had to open up the diaphragm again manually after shooting. On modern lenses, this, too, is automatic. The lens opens up again as soon as the shutter closes.

On some lenses, the diaphragm can also be operated by a "preview" button so that you can check the depth of field before shooting. Also, on a number of cameras with through-the-lens exposure meters, the act of switching on the meter also closes down the diaphragm.

All these types are known as "automatic" or "fully automatic" lenses.

The automatic lens is by no means essential but it is less frustrating. It is only too easy to forget to stop down between focusing and shooting. The need to do so also slows down the operation of the camera.

INSTANT-RETURN MIRROR

The instant return mirror is now incorporated in almost every single lens reflex camera. In some models the mirror flips up just before the shutter is released and stays up until the shutter is retensioned. This is often said to be a drawback with moving subjects but it is doubtful if the effect is anything more than psychological. Where it does become a disadvantage (and one camera was particularly bad in this respect) is where the mirror has a tendency to flip up a measurable time before the shutter is released. On some cameras this was caused by too long a travel between the release points in the shutter release mechanism. The closing of the iris, the lift of the mirror and the travel of the shutter were three quite well-spaced operations and you were sometimes caught with your mirror up and your finger still poised on the button. There was nothing for it but to shoot blind.

Even this feature could be turned to advantage, however. Where you were working with a tripod and a time exposure you could allow the mirror to rise and wait for the possible vibrations to die down before releasing the shutter.

The SLR could easily do without the instant-return mirror but the point is academic. You have it whether you want it or not.

POWERED FILM TRANSPORT

Finally, we come to the gimmick which, surprisingly, has been built into only a few cameras—powered film transport and, sometimes, rewind.

Perhaps it is not completely fair to call this a gimmick because it has its undoubted uses for pressmen and a few other specialists. The motorized SLR, for example, is extremely popular with motor racing photographers but this is not usually a built-in feature. The motor unit is a separate, quite bulky piece of equipment of sophisticated design with various automatic features.

For general use, however, the ubiquitous lever wind is so fast in use that the additional complication and weight of a motor to wind on the film between exposures is a quite unjustifiable expense.

ARE THEY WORTH IT?

Do take a good long look at the extras built in to a camera and consider whether they are really worth while. They must either add to the cost or detract from the quality of other, more essential components. The camera with automatic exposure control, for example, must cost more than the camera without it, unless it cuts the cost in some other way—a less reliable lens or shutter, inferior components or finish, less robust construction, etc.

Unfortunately, you do not often have much choice. The straightforward, picture-taking camera without frills is a rarity, although the more exotic examples seem to have met their due desserts. Let us quietly forget that there was once a camera with built-in transistor radio—or was it vice-versa?

4: Films and Film Speed

You can stick to one film for colour
and another for black-and-white
for nearly all your photography.
When a special job comes along, however,
there is a film for it, probably of a different speed.
It is as well to know
just what film speed means.

Every film has to have some sort of label attached to it to tell you something about its sensitivity. Some films are more sensitive to light than others. That means that they can produce a given tone range with less exposure to light than the less sensitive films. We say that the film is slower or faster according to its sensitivity.

Of the range of materials in common use the fastest black-and-white film is about eight times as fast as the slowest and the fastest colour film about six times as fast as the slowest. The range of films actually *available* is much greater but those at the extremes of the scale are really for specialist use.

The average amateur can in fact get by quite comfortably with a medium speed black-and-white film for nearly all purposes and another one about three to four times as fast. This one would be for dim-light subjects with some movement or when he hand holds the camera and a medium speed film would require relatively slow shutter speeds.

Why different speeds?
When you consider that most cameras now have shutter speed and aperture settings that give a wide range of different exposures—a

ratio of 30,000:1 is not uncommon—you may wonder why we need films of different speeds.

It is not all that long since films—or plates—used to be so slow that exposure times of several seconds were quite normal. Obviously, any movement in the subject was ruled out. Similar considerations can still apply to the slowest of present-day films. They would not be suitable, for instance, to cover a football match on a dull winter's day. Nor would they readily be able to catch the cabaret in a dimly-lit night club.

So the reason for faster films is obvious. Why then, do we need slower films? The truth is that we very rarely do. We did—even in quite recent years—because the faster films had three important disadvantages. They were less able to reproduce fine detail, they gave rather low contrast and any significant enlargement of the image in printing brought out very noticeably the granular structure of that image. This was partly because the silver grains in the image were, indeed, larger in the faster film and partly because they had a greater tendency to clump together.

This is still true, but far less so than it used to be. There are now fast films available which compare very favourably in grain size with the slowest films of a few years back. In fact, for some years now, grain has ceased to be any serious problem for the photographer.

There is, therefore, hardly any need for the average photographer ever to resort to the very slow films to achieve what he calls grain-free results. The medium-speed films can give him all the quality he could wish for.

On the other hand, considerations of image quality apart, the slow films are an asset to photographers working in sunny climates, especially where any application of depth of field techniques is called for. In these conditions slow materials allow for greater flexibility of operation.

Systems compared

There are only two film speed systems in popular use—ASA and DIN. The initials are those of the American and German standards associations respectively. There have been many other systems but none of them now have other than specialist use.

The ASA system is arithmetic. A doubling of the ASA number

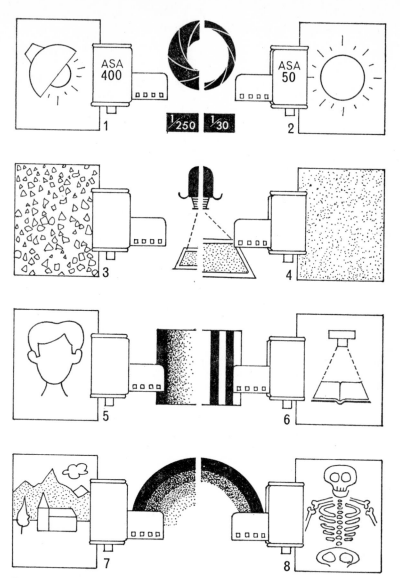

Fast films (1) permit fast shutter speeds and/or small apertures where slow films (2) might only be usable with wide apertures and for slow speeds. Fast film has a coarser grain structure which may limit the degree of enlargement (3, 4). Fast film can cope well with portraits (5) but slow film gets down to fine detail better (6). Panchromatic film (7) is now universal for general work. Orthochromatic film (8) has a restricted colour response.

indicates a doubling of film speed. The 100 ASA film is twice as fast, or twice as sensitive to light, as the 50 ASA film. The figures themselves mean nothing. They simply relate to the calibration of exposure meters and the recommendations of exposure tables.

The DIN scale is logarithmic. A doubling of speed is indicated by an increase of three in the DIN number. The 24 DIN film is twice as fast as the 21 DIN film.

The two scales are almost directly comparable.

The only other current film speed system is GOST, used on Russian cameras. No accurate conversion table can be given but the figures are very close to those used in the ASA system. If you treat the GOST figure as being the same as or equal to the next higher figure in the ASA system, you won't go far wrong.

FILM SPEED COMPARED

ASA	DIN	GOST*	ASA	DIN	GOST*
25	15	22	200	24	180
32	16	32	250	25	250
40	17	32	320	26	250
50	18	45	400	27	350
64	19	65	500	28	500
80	20	65	650	29	500
100	21	90	800	30	700
125	22	130	1000	31	1000
160	23	130	1250	32	1000

*Approximate

If you run across any other film speed system on a camera with built-in exposure meter or on a separate meter, it is pointless to try to convert it to the current systems. It would be much wiser to conduct tests to find the settings that give correct exposure, starting by doubling the film speed figures on the meter if they are arithmetic and adding three if they are logarithmic.

This really applies to any film speed rating or exposure meter calibration. No film can be comprehensively described by a single speed rating which you can apply in all circumstances and it is always wise to conduct tests whenever you use a new film or new equipment.

The real value of a film speed rating is that it enables one film to

be reasonably accurately compared with another. You can take it that two different films with the same speed rating will give very much the same sort of result if identically exposed and processed in an orthodox developer. Beyond that, you are on your own!

Film speed and exposure

There have been many methods of working out film speed, nearly all based more on science than photographic practice. There is no need to know what these methods were or are. All you need to remember is that the film speed gives you a starting point for working out your exposure. What your actual exposure will be depends on the nature of the subject, the kind of result you want, the accuracy or otherwise of your marked shutter speeds, your methods of processing and so on.

First, however, it depends on how you work out the exposure. The film speed itself means nothing until it is translated into an exposure recommendation. You may effect this translation by consulting an exposure table or by using an exposure meter. It is evident that the table must be compiled and the meter calibrated to correspond with the film manufacturers' intentions.

In point of fact, the opposite is now the case. Films are given speed figures to correspond with the more or less standard calibration of exposure meters. This is because, in the early 1960s, film manufacturers decided that it was time to update their attitudes to exposure levels. Up to that time, they had tended to recommend exposures which, with normal processing, were rather on the generous side.

That was useful when there were so many box cameras about giving a standard exposure of about 1/40 sec. at f11. Results often showed evidence of underexposure. As film speeds increased and cameras became more versatile, results tended more and more towards overexposure.

The solution was obvious and manufacturers promptly started to recommend exposures of only half the level they had previously recommended. No change had been made in the film but its speed was doubled overnight. That is as clear evidence as you could want that there is nothing sacred about the film speed figure. It was altered because it would have created chaos having to recalibrate all exposure meters.

Interpreting the figure

Chaos was, in fact, created in the minds of some users who had been in the habit of basing their exposure on past experience. Such a user will often tell you that he rates his films at, say, 125 ASA—and yet a film speed figure means nothing unless related to an exposure table or meter reading.

When the manufacturers suddenly doubled the speed of this user's favourite film, he felt obliged to adjust his exposures accordingly. Very soon, he was ridiculing the change and saying that these new film speeds were completely inaccurate. He still had to give the same exposures that he had always given. That was hardly surprising. It was still the same film.

This type of user knew from experience what exposure to give for the result he wanted. He was probably giving a shorter exposure than an exposure meter or table would have recommended. In other words he was already rating the film faster than its official speed. Or he might have been rating it about the same but he liked a "meaty" negative.

Naturally, there was no need for this man to change his methods at all. But he was by no means the only confused person. No change of method was necessary for anyone who was already getting the type of negative he wanted—and that should really have applied to every serious camera user. The only photographer who needed to change his exposure methods because of the introduction of the new film speeds was the one who accepted film speed figures blindly and always exposed his film according to the reading of a meter set to that figure.

By taking action the manufacturers were simply falling into line with a practice already accepted by many users of 35 mm film who were giving the minimum exposure compatible with the production of a printable negative. Manufacturers called this the *basic minimum exposure* and we had better consider next just what that phrase really means.

Basic minimum exposure

When the film manufacturers decided that they could safely double the film speed figure attached to their films, they were working on the premise that what everybody wanted was the finest possible grain

Rollfilm often takes a less than straightforward path through the camera. The path is slightly different in the twin-lens reflex (1) and the single-lens reflex (2). Rollfilm is not rewound after exposure. 35 mm film (3) is usually fed straight across the camera back. After use, it is rewound into its cassette. Instant-loading 126 film (4) needs no threading. The cartridge is simply pressed into the camera and engages automatically with the film transport mechanism.

structure and the best possible resolution. Graininess, which is caused by the clumping together of the otherwise invisible grains of silver in the emulsion, is encouraged both by overexposure and over-development. Cut down the exposure and you reduce the tendency to produce grainy prints.

So the manufacturers set their film speed figures at a level which would give the least practicable exposure to the average subject. What effect does this have in practice?

If the shadows in your subject are of average density, an exposure based on the manufacturer's film speed will be just about sufficient to record the detail in them. A fraction less exposure (caused by inaccurate shutter speeds, for example) and the film will not receive enough exposure to record any density at all in the deeper shadows.

That is for the average subject. Suppose your subject has quite heavy shadows but you nevertheless want detail in them? Then the manufacturer's film speed just will not do. You have to rate the film as rather slower and would be well advised to go back to the older, one stop slower figure and thus give more exposure.

Increasing film speed

Naturally, the converse applies, too. If your subject has no pronounced shadows or if the detail in the shadows is not required, then you can afford to give less exposure. You may be able to rate the film as twice or even three times faster than the manufacturer's rating. This is, in fact, the basis of many extraordinary claims that various developers or special processing systems can give increased film speed.

Before it can be claimed for any developer that it will increase film speed it is necessary to decide just what is meant by film speed. We have indicated that the manufacturer's rating is not absolute. It is a guide to the exposure that will generally prove adequate for the average subject. When the subject is non-average it can be adjusted.

It is thus quite easy to take a subject with a very short tonal scale, without pronounced shadows or extreme highlights, give it two or three stops less exposure than a meter set to the manufacturer's film speed would indicate, and still produce an acceptable print. If you add to that a degree of overdevelopment, whether with full strength

or dilute developer, it is not difficult to see how claims to increased film speed can be apparently substantiated.

Nevertheless, there are a few well-known proprietary brands which do give more shadow detail for a given exposure than the standard formulae. These can be regarded as speed-increasing in practice but the genuine increase is never more than 100%.

Correct film speed

Claims that film speed can be increased by more than 100% are ridiculous, but they serve a useful purpose in highlighting the fact that the manufacturer's figure is not sacrosanct. It applies only to the average subject. It presupposes processing according to the manufacturer's recommendations. It assumes that resolution and fine grain are the most important factors. And it takes it for granted that the ultimate aim is a faithful reproduction of the tonal scale of the original.

Like all other theoretical calculations it is also based on the supposition that we live in a perfect world. In this context it implies a consistent relationship between *f*-number settings and the amount of light passed by different lenses and absolute accuracy of marked shutter speeds. That is virtually impossible.

There is only one way to determine the speed figure you should attach to a particular film—and that is by practical experiment. Select about half a dozen ordinary subjects of the type you usually photograph. Give each three or four different exposures varying by a stop or so either way the exposure recommended by your meter set at the manufacturer's film speed.

Process the film in your usual manner and examine the results. Select the result which gives you the type of picture you want. If it is a negative, make sure that there is detail in the shadows and that, overall, it is of the density you prefer to print from.

Then, no matter what is printed on the packet, the speed you should attach to that film in future is the speed indicated by your best exposure on test. If that exposure was one stop more than the meter recommended, then you should rate the film at half the manufacturer's speed and so on. Only in the case of an unusual subject, or a particular non-standard result you are striving after, should you depart from your rating.

You may, for example, want to see right into the shadows of a deeply shaded subject. Then you can give more exposure (or rate the film slower) because what you really want to do is to make the shadows lighter than they actually are. Or you may be seeking to subdue shadow detail altogether. Then you can rate the film faster (give less exposure) and, if it is really high contrast you are after, perhaps you can increase development time, too.

In given conditions, for a given user and a given result, the film speed figure is stable. As the conditions vary so you can vary the film speed to suit the subject, the required result, the processing—even the known vagaries of the equipment. It is quite possible, for example, that two different lenses used with the same camera and film might have to be set at different aperture stops to provide similar results.

That is why it is important always to settle for a film speed that suits you. The fact that a friend tells you he rates so and so's film at 200 ASA while you only rate it at 100 ASA is of no importance whatever. When the variables of shutter speeds, processing, lens performance, and personal preference are taken into account, it is quite possible that you are both giving the same exposure anyway.

Choosing your film

Which film of the many brands on the market you decide to use is a matter of personal choice. There is very little to choose between them in actual performance. Each does, however, have its own characteristics and it is wise to settle for one particular film and stick to it. You then know just how it will behave in given conditions.

It follows that a well-known, easily obtainable film would be a good choice. Lesser-known films may be just as good but if you cannot be sure of always getting supplies there is little point in using them.

Your first choice, for all general black-and-white work in reasonable light conditions, could be a medium-speed film (100–160 ASA). Such a film can give superb quality, with adequate contrast and resolution of the finest detail. It will stand considerable enlargement before the grain structure becomes noticeable.

If you occasionally shoot in poor light conditions and cannot give long exposures you should have a faster film (320–400 ASA) in reserve. As before, choose one and stick to it. As you need it for

conditions that are far from ideal it is particularly important that you should know just how it behaves.

Only in really exceptional conditions do you need a film faster than 400 ASA. Keep this for really poor light when you have to get a picture regardless of quality.

If you rarely need to make enlargements greater than about six times the linear dimensions of the negative, you may even make the 400 ASA film your first choice. There are now at least two films in this category which give really exceptional results—although of a very different nature to each other. These films can cope with virtually all your photography—and it is very useful to have that extra bit of speed available for the unexpected poor light subject.

Perhaps the most important thing about your choice of film is that, for reliable results, it must be fresh. Cheap "surplus" film can be used for experimental shots where quality is not important or for shots that can easily be repeated. It should never be relied upon for important or unrepeatable shots or for any purpose where good quality and/or consistent results are required.

This applies particularly to colour film. Even long-outdated black-and-white film will probably give results indistinguishable from fresh film but it cannot be guaranteed to do so. Outdated colour film is likely to have been badly stored and it will then certainly show some colour distortion. This slight distortion may not be of great importance in general photography but it can be enough to upset any calculations based on experience of fresh film.

"Surplus" film, usually sold in lengths of 25 ft and more, is often cut from short ends of bulk film discarded by film studios. It bears well-known names but is often motion picture stock which is not the same material as that sold for still-camera use. It is not uncommon for it to be damaged or even code-perforated over some considerable part of its length at one end or another. And you won't see that in the dark!

Buying film

Film can be bought in various packings from different sources, particularly if you work in 35 mm.

The standard 35 mm black-and-white film packing is the 36-exposure cassette. It is also the most uneconomical. You pay a quite

extraordinary amount for the packing and the cassette. Presumably you are also paying for a guarantee that the film has been expertly packed.

It is nice to know that if the film is found to be faulty, the manufacturers will replace it free of charge. Naturally, they do not hold themselves responsible for the unrepeatable shots you inevitably lose. Fortunately this rarely happens but when it does, the guarantee seems rather poor value for money.

With black-and-white film, it is much more economical to buy cut-to-length refills and load your own cassettes. With a little practice this is not at all difficult and the apparent risk of scratches from used cassettes is, in practice, negligible. Very few scratches on films are caused by cassettes. Most of them arise in the camera or the enlarger or by drying marks on the back of the film carelessly polished away. The modern 35 mm emulsion is tough, even tougher, it often seems, than the film base.

If you want to be still more economical, you can buy most 35 mm films in 5-metre or 17-metre lengths. These give 3 and 10 full-length, 36-exposure refills respectively. Loading the cassettes is not quite so easy, because you have to measure off the required length from the bulk roll.

Measuring reloads

This is not really difficult if your darkroom has a clear five-foot dimension in one direction or another. The perforations are useful, because you can hook one of them at the end of the roll over a small-headed nail and run the film down the door or along the edge of a table to another nail or marker just 63 inches distant. You cut the film at the second marker and you have a 36-exposure length of film.

Naturally this operation has to be carried out in complete darkness. Don't be tempted to risk a dark green safelight. By the time you reach the last loading from a 17-metre length, you will have exposed the film to quite a lot of light.

When you have your cut length of film, attach one end to the cassette spool and carefully wind the film on to it, holding the film between finger and thumb by the edges only. Trim the end of the film square and stick it to the spool with adhesive tape. Manu-

facturers used to use rather fancy trims which enabled them to push the end of the film into a slot in the spool, where it was held by a toothed strip or a spring catch. Fortunately, most of them have now abandoned such elaborate methods and have turned over to the less elegant but more practical methods the amateur has been using for years.

Similarly, the manufacturers still trim a rather lengthy leader on the other end of the film although the bottom-loading Leicas are the only cameras for which this long trim is necessary. For most other cameras, it is unnecessary because for safe loading you really need to see the perforations on both edges of the film fully engaged before you close the camera back. A much shorter leader is then preferable. Trim the leaders of your film only to the extent required by your camera.

Hand-loading cassettes is not difficult but it is a little tedious. If you intend to buy your film in bulk, a cassette loader is a worthwhile investment. This has a storage compartment that has to be loaded in darkness but from then on the loading of cassettes can be accomplished in daylight—and in a fraction of the time that hand-loading takes.

Colour film cannot generally be bought in bulk, although two manufacturers are making valiant efforts in that direction. In the 35 mm size it is usually available only in 36 or 20 exposure lengths in cassettes. The manufacturers will not even trust you to load refills. Again, this is the price of your guarantee, with a little more reason this time.

The standard rollfilm is, naturally enough, only generally available in its normal form. It would be quite a tricky job loading your own cut lengths into backing papers. There is another size—220—to give 24 exposures, but that needs a special type of camera and is really intended for professional use. So the only opportunity for economy in rollfilm is to get more exposures on to the standard length. That rather defeats the object of using rollfilm and is not really to be recommended.

Colour films

Colour film is generally available in two forms—negative for prints and reversal for slides. Reversal film may also have daylight and artificial light versions.

Colour transparency film (*above*) is primarily designed for the production of colour slides to be viewed by projection on to a screen. But the transparency can also be used to produce colour prints and black-and-white prints. Similarly, colour negative film (*opposite*) is designed for the production of colour prints but black-and-white prints and colour transparencies can also be made from it.

Costs of the different processes vary according to the type of film used. The charts show the relationship between these costs. The panels indicate the relative costs of the steps from purchase of film through colour transparency or colour negative to colour and black-and-white prints.

A. Reversal film. B. Processing. C. Internegatives for black-and-white prints. D. Black-and-white prints. E. Colour prints. F. Colour slide from colour negative.

Negative for prints

The prime purpose of colour negative film is to provide prints. The procedure is basically the same as with black-and-white but considerably more complicated. The film used in the camera has three emulsion layers, separately sensitive to red, green and blue light. It is processed to produce a negative with both colours and tones reversed.

The processed film is printed through filters on to paper with a similar type of emulsion, to produce a full-colour print. The filtering can be adjusted to vary the colours in the final print within quite wide limits.

Any colour film, however, has to be made primarily for exposure in one particular type of lighting. The three emulsion layers have to be "balanced" (see page 288) to ensure that they respond identically in terms of speed and colour rendering. Most negative colour films are now balanced for daylight or electronic flash. No matter what lighting it is primarily intended for, however, colour negative film can be used in any normal type of lighting. The filtering used at the printing stage can be adjusted to compensate for any error in balance or lighting, and to produce a satisfactory, if not always completely accurate result.

Nevertheless, the type of lighting used should preferably be of the normal photographic variety. When flash is used, it should be either electronic or blue bulbs. Clear flashbulbs should not be used and, in fact, they are not now easily obtainable. This is purely for the convenience of the printer. He cannot tell which type of flash has been used and his work is made more difficult if he has to solve that problem first.

Reversal for slides

The other type of colour film is reversal colour. This involves only one process, albeit a fairly complicated one. The film used in the camera produces the final picture—in positive, full-colour form. There is no intermediate negative. The reversal colour film is, in effect, first processed to a negative and then printed on to itself to form the positive. This positive, in three layers similar to those of the colour negative, is then dyed. In some films, the dyeing is effected by three separate operations, using colour developers containing the

dye; in others the dye is already in the emulsion layers and is released in one colour development operation. Films of the latter type can be home processed, those of the former cannot.

Because there is no separate colour printing process, reversal colour film can be used only in the light for which it is balanced. This is usually daylight but some special artificial light films are also available.

Choosing your colour film

Colour films are highly individual products. They all have their own peculiarities. None of them can provide absolutely accurate colour rendering and some are even deliberately designed not to do so. Kodachrome II, for example, provides brilliant colours that are rather larger than life—despite frequent disclaimers. In particular, it gives flesh tones of a fine, healthy nature. For most people, this is a pleasant rendering.

Kodak's other colour film for slides—Ektachrome—is entirely different. Its colours are much truer to life and, in direct comparison, look less lively. It would be easy to say, and has been said, that the first is for amateurs and the second for professionals. As Kodachrome is made only in the smaller sizes, the manufacturers appear to go along with that idea.

The choice depends, however, on the rendering you want. Some professional photographers have to get as close as possible to the real colours and Ektachrome makes their job easier. But there are plenty of professionals who like Kodachrome and regret that they can use it only in 35 mm. The real reason, no doubt, is that the manufacturers do not fancy the task of putting in additional machinery for processing both types.

Agfa's film for colour slides—Agfacolor in Europe, Agfachrome in the USA—gives a rendering about midway between the respective lively and subdued characteristics of the beforementioned types. It is available in both 35 mm and rollfilm.

Most colour films are now much faster than they used to be. The most commons speeds are 50 and 64 ASA. This provides a film of quite adequate speed for most occasions and a reasonably fine grain structure. There are faster products. Ektachrome High Speed has been available for some years at 160 ASA. Ansco have a 200 ASA

and a quite extraordinary 500 ASA film. At present, however, these higher speed films must be regarded as for emergency use only. Their colour rendering and grain structure are in the nature of a compromise.

Kodachrome II, while it remains available, is now unique in being a rather slow film of only 25 ASA. It compensates for its lack of speed with a secret emulsion structure (it has never been patented) that gives a really crisp image even when projected from half frame on to a four-foot screen. Its resolution of fine detail is quite extraordinary.

The colour film for you, however, is the film that gives the colour you like. There is no best for all circumstances.

Colour casts and colour temperature

Although you can use any type of lighting with colour negative film, you should not construe that to mean that you can use different light sources on the same exposure. Any colour film—negative or reversal —responds differently to each type of light according to the colour temperature of that light.

The colour temperature concept is simple as far as the photographer need understand it. Light, which consists of a mixture of the various colours of the spectrum, is given a figure to denote its colour content. This figure is on a scale of Kelvin units. The greater the proportion of blue in the light, the higher the colour temperature figure. Average noonday sunlight is about 5–6,000 K, containing a fairly high proportion of blue. Photofloods, containing proportionately much more red, are rated at 3,400 K.

Daylight varies quite considerably in colour temperature but, while the blue predominates, colour films balanced for daylight can usually cope with most of its variations without producing undue distortion of colour rendering.

When, however, the light contains proportionately more red and yellow than blue, as with photofloods, studio and domestic lighting, the film balanced for daylight produces colours that are overlaid with a red or yellow tinge, known as a "cast".

Conversely, the film balanced for artificial light produces a blue cast when exposed to daylight or other light, such as electronic flash, in which blue predominates.

If artificial light and daylight were used together, as with a fill-in

lamp for a picture taken by window light, the area lit by daylight would, on the daylight film, reproduce reasonably natural colour, while the area lit by the lamp would show a strong red cast.

Even on negative film, this cast cannot be filtered out because the filter would put its own cast on the part of the film that was the correct colour. Thus, a cardinal rule with any colour film is that light sources cannot be mixed unless they are of more or less the same colour temperature.

In practice, this means that no form of lighting can be mixed with studio lighting or photofloods, which must be used with artificial light reversal film or with colour negative film. Daylight, however, can be used in conjunction with electronic flash or blue-coated flashbulbs because both these light sources are specially manufactured to approximate to daylight in colour temperature.

Conversion filters

Where no mixed sources are involved, colour films can be used in lighting for which they are not balanced by placing suitable filters between the light source and the film. This is usually done with a filter over the lens because it is more convenient, but it would be equally effective to filter the light source. This is what happens, in effect, with blue coated flashbulbs.

Using daylight film in artificial light is not very practicable. It calls for a rather deep blue filter to cut down the predominating red content of the light. This leaves the light pretty weak altogether and the effective film speed is considerably reduced.

The conversion of daylight into light suitable for films balanced for artificial light is more easily effected. The blue light in daylight has less influence than the red in artificial light. Less of it has to be cut out, and a pale salmon coloured filter is sufficient. This has a far less drastic effect on film speed.

5: Lenses and their uses

Modern lenses are marvellous,
but they have to be used properly.
Wide-angle and long-focus shots
can make the same subject look very different.
Know when to use them.
Know, too, about the alternatives,
such as tele-extenders.

The lens is the most important part of the camera, although you can actually take pictures without one. Nevertheless, modern photography requires that the camera lens be of a certain quality.

Fortunately, we do not have to worry too much about that. All but the very cheapest camera lenses are now capable of producing pictures of a quality sufficiently good to satisfy most people—provided they are used within their capabilities. The point of more expensive lenses is that their capability is greater: they can be used in less favourable conditions; their results can be enlarged to a greater degree; and they can produce the sharpest results where sharpness is all important.

But the ideal photographic lens has a number of qualities. It should produce sharp, distortion-free pictures of adequate contrast and it should transmit a reasonable amount of light. No lens can, in fact, produce absolutely perfect images in all conditions. Lenses suffer from various faults, or aberrations, some of which can be corrected only at the risk of creating others. Generally, the more expensive the lens, the more nearly the aberrations are completely eliminated.

What does resolution mean?

Most people regard the sharpness of the image produced by the photographic lens as its most important quality. This is reasonable, but sharpness is not easily defined. It might be regarded as synonymous with resolution, for example. There was a fetish not long ago—and it has not yet completely died out—of judging lenses by the number of lines per millimetre they could resolve. Test targets of various patterns were devised and photographed from stipulated distances. The shooting distance and the spacing of the lines on the target provided the basis for calculating the resolving power of the lens.

On the face of it, that seems a reasonable test. In practice, it rarely is. Test targets are usually high-contrast subjects. Most ordinary photographic subjects are of much lower contrast. Moreover the image produced by the lens is of lower contrast than the original and the lower the contrast of the original the more difficult it is for the lens to reproduce fine detail in the image.

But lenses do not all perform similarly. Some maintain both high contrast and separation of detail up to a point of fineness and then lose both rapidly. Others lose contrast more rapidly as detail gets finer but soon tend to level out and give high resolution at quite reasonable contrast.

Of rather more practical importance, however, is that you use your lens in conjunction with a film, which is processed in a certain manner. The resolution you are concerned with is that of the lens-film-developer combination—not to mention your exposure and processing technique.

Transfer function

The potential of any lens-film combination is nowadays usually assessed in terms of the *transfer function*.

The transfer function, or contrast transfer function, describes how the response of the photographic system to variations in exposure depends on the fineness of detail to be resolved. This is usually expressed in the form of a two-dimensional graph which plots spatial frequency (which may be taken as resolution, or number of lines distinguishable from a line-pattern test target) against contrast. The shape of this graph shows how efficiently a lens or film may reproduce an image.

The overall transfer function of a camera system may be arrived at by multiplying the transfer function of the lens by that of the film. Thus, a means is provided by which the total performance capability of photographic systems can be measured or compared.

Resolving power

A lens manufacturer may tell you that his lens has a resolving power of 120 lines per millimetre. Somebody else might remind you that the film you are using cannot resolve more than 80 lines per millimetre. What is the use of the extra resolving power of the lens? That question puzzles many people.

It is, in fact, perfectly true that most photographic lenses can resolve far more detail than the films with which they are generally used. As we have said before, however, the resolving power you should be concerned with is that of the lens and film together—which is always lower than that of either the lens or the film. In other words, where a film has a theoretical resolving power of 80 lines per millimetre, no lens will actually cause that film to resolve 80 lines per millimetre. With the average lens, it will resolve no more than 50–60 lines per millimetre. The higher the resolving power of the lens, however, the nearer you might get to the theoretical maximum resolving power of the film.

So, although most films have a lower resolving power than most lenses, the better lens might well give better results, but only, of course, if it has a better contrast performance out to the resolution limit of the lens.

But for the average user, there is little point in continually seeking better quality in lenses. Even moderately-priced lenses are today capable of producing results adequate for most uses. If you habitually produce enlargements of $6\times$ and greater, then you need a lens of reasonably good quality. If your degree of enlargement is always less than that, and you are working for pleasure rather than profit or exhibition honours, most lenses will do.

Too much attention to theoretical resolving power figures can lead you to strange conclusions. One lens, for example, might resolve the very finest of detail but produce a negative severely lacking in contrast. Another might have rather less resolving power but produce an image of greater contrast. The second lens is the better for

most photography and the results it produces will actually *look* sharper.

Sharpness is not the same as resolution. For an image to be sharp it must have what is now commonly called contour sharpness, i.e. the edge transition from one tone to another should be abrupt like a cliff edge rather than a gentle slope through intermediate tones. Modern lenses and films are designed to provide this edge effect. The older ideas of resolution and fine grain as prerequisites of sharpness have been largely superseded.

The idea of lens quality can become an obsession. Don't fall into that trap. By all means pay as much as you can afford for your lenses but remember that your results will be no better than the next man's unless your technique, processing and enlarging equipment are of similarly high quality.

Interchangeable lenses

The number and type of lenses you buy depends on your camera. There are many cameras designed to use only the lens with which they are supplied. These are fixed-lens cameras. The lens is solidly mounted on the camera body and you must not attempt to detach it. Other cameras can take a variety of lenses. The lens is attached to the camera by a screw-thread or bayonet-type fitting or, on larger cameras, it may fit into a panel which slots into the camera. These are interchangeable-lens models.

Interchangeable-lens cameras accept lenses of various focal lengths in place of the normal standard lens usually fitted. These lenses are generally classified as wide-angle and telephoto. They enable you to take in more or less of the scene in front of you without changing your viewpoint—or to maintain the same image size at shorter or longer range.

Focal length is the distance between a lens and the image it forms of a distant subject. With the standard lens, this distance is relatively small and is roughly equal to the diagonal of the picture to be produced on a film, i.e. 2 in. for 35 mm and $3-3\frac{1}{4}$ in. for $2\frac{1}{4}$ in. square. It gives an angle of view of 40–50 deg. and is intended to present a picture much as would be seen by the human eye. It takes in a reasonable sweep of the scene before the camera and can focus on objects as close as 3 ft without any special attachment added.

Telephoto construction

The so-called telephoto lens would be, as often as not, more accurately termed a long-focus lens. It has a greater focal length than the standard lens and therefore has to be positioned further from the film. A 6-in. lens, for example, must be at least 6 in. away from the film. So the lens is supplied mounted in a tube. On large cameras, this extra distance between lens and film is achieved by extending the bellows.

The telephoto lens is, in fact, a long-focus lens constructed in such a way that its back focus (distance between lens and film) is less than its focal length. This is a common construction for 35 mm cameras enabling long-focus lenses to be made much less lengthy and therefore less bulky than if they were of normal construction.

Wide-angle construction

The wide-angle lens has a focal length shorter than that of the standard lens and a wider angle of view—60 deg. and upwards. This is the opposite of the long-focus lens. It takes in a broad sweep of the scene in front of the camera and therefore produces a smaller image of any given object from a given distance. That can be very useful for shooting in cramped surroundings, narrow streets and for rather tall buildings when you can only work from a viewpoint nearby.

The normal construction of a wide-angle lens places it very close to the film. The wide-angle lens has its counterpart of the telephoto construction. This is the inverted telephoto or retrofocus lens. It has a back focus greater than the focal length, allowing the lens to be placed further away from the film—a useful feature with reflex cameras, in which the swinging mirror might otherwise foul the back of the lens. At one time, indeed, few 35 mm reflexes could use lenses of focal length shorter than 35 mm without the mirror having to be locked in the retracted position. Then a separate viewfinder had to be used and the camera lost its reflex viewing and focusing facilities.

Many standard focal length lenses for use on reflex cameras are also now of retrofocus construction.

Image size and angle of view

The long-focus lens differs from the standard lens in that it takes in less of the scene in front of it, i.e. it has a narrower angle of view. Thus, the image of any particular subject is larger on the film when

the lens of longer focal length is used from the same viewpoint. Under these conditions the magnification of the image is proportional: a 200 mm lens gives an image four times as large as that given by a 50 mm lens.

The size of the image given by a lens is the same no matter what the size of the film. A 135 mm lens might be used on a 35 mm camera or on a 9 × 12 cm camera. In either case, it produces the same size image of any given object. However, on the larger camera it is a standard lens with an angle of view of 40–50 deg. and taking in a reasonably broad scene. On the 35 mm camera, it is a long-focus lens with an angle of view of about 18 deg. and taking in only a small part of the scene before it.

It may seem strange that the same lens, or lenses of the same focal length, can have different angles of view. But angle of view is only important in so far as it relates to the picture the lens produces—and that depends on the size of film used. The angle of view is therefore related to a dimension of the film: it may be the height, the width or the diagonal. That is why there sometimes appears to be conflict between different published versions of angles of view. Some are expressed according to one dimension and some to another. In the examples quoted here, we have used the diagonal.

Nevertheless, lenses of the same focal length are not necessarily the same in other characteristics. We have said that a 135 mm lens could be standard for 9 × 12 cm and long-focus for 35 mm. But the lens designed for the 35 mm camera cannot be used on a 9 × 12 cm camera. It would not "cover" that area. It is designed to produce a sharp, bright image over an area of only 1 × 1½ in. It will cover a rather greater area than that but both illumination and definition are likely to fall off considerably before it reaches the edges of the 9 × 12 cm area. The lens for the larger camera has to be designed to cover that larger area.

Are additional lenses necessary?

Do you need lenses of different focal lengths? Not necessarily. Most people get by perfectly well without them. But in some circumstances they are handy—particularly the wide-angle lens.

Most people tend to think first of long-focus lenses when they decide to buy an additional lens. This is natural enough. We like to

see further than the unaided eye can. Hence the popularity of the seaside telescope.

If thought of purely for long distance subjects, however, long-focus lenses have limited use. True, certain specialist photographers use them all the time because they cannot get near to their subjects. But you may not often tackle this type of subject. In everyday outdoor photography of people, places, animals, children, special events and so on, opportunities that justify the use of a really long-focus lens are rare indeed. You may feel a little shy sometimes coming close to a human subject for a candid picture—you don't want him to see you. But that is something you have to fight if you want to take good pictures. The long-focus lens is not a complete substitute for going in close. It is apt to create an unnatural effect.

Long-lens perspective

The most striking feature of a picture taken with a long-focus lens is the strange perspective effect that is almost inevitably present.

You have seen, for example, the boat race crew who appear to be sitting in each other's laps and the cricket shot where the bowler seems to be almost treading on the batsman's toes. You may have seen horse-racing pictures on television where the whole field races into the bend in a bunch. Then the shot switches to a side-on view from another camera and you see that the leader is at least 10 lengths clear and the backrunner is 50 yards behind him. These are long-lens shots.

The effect is not really due to the lens itself. It is the long shooting distance that causes this apparently distorted perspective. The human eye sees in exactly the same way but the brain usually knows how to make allowances for it. The shorter focal length lens presents exactly the same perspective if used from the same viewpoint but then the distant figures are only a small part of the scene and the effect is not so noticeable. If you enlarged only a portion of the picture to correspond with the part seen by the long-focus lens your pictures would be identical.

Uses of distortion

This perspective effect is not always a disadvantage. It can be used to create striking and unusual compositions. It can also be used to

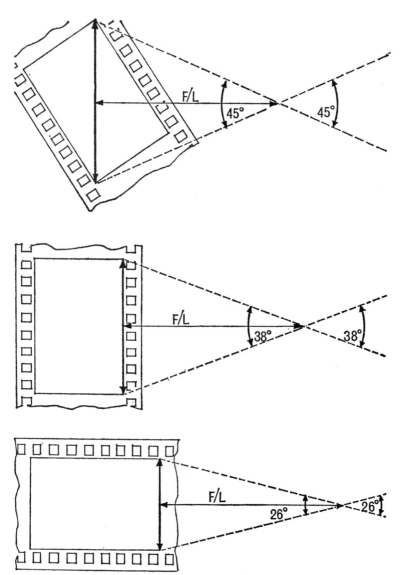

The angle of view of a lens is governed by the size of the image area. It can be expressed on the length, breadth or diagonal of that area. To calculate angle of view you simply draw a line as long as your chosen dimension (the diagonal is preferable), erect from its centre a perpendicular as long as the focal length of the lens, complete the triangle and measure the angle opposite the base line. This is the angle of view at infinity setting. At closer range, the angle is smaller.

95

create a normal effect. If you wanted to take a head and shoulder portrait, for example, you might have to go as close as 3 ft with a standard lens in order to fill the film area. That could produce the opposite type of perspective distortion. Instead of well-separated objects looking similar in size and thus closer together than they really are, you might get your subject's near shoulder looking enormous and the far shoulder looking very small. This is the typical effect of too close a viewpoint. A *moderately* long-focus lens can counteract the distortion by enabling you to shoot from further away while retaining an image of the same size on the film.

The moderately long-focus lens is, in fact, generally more useful than the really long-focus. For the 35 mm camera, that means a lens of a focal length between 90 and 135 mm. It is extremely suitable for portraits and also makes life much easier on those occasions when you either cannot or do not wish to approach your subject too closely.

Don't go for a lens much longer than that unless you have definite specialized interests. If you do, you will soon find that you have to cultivate a whole new shooting technique and even then you might be disappointed with the results. Once your lens becomes too long and unwieldy you cannot guarantee sharp results with a hand-held shot.

Avoiding camera shake

Camera shake is a danger with any lens. It is the greatest enemy of sharp pictures. The lens projects an image of the subject on to the film. If the resulting picture is to be sharp, that image must remain perfectly stationary while the shutter is open. If you move the camera while the shutter is open, the image moves and that movement is reproduced on the film.

There are innumerable photographers shooting away merrily in the firm belief that they can hold their cameras perfectly steady at almost any shutter speed. When they get unsharp results, they blame the lens, movement in the subject, and even the printer. If only they would take a few shots, even at fairly high shutter speeds, with the camera really rigidly supported on a tripod!

Most modern photographic lenses and quite a few old ones are of really good quality and can produce extremely sharp images if properly used. A shake-free camera hold is worth cultivating. There is no one hold that is perfect: you must devise your own. One or two

rules are useful, however. First, balance your body. That usually means standing with the legs slightly apart and with the body weight evenly distributed on each foot. Second, keep your elbows close to your body when using a camera at eye level. Third, hold the camera in your hands in the way that feels most natural and comfortable to you. Fourth, squeeze the shutter release: don't jab at it. The action should consist of smooth, controlled pressure, not a sudden push.

There are additional precautions you can take. Use any support that may present itself, such as a wall, to lean against or rest your elbows or even your camera on. Indoors, turn a chair round and straddle it with your elbows resting on the back. Again, with an eye level camera, use the camera strap for additional support. Wind it round your wrist or arm so that you have to pull up hard on the camera to get it to your eye. Then brace it against your forehead or cheek.

All these precautions are advisable whatever lens you use but with the long-focus lens they are doubly so. Any long-focus lens tends to unbalance the camera. Counteract that by holding the lens barrel with one hand, supporting the camera and operating the shutter release with the other. A very slight shake might pass unnoticed when you use a relatively short focus lens. With the long lens, however, both image and shake are magnified on the film. Don't be misled by the sometimes-quoted fact that equal shake produces equal blur on same-sized images. In the circumstances usually quoted, that is perfectly true. What you are concerned with, however, is obtaining a sharp image on the film. Where you might be able to enlarge the image from a 50 mm lens 6 times before the shake became noticeable, an equal degree of shake when using a 300 mm lens would be visible in a contact print because it would already have received its 6 times magnification. And it is not usual to enlarge your pictures only in proportion to the focal length of the lens with which they were taken.

This is one of the advantages of the telephoto construction. There are one or two lenses up to 200 mm now that can be hand-held with care. Generally, however, the 35 mm camera fitted with any lens over 135 mm in focal length is difficult to hand-hold.

Wide-angle advantages
When you decide to buy a second lens, however, do think about the wide angle. This is a lens that really gives you something extra. You

can always duplicate a long-lens shot by enlarging up a portion of a picture taken with a lens of shorter focal length. You may lose a little quality but otherwise the result is identical. But you cannot gain the effect of a wide-angle shot by any other means. The wide-angle lens lets you move in close and still take in a relatively large area. It has innumerable uses for those holiday pictures of interesting narrow streets and buildings, for cramped interior shots of party games, for large groups of people and sweeping views of the crowded city centre.

Its short focal length allows you to be less precise in your focusing, especially at small apertures. It makes it easier to preset your lens so that you are ready for instantaneous shots over a wide range of distances from the camera. Many a great picture has been missed or spoilt because there was not time to focus properly.

There is an enormous range of subjects for the wide-angle lens. It is, if anything, easier to use than the standard lens—and it does not take up much room either.

Wide-angle drawbacks

The first thing you notice about a picture taken with a wide-angle lens is that the scale between foreground and background objects appears quite disproportionate. This usually increases the impression of distance, and, while for certain special effects this may be desirable, it precludes any representation of natural perspective. Distortion is especially evident where solid objects are photographed at close range and a greater part than normal of the sides of these objects is visible. They therefore appear "stretched" backwards towards the vanishing point, and both they and the scene appear to have greater depth than is the case. Spherical and cylindrical objects toward the edges of the frame are made to look fatter than similar objects more centrally placed. Even flat circular objects in a plane parallel to the lens axis are drawn out to the corners of the frame in exaggerated ovals. At right angles to the lens axis, however, they remain undistorted.

Just as with a long-focus lens, you should avoid extremes when choosing the most useful focal length. There are lenses for 35 mm cameras, for example, which have an angle of view approaching 180 deg. but they produce very strange-looking circular images with hardly a straight line in them. Straight lines on the edge of the image

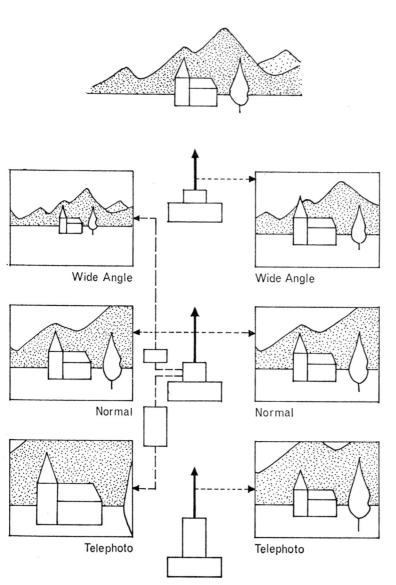

The perspective distortion (apparent changes in size relationship of objects in a scene) associated with wide-angle and telephoto (long-focus) lenses is purely a matter of shooting distance. When the camera position remains unchanged (*left*) shots taken with different lenses show exactly the same perspective. When the viewpoint is changed (*right*) to keep the main subject the same size, the relative sizes of background and foreground objects change.

99

area become semi-circular. This property (known as barrel distortion) can be present in any wide-angle lens and the wider the angle the more likely it is to be noticeable.

Likewise, a failure to cover the corners of the image area, which is a marked and indeed, inevitable consequence of using the 180 deg. or fisheye lens, is a danger with wide-angle lenses in general. It simply means that some or all of the rays coming in from the extreme edges of the picture fail to reach the film. This is often encountered, even with lenses of moderate wide angle. Sometimes the effect is only slight, and it may be almost unnoticeable in black and white. But it can have a disastrous effect on the sky in colour shots.

Because of the difficulty of eliminating these undesirable qualities, a good wide-angle lens tends to cost more than a long-focus lens of comparable quality. The cheaper ones should be considered with care. They are more likely to be of inferior quality than the cheaper long-focus lens.

Your aim should be to obtain a lens of moderate wide-angle, say 35 mm for 35 mm film, as free from barrel distortion and vignetting as possible. The wider angle 28 mm and 21 mm or thereabouts are unlikely to be of satisfactory quality unless they are rather expensive.

Zoom lenses

Separate lenses of different focal lengths can sometimes be replaced by a zoom lens. These are available only for some 35 mm reflexes and one half-frame. Their function is to provide a range of focal lengths in one lens. They have an additional control which changes the focal length progressively between limits such as 100 and 200 mm, so that exact framing of the actual picture required can be obtained without moving the camera. Once focused, they should hold that focus throughout the zooming range. Not all of them do.

Most zoom lenses have a range of $2\frac{1}{2}$–3 times from moderate to longish telephoto, i.e. about 80 to 200 mm. The "long zooms" may give a range of 200 to 400 or even 600 mm. A few shorter focus types, about 50 to 80 or 90 mm are becoming available and there is one exceptional 50–300 mm at about the price of a Mini. The control for changing the focal length allows you to frame the picture exactly as you want it just before you shoot. You should focus with the zoom set to the maximum focal length (biggest image) at which you can still

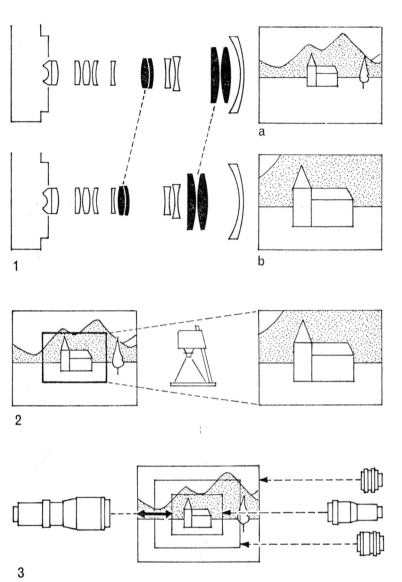

The zoom lens contains movable elements (1) which alter its focal length. This permits variations in the scale of reproduction and thus in the framing of the subject (a, b) without changing the shooting distance. Because there is no change in viewpoint, there is no change in perspective (2). The average zoom lens for 35 mm cameras (3) provides a zoom ratio (shortest to longest focal length) of about 2.5 :1 or 3 :1.

use the focusing screen. That gives the least depth of field and thus makes focusing easier and more positive.

Apart from zooming, the zoom lens works in the same fashion as an ordinary lens. Despite the changes in focal length, you do not need to alter the aperture. The marked *f*-numbers indicate the same light-transmitting ability at all focal lengths. This normally means that the zoom lens is of moderate maximum aperture because it is inconvenient to have a maximum *f*2.8 at 100 mm, for example, reducing to *f*3.5 or *f*4 at 200 or 250 mm. Nevertheless, this is sometimes done.

The greater the focal length, the more travel you need in the focusing movement for close focusing. So, the minimum focusing distance is rather greater than it would be for an ordinary lens of the minimum focal length of the zoom.

The net result is usually that, although the zoom lens may have a minimum focal length of about 80 mm, it will have a maximum aperture and minimum focusing distance more usually associated with a lens of its maximum focal length—which can be a little frustrating at times.

The disadvantage of the zoom lens (apart from its enormous cost) is that, for most of your shots, you are carrying unnecessary bulk. It is also, despite vast improvements in recent years and constant claims to the contrary, extremely doubtful whether any still-camera zoom lens can give as good quality results as single focal length lenses in a comparable price range.

For black-and-white work, the disadvantages tend to outweigh the advantages quite heavily, because selective enlarging is a simple matter. But the colour worker can find the zoom lens useful. It enables him to trim his picture in the camera, which is infinitely preferable to masking down the transparency for projection.

Tele-extenders

For long-focus work, there are alternatives to buying orthodox lenses. You can, for example, buy a tele-extender, tele-converter or whatever else the manufacturer chooses to call it. These items became a practical proposition with the widespread use of the 35 mm single-lens reflex, which presents on the viewing screen the image seen by the lens.

The tele-extender is a negative lens, i.e. it causes light rays to diverge. Thus it cannot be used on the camera alone because it would

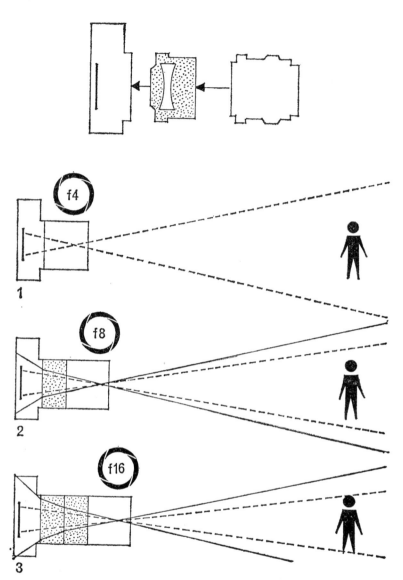

The tele-extender is a negative (diverging) lens placed behind the camera's positive (converging) lens. The camera lens (1) projects most of its received image on to the film. When a tele-extender is added (2) the image is enlarged but spreads beyond the borders of the film. This reduces the intensity of the image and, where image size is doubled the light loss corresponds to two stops. Tele-extenders can be used in tandem (3) but the light loss is greater.

not bring those rays to a focus. Placed behind the normal positive or converging camera lens, however, it lessens the convergence of the rays and brings them to a focus at a greater distance from the camera lens. That extra distance is provided by the mount of the tele-extender.

By lessening the convergence of the rays and increasing the distance to the focal plane, the tele-extender spreads the image over a greater area. As the film remains the same size, the result is a larger image of part of the subject seen by the camera lens, i.e. a long-focus effect. The ordinary telephoto lens works in much the same fashion, with a front group of lenses causing convergence and a rear group introducing a less drastic divergence.

The quality of the image provided by the tele-extender cannot be better than that given by the camera lens alone and it is, in fact, invariably worse. Generally speaking, the more costly the attachment, the better the image and the best of them give remarkably good results. The cheapest, and particularly those of earlier design, may give quite good results in the centre of the field but very poor definition at the edges.

The tele-extender has one outstanding disadvantage. By spreading the image over a larger area, it reduces the illumination of the original area—the film—in accordance with the inverse square law. If it doubles the focal length, it reduces the strength of the illumination by about 75 per cent. Thus, all the marked f-numbers of the camera lens have to be doubled to provide reasonably accurate indications of the light-transmitting power of the combination. A 50 mm $f2$ lens plus a $2 \times$ tele-extender becomes a 100 mm $f4$ lens.

There is an advantage, too. The addition of the tele-extender has no effect on the focusing scale of the camera lens. It retains its ability to focus at its closest marked distance. Thus, if you have a 135 mm lens which focuses to 5 ft, you can convert it to a 270 mm lens focusing to 5 ft, which you will not get with an orthodox lens. You can, for that matter, increase the focal length still more. You can use two $2 \times$ extenders to give a fourfold increase—but with only one-sixteenth of the light transmission.

You can use a $3 \times$ extender or one of the variable types giving a pseudo-zoom effect between $2 \times$ and $3 \times$. The greater the power of the extender, however, the less satisfactory the image. The mind boggles at the effect of two or three cheap extenders used together.

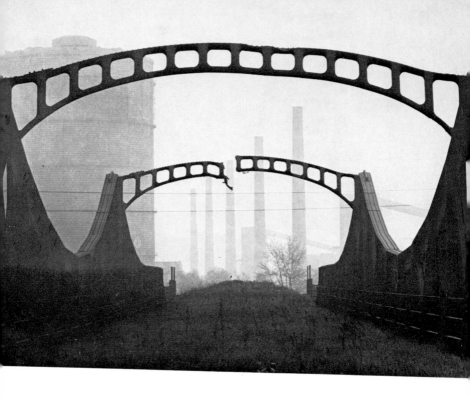

PLACES

The camera can bring life to inanimate objects. Its restricted field of view concentrates the interest, plucking out from a vast area the photographer's appreciation of the objects around him. He may contrast form and shape (pp. 109 and 110), present a mood (p. 107) or highlight a detail (p. 108). He may communicate his impressions or awaken different ones for you.

Pictures of this kind can be found everywhere. The location rarely matters. The attraction is of shapes, tones, contrast, lighting. Detail within the picture is

(continued on p. 109)

106

(continued from p. 105)

unimportant as in the houses on page 111 and the wooden posts on page 112. It takes its place in the whole—as part of a pattern, perhaps, or to point a contrast. Individual objects lose their identity. The true function of the roof on page 111, for example, is irrelevant.

Photographs of places, if they are to be regarded as pictures rather than aide-memoires, have a greater purpose than to give information. They show the place not simply as it is, but as the photographer sees it.

111

Photos by: Erwin Pohl (p. 105), S. V. Malli (p. 106), Bert Börjesson (p. 107), R. Heinzl (p. 108), Harald Mante (pp. 109 and 111, top), I. Janza (pp. 110 top, and 112), Heinz Auer (p. 110, bottom), R. Funk (p. 111, bottom).

Although the use of a tele-extender is only fully practicable on the single-lens reflex, the fact that it has no effect on the focusing scale makes it usable in principle on a non-reflex camera. A separate viewfinder is required but that presents no real difficulty. No models for non-reflexes have, however, become generally available, although a Japanese model coupling to the rangefinder of the Leica screw-thread cameras has been produced.

Monocular

Long-focus effects can also be obtained by shooting through a telescope or one side of a pair of binoculars. Even without a reflex camera, you can focus the telescope or binocular, move the camera close to the eyepiece with the lens set to infinity and shoot. Results vary, as might be expected.

This principle has been extended by the introduction of mono-culars specially designed for photography. They can be used with an adaptor to attach them to the front of the camera lens or with an extension tube direct into the camera body. One type has an extension tube of variable length and other attachments which provide a focal length of about 1200 mm.

When used with the camera lens, the monocular increases the focal length of the lens by the magnifying power of the monocular. The power of the monocular is always stated in its specification, together with the diameter of the front glass. A 7×50 monocular for example, has a $7 \times$ magnifying power and a front glass of 50 mm diameter.

These figures enable you to calculate two things. First, when used with a 50 mm lens, the combined focal length will be 350 mm. Secondly, as the front glass is only 50 mm across, the maximum aperture can be no more than $\frac{350}{50} = f7$. In practice, it will be $f8$ or smaller no matter what aperture you set the camera lens to. With an 8×30 monocular, the theoretical maximum in the same circum-stances would be $\frac{400}{30} = f13.3$. That in practice would be about $f16$.

If you use it on a lens of longer focal length the maximum aperture is proportionately smaller still. The monocular is much cheaper than an ordinary long-focus lens of comparable focal length and it can

give reasonable image quality. It is, however, awkward to use, apart from the loss of light transmission already mentioned.

Mirror lenses

One of the snags about very long focus lenses is that the sheer physical size of the tube makes them cumbersome. The telephoto principle is expensive to apply satisfactorily. Instead, the result is usually an unbalanced camera that needs an extremely rigid support to avoid camera shake.

A solution first tried out many years ago and now in production is the catadioptric or mirror lens. This lens uses mirrors which fold the light path back on itself inside the tube. This means that the length of the lens barrel is considerably shortened, although it is usually of much greater diameter. Early lenses of this type could not be produced commercially because they required unorthodox lenses that were impossible to mass-produce.

Later, less expensive optics achieved reasonable success, and several such lenses are now available.

In the relatively shorter focal lengths, such as 500 mm, the lens is even compact enough to be hand-held with some practice. One snag however is that the large tube will invariably obstruct the view of a built-in, non-TTL meter.

As the mirror lens does not use the rays striking the centre of the front element and as it has to incorporate masking to prevent other rays passing through without being reflected by the mirrors it cannot use the orthodox iris diaphragm to control relative aperture. Most mirror lenses have one aperture only and any stopping down that may be required has to be effected by neutral density filters.

When selecting such a lens, therefore, it is worth considering whether the advantage of a greater maximum aperture offsets the disadvantage of more restricted depth of field. Most popular Japanese 500 mm types were originally $f5$, while a German one was $f4.5$. The Russians used $f8$ and made their lens a great deal cheaper. The Japanese are now following suit.

For the amateur, the mirror lens is interesting but not really a practical proposition unless he intends to do a considerable amount of long-focus work and has money to spare. The cheapest of these lenses costs about as much as a high-quality camera body, while the dearest costs ten times as much.

6: Focusing and Sharpness

To get a sharp picture,
you have to focus carefully—or do you?
There are many factors affecting focus and sharpness.
Some are factual.
Others, such as depth of field.
are highly theoretical.

The simplest cameras do not have to be focused. They make use of the depth of field (see page 121) available when a fairly short-focus lens with an aperture of about $f8$ or $f11$ is set to 25–30 ft. Then, everything is reasonably sharp from 5 or 6 ft to the far distance.

Most cameras, however, have lenses in focusing mounts and there are three basic methods of ensuring that correct focus is achieved with such cameras: scale, rangefinder and screen.

Focusing scales

All focusing lenses have a focusing scale, marked in feet or metres (and often both) which indicates that when you set a certain distance opposite a mark, the lens is focused on that distance. The biggest snag of scale focusing is that you have to be a good judge of distances. If, for example, you were shooting at a wide aperture with a standard or longish focus lens and judged your subject to be 25 ft away when it was actually 20 ft, you would not get a very sharp picture. With longer focus lenses the position is even worse.

The focusing scale is useful even if you have a rangefinder or reflex camera. If you have a reasonable knowledge of the principles

of depth of field (see page 121), you can often use the focusing scale much more quickly than the rangefinder or focusing screen. It also enables you to carry your camera set ready for that unexpected opportunity to take the picture of the century. If you carry a 35 mm camera with standard lens set to $f8$ and 25 ft you are ready focused for a shot anywhere between about 15 and 40 ft. You only have to whip the camera up to your eye and shoot. Focusing, setting aperture and shutter speed could take long enough for your subject to be in the next county.

Reflex users in particular are apt to regard the focusing scale as superfluous but there can be many occasions when you do not want to place the subject exactly at the point of correct focus. You may have too much depth of field for a particular shot in which you wish to throw the background well out of focus. You can then use your focusing and depth of field scales together to place the subject at or about the near limit of the depth of field.

If your subject is 7 ft away for example and the background 10 ft, they might both be rendered sharply if you focus on 7 ft. If you set your lens to 5 ft. however, you might reduce your far limit to about 8 ft, taking in the subject comfortably but nicely blurring the background.

If you have a camera which focuses only by a scale and you find your judgment of distances bad, you can buy a separate rangefinder at quite low cost.

How the rangefinder works

If you observe various subjects from two different points a fixed distance apart, your two lines of sight converge on the subjects at different angles according to their distances from your viewpoint. Find the distance corresponding to each angle and you have a rangefinder.

The greater the distance between the two viewpoints, the more accurate the rangefinder can be. The photographic rangefinder is limited for reasons of convenience to a few inches in length but it can be surprisingly accurate. It has a viewing window facing forward at each end and an eyepiece on the other side giving a direct view through one window and a reflected view through the other. The reflected view may come from a movable full silvered mirror while the

straight-forward view goes through a semi-silvered mirror which also accepts the image from the movable mirror. When the two images so presented coincide you have found the range. You make them coincide by turning a wheel or other control for the movable mirror. The amount of the movement can be read from a scale calibrated in image distances. Transfer that distance to your lens focusing scale and you are ready to shoot.

Built-in rangefinders

The rangefinder may be a separate accessory mounted in the accessory shoe of your camera. But nowadays it is most often built into the camera body. Moreover, most such rangefinders are now coupled to the lens focusing mechanism in such a way that the lens itself forms the control for the movable mirror. Thus, when the images coincide, the lens is focused.

The two images are seen in a small central part of the rangefinder in most modern cameras although some older models, notably the Leicas, had separate rangefinder and viewfinder windows and eye pieces.

Rangefinders may be of the coincident or split image type. The coincident image type presents two complete images of the part of the subject in the rangefinder area. When the subject is not correctly focused these two images are out of register. When they fuse into one image, the lens is correctly focused. This is more satisfactory than the split image type which shows the image in two displaced halves and is easy to use only when the subject has straight vertical lines. (See also page 116.)

Screen focusing

Screen focusing dates back almost to the beginning of photography. In early cameras and in many current technical cameras, the plate or film is not carried in the camera. It is inserted into the back in a suitable light-tight holder just before you shoot. Until then, its place is occupied by a focusing screen of the same dimensions as the film. You focus and compose your picture (which is presented upside down and back to front) on that screen.

Originally ground glass, with perhaps a clear area for critical focusing, the screen now usually has a fine pattern of concentric lines all over it. That is the fresnel screen—a special form of condenser

lens designed to spread the light evenly all over the focusing surface, which is still glass or plastic with a finely ground surface.

It is the ground surface that forms the image but you can focus by mistake on the image of a fresnel screen, so be careful if you ever attach a fresnel screen to a ground glass. The fresnel rings must be in contact with the ground surface and, of course, the ground surface must be in exactly the same position as the film will subsequently occupy.

The ground glass and fresnel screen are fitted to most modern reflex cameras. Generally used at waist level in the twinlens models and in the 2¼ in. square single lens reflexes, these screens present the image right way up but reversed left to right. The 35 mm single lens reflex, however, is nearly always an eye-level camera with a pentaprism and viewing eyepiece mounted above the screen. The image is then both right way up and right way round.

Rangefinder and screen combined

The 35 mm screens tend to be somewhat cluttered. Virtually all of them have a central rangefinder section formed either by a pair of wedge prisms or by a vast number of microprisms. Many of these rangefinder sections are also surrounded by a collar of finely ground glass free of the fresnel rings. The result is intended to supply perfect focusing for all conditions. In practice, it is somewhat distracting.

It is always advisable (particularly if you wear spectacles, and/or are using a long-focus lens) to check your rangefinder for accuracy against the image presented by the rest of the screen. Check it with the lens stopped down, if possible. By this, we mean focus with the rangefinder at full aperture and then check the focus on the screen at shooting aperture. This you will find easier at close range, where there is less depth of field. It is not uncommon to find that the focus has shifted.

On the whole it is better to train yourself to use the whole screen for focusing rather than place total reliance on the rangefinder section.

Focusing technique

Focusing with a screen is really the same as focusing a projected image, such as that of a slide projector or enlarger. You have to rack back and forth, narrowing the movement each time until you find

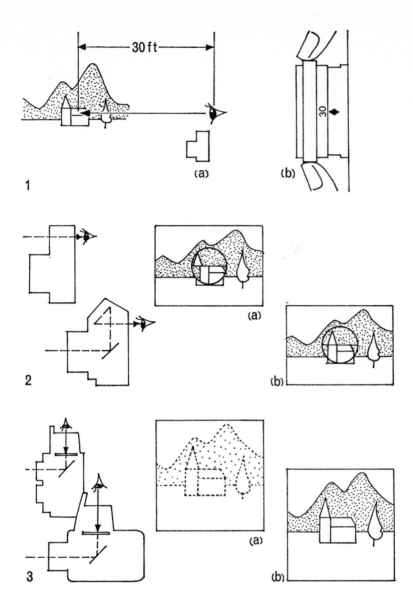

Scale focusing (1) demands an estimate of subject distance (a) followed by setting the lens according to the scale engraved on it (b). Rangefinder focusing (2), used in both non-reflex and reflex cameras, presents displaced image portions (a) which, when brought into coincidence (b) ensure the correct lens setting. Screen focusing involves racking the lens back and forth until the unsharp screen image (a) is made to look sharp (b).

119

the correct setting. It is a little tricky for the uninitated but becomes quicker and easier as you get used to it, although it is never so easy and positive as the rangefinder of the non-reflex camera.

Don't take too long over focusing on a screen. The eye has an unfortunate habit of accommodating itself to unsharp images and if you dally over focusing the image you will find that you are totally unable to decide on the right setting.

Always focus at full aperture. There the transition from sharp to unsharp image on the screen is steepest, owing to the limited depth of field at wide apertures.

Focus on the principle part of the subject unless you are making special use of the depth of field (see page 121). In a portrait for example, focus on the eyes. In a traditional type landscape, focus on the plane where most interest lies, which will usually be about mid-distance—but make sure that you have enough depth of field to keep the foreground in focus.

A note about focusing by scale only. The point of focus for an image reflected in a mirror or similar reflecting surface is the distance between camera and surface plus the distance from the surface to the subject. If you stand 5 ft from a mirror and photograph yourself with the camera hand held or close to you, your focused distance is 10 ft.

The same applies also of course to a reflection in a puddle, stream etc. A building reflected in a puddle may be 100 ft or more away. If you focus on the puddle from 6 ft or so you will get a very fuzzy reflection. Naturally, the rangefinder and focusing screen take care of this by themselves.

Moving subjects

A moving subject sometimes presents focusing difficulties if it moves haphazardly or unexpectedly. Where the movement is regular and can be anticipated, common sense often solves the problem. With races, for example, whether horses, cyclists, cars or athletes, it would not be very wise to try to focus while swinging the camera as the subject moves towards you. You would need three hands—one to hold the camera, one to focus and one to release the shutter at the exact moment you achieve correct focus. What usually happens, in practice, is that you shift your grip after focusing and shoot when the subject has passed well out of focus.

The sensible method is to focus on a part of the road or track that the subject has to pass and wait for it to come into focus at that point. It will usually be far enough away for a minor inaccuracy to pass unnoticed.

Prefocus in this way whenever you can, so that you are ready to catch any unexpected opportunity. Even where the subject is static, such as a celebrity opening a garden fete, focus on the platform, microphone or what-have-you in advance of the celebrity's actual appearance. You never know, the platform might collapse just as he steps on it.

Depth of field

When you focus a lens at, say, 6 ft, all objects 6 ft from the lens are reproduced sharply. Objects farther from or nearer to the lens are reproduced less sharply—the degree of sharpness falling off only very gradually as the distance from the focused plane increases.

The depth of field is the total distance from the nearest to the farthest point of the scene in front of the camera that is reproduced sharply in the final print or projected transparency.

It is a subject that the experts can argue over indefinitely. They can compile tables for you to show the depth of field for any given lens at any aperture and shooting distance. Some of these tables even contain figures such as 100 ft $7\frac{3}{4}$ in. which implies (a) that you could measure such a distance accurately and (b) that it would be of any practical value if you could.

The experts who compile these tables can also give you an exact mathematical formula for something that is about as exact as betting on horses.

For example:

$$Dn = \frac{D}{1+Dcf/F^2} \quad \text{and} \quad Df = \frac{D}{1-Dcf/F^2}$$

where Dn = near limit of depth of field
 Df = far limit of depth of field
 D = focused distance
 c = limiting circle of confusion
 f = f-number of lens
 F = focal length of lens.

Circle of confusion

All that looks clear enough except for c = limiting circle of confusion, and that is, indeed, where some of the trouble starts.

The theory of the circle of confusion is that a correctly focused lens reproduces a point as a point. In fact, no lens can do that but, for the moment, we will let it pass. When the lens is not correctly focused, the theory continues, the point is reproduced as a disc.

So far, so good. But the theory goes on to say that at a certain viewing distance, the human eye sees a disc of a certain size as a point. Thus, provided the lens reproduces points as discs no greater than a certain size, the image will look sharp. That disc is the limiting circle of confusion and its size is the nub of the whole subject of depth of field.

Depth of field tables and formulae work on the principle that the size of the circle of confusion can be accurately predicted. Furthermore, the size of a circle of confusion that is indistinguishable from a disc is known. Therefore, depth of field can be worked out exactly.

The influence of enlargement

As far as it goes that is true enough. All could, indeed, be worked out scientifically and with a reasonable degree of accuracy if we were concerned only with the image produced on the film, i.e. if all prints and projected images were subject to no enlargement or were always enlarged to exactly the same degree.

But virtually all amateur work and a large proportion of professional photography is now carried out on formats of 2¼ in. sq. or smaller. It is quite common to enlarge only a portion of the negative. And viewing distances vary with the function of the final print or transparency.

What is sharp in a contact print become distinctly unsharp in an enlargement—unless it is viewed from a correspondingly greater distance. The theoretical ideal viewing distance is the focal length of the taking lens multiplied by the degree of enlargement. Enlargements are, in fact, viewed from reasonably consistent distances according to their size, not their degree of enlargement. We tend to look at small prints from fairly close range and larger prints from

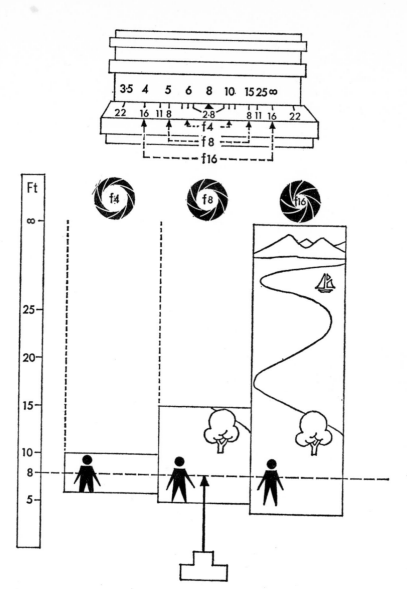

The size of the aperture governs the relative sharpness of different parts of the scene. At *f*4 and a focused distance of 8 ft you might have a sharp zone (the depth of field) from 5½ ft to 10 ft. As you stop down so the zone increases in depth both in front of and behind the focused plane. Most camera lenses have a depth of field scale (top) with pairs of aperture numbers indicating the nearest and furthest sharp planes at each setting.

a greater distance. But the prints may have been produced from all or part of a negative.

An acceptable circle of confusion on a 35 mm negative may remain acceptable if almost the whole image is enlarged to provide a 10 × 8 in. print which is viewed from about 16 in. This assumes that a 50 mm (2 in.) lens was used. The eight times enlargement then demands an 8 × 2 in. viewing distance.

If, however, you enlarge only a tiny part of the negative to a 5 × 4 in. print and view it from the normal 10 in. or so, the previously acceptable circle of confusion becomes much less acceptable and the depth of field of the lens apparently decreases.

Same lens—different depth

That leads to the conclusion that the same lens used at the same shooting distance and the same aperture can produce two pictures with different depths of field.

That sounds ridiculous, which is unfortunate, because it is true unless we stick to the rules about the correct viewing distance. A depth of field table for a 135 mm lens, for example, cannot pertain to all applications of the lens. The figures given should vary according to the size of film with which the lens is being used. Alternatively, they should vary with the degree of enlargement in the final image, which amounts to much the same thing.

Naturally, there is a formula to take care of that, too, and somewhere there must be a formula which also takes into account the viewing distance.

There is no formula which considers the eyesight of the viewer and the quality of the lens. No lens is fully corrected. No lens can, in fact, reproduce a point as a point. Every point in a photographic image is a disc of finite size and even the sharpest image becomes unsharp when it is grossly enlarged.

The laws of physical optics, on which depth of field calculations are based, have no regard for these matters. Nor can they lay down what is sharp and what is unsharp. In the final analysis, depth of field depends on *your* interpretation of sharp and unsharp. It also depends on your requirements. You may want the greatest possible depth of field or the least possible. In the latter case, you want to throw the background completely out of focus so that it does not

detract attention from the image. Then the depth of field table is useless. You don't want to be just outside the depth of field, you want to be right outside it.

What governs depth of field

Now that we have just about completely demolished the whole concept of depth of field, we had better set about rebuilding it. Used intelligently, depth of field tables and calculations are of some value. You can use them intelligently, however, only if you know what lies behind them and if you appreciate their limitations.

The easiest way of doing this is to think of the subject as a point and show how the lens reproduces it. We can imagine light spreading out from that point in the form of a cone with its base on the front glass of the lens. The lens bends the light back again so that it forms another cone, usually smaller, coming to a point on the film. The point in front of the lens is then reproduced as a point behind the lens.

To do that, however, the lens must be correctly focused. If it is not, the cone behind the lens comes to a point either in front of or behind the film. In the first case, the rays of light forming the cone cross and start diverging again, so forming a disc on the film. In the the second case, they cut through the film before coming together, again forming a disc. This disc is the circle of confusion and you can readily see that the greater the error in focusing, the larger the circle of confusion.

Depth of focus

It follows that, although you may focus a point at, say, 10 ft correctly, a point at 9 ft is incorrectly focused and is therefore rendered as a disc. This is where one of the factors influencing depth of field comes in. You know that, to focus an object close to the camera, you have to move the lens away from the film. That makes the cone of light behind the lens longer and therefore slimmer towards its pointed end. You can see that if you could move the film closer to the lens, keeping the lens the same distance from the object, you would be able to effect a greater movement with the slimmer cone than with a fatter cone to produce the same sized disc of confusion. This is, in fact, depth of focus. It shows that, the closer the subject is to the lens, the greater the latitude you have in the placing of the film plane.

This is of passing interest only to most camera users but there are some technical cameras that do provide back-focusing facilities.

Focused distance

Exactly the same applies the other way round, but this time the slimmer cone (in front of the lens) is formed by the distant object. You can move the distant object much further out of the plane of focus than you can the near object before the circle of confusion becomes too large.

That is why depth of field formulae contain a symbol indicating focused distance. The depth of field is greater when the focused distance is greater.

Effect of aperture

Formulae also contain a symbol for the lens f-number. This, too, affects depth of field because it is the base of the cone. When a lens is stopped down, some of the light striking the front element is cut off by the diaphragm before it reaches the film. You will remember that the f-number is an expression of the diameter of the light beam that strikes the lens and passes through the aperture.

Thus, with a smaller aperture, the base of the cone becomes smaller and the cone itself is thinner. This, in turn, means that you can move further along the cone in front of or behind the film before you reach your limiting circle of confusion. That movement corresponds, of course, to a much greater movement along the cone in front of the lens and means that the smaller the aperture the further the object can be from the focused distance before the image on the film becomes unsharp. In other words, depth of field is greater at smaller apertures.

Focal length and aperture

Finally, the formulae may also contain a symbol for focal length. You may or may not have realized by now that the only real factor governing depth of field at any given shooting distance is the actual size of the base of the cone we used for illustration purposes.

This is because depth of field depends solely on how far you can move along that cone before you spread your point into a disc of unacceptable size. The longer and/or the slimmer that cone, the further you can move.

It is, therefore, the physical size of the base of that cone that is important and that is the focal length of the lens divided by the f-number. Thus, the longer the focal length, the larger the cone at any given f-number and, therefore, the less the depth of field. In practice, that means that, other things being equal, the longer the focal length of the lens, the less the depth of field.

It also means, incidentally, that when the effective aperture (the base of the cone) is the same, the depth of field must be the same, regardless of focal length. In other words, at the same scale of reproduction, a 400 mm lens used at f 8 gives about the same depth of field as a 100 mm lens used at f 2 because, in either case, the effective aperture is 50 mm. This, too, depends on the considerations already mentioned regarding degree of enlargement and viewing distance.

Have tables any value?

Now we know what governs depth of field, we can assess the value of depth of field tables. We know, for example, that these tables have to assume a certain acceptable circle of confusion. Unless the table states the size of that circle of confusion, it is of little value to us. Suppose you find a table for a 300 mm lens. That focal length would be little more than standard for a 10 × 8 in. camera and, if the table was compiled for such a use, the circle of confusion assumed would be far greater than for a lens of similar focal length that you intended to use on a 35 mm camera.

If, however, you find depth of field tables in a book devoted to 35 mm photography, it is to be hoped that they would be worked out on a circle of confusion of at most 1/750 in. on the negative. Some tables are calculated on the basis of a circle of confusion of $f/1000$, f being the focal length of the lens. This is pointless if the lenses are to be used with the same size film. It gives a larger circle of confusion to the longer focus lens, which is only sensible if its image is to undergo a lesser degree of enlargement.

Depth of field in practice

So how, in fact, do you calculate depth of field? If you have any sense, you don't. You simply use the depth of field indicator on your lens and learn whether to adjust its recommendations to your own requirements. If your lens has no indicator, you consult a depth of

field table and try out its recommendations and similarly learn whether any adjustment is needed.

The depth of field scale is easy to use. Two sets of *f*-numbers are engraved, one on each side of the focusing mark on the lens barrel. The pairs of *f*-numbers are equidistant from the focusing mark, with the smaller apertures spaced further apart. These numbers are positioned alongside the footage figures on the rotating focus ring. Thus when the camera is focused and the distance figure is set opposite the focusing mark, those figures on the depth of field scale for the aperture in use appear opposite certain points on the focusing scale.

These points are the two extremes of sharp focus. When you set a particular distance to the focusing mark, you can read off the near and far limits of depth of field against any pair of *f*-numbers you wish. Thus by setting a certain *f*-number and focusing at a particular distance you can work out a suitable depth for any scene. Looking again at the scale, it is obvious that the more widely spaced *f*-numbers cover a greater part of the footage scale, whatever the distance set. This is because the smaller apertures give greater depth of field.

If you are aiming for sharpness throughout the zone, it may be advisable to use a smaller stop than that indicated by the scale to be sure that you get what you want. If you are aiming to throw your background well out of focus, you will almost certainly need to open up your lens by at least two stops. When you want the greatest possible depth of field, bring the infinity symbol to the shooting aperture on the depth of field scale. The focused distance is then what is known as the hyperfocal distance and depth of field extends from half that distance to infinity.

With some reflex cameras you can examine the depth of field on the focusing screen by using the preview device, which stops down the diaphragm from the normal fully open position to the *f*-number that has been preset. This method is just about workable on the larger cameras but it is not a very reliable means of judging depth with 35 mm models. The image, although magnified by the viewfinder eyepiece, is rather small. As it gets darker when stopped down, the image is often partially obscured by the fresnel rings and rangefinder which appear more prominent. Consequently the scene may look a lot sharper than it does when enlarged or projected.

7: Beating Exposure Problems

Even the TTL meter
does not solve all exposure problems.
The difficulties are minimized, however,
if you know just what you are trying to do
and whether the meter
is working with you or against you.

Anybody who buys a camera soon runs across the problem of exposure. The paradox however, is that he who buys the more complicated and more expensive camera finds himself with the greater problems. This is entirely due to the fact that the camera *is* complicated. The problem remains the same and it is a basically simple one.

The film you put in the camera is coated with a light-sensitive emulsion. If you expose it to light, it will, after suitable development, darken to a greater or lesser degree according to the amount of light it received. So, if you project an image on to the undeveloped emulsion by means of a lens, it can reproduce that image in negative form—the darker parts being where the most light fell and representing the lighter parts of the subject.

The problem is to gauge the amount of light you need to strike the film to produce a negative of printable quality. Too much light gives too much density and makes the negative difficult to print. Too little light fails to register some of the shadow detail and produces a thin negative that usually gives a rather flat print.

Too much light is overexposure, too little is underexposure. With

colour transparency film, overexposure produces a result with very light colours, tending towards the pastel. Underexposure gives a transparency that is too dark, with very rich, deep colours.

There is a point between the two extremes where the exposure is just sufficient to produce the ideal negative or colour transparency. The problem is to find that ideal exposure. It is generally easy enough. Where the difficulty sometimes arises is in setting the camera controls to give the required exposure, because there are many settings that will give the same or very nearly the same result.

The camera settings that control exposure are the aperture and the shutter speed. The aperture (very unscientifically but so satisfyingly defined by H. J. Walls in *Camera Techniques* as "the hole by which light passes through the lens") controls the amount or volume of light transmitted by the lens to the film. The shutter controls the length of time for which that amount of light is allowed to act on the film.

f-numbers and the inverse square law

The size of the aperture is, unfortunately, denoted by a most odd series of numbers known as *f*-numbers. There is actually a quite logical reason behind this strange progression but it is nevertheless, rather confusing at first.

The *f*-number is, in fact, roughly the diameter of the aperture divided into the focal length of the lens. There is a reason for that. When a lens is set to focus on objects at very long range it is positioned at a distance from the film equal to its focal length. So the light transmitted by the lens has to travel one focal length.

The further light travels, the more it spreads out (except where it is transmitted as a parallel or converging beam). The greater its spread, the less intensity it puts on to a given area. There is a physical law explaining this. It states that the intensity of light on a given area is inversely proportional to the square of the distance of the light source. Thus, if the distance of the light source is doubled, the intensity of light it throws on to a given area (such as the image area) is reduced to one quarter.

The inverse square law, like most laws of its kind, applies only in given conditions. Strictly, it applies only to a point light source—and there is no such thing. However, a light source can be regarded

as a point source if it radiates light in nearly all directions and is small in comparison with the distance to the object.

This has two important applications in photography. It means that the inverse square law does not apply to a spotlight, which, being a more or less parallel beam, maintains its intensity at quite long range. It also needs some modification in close-up photography. A floodlight used at 1 ft from a small object will probably not give four times the illumination that it would at 2 ft. It does not follow, in these particular conditions, that by moving a floodlight very close to the subject you are going to gain as much light intensity as calculations might suggest.

How does the inverse square law apply to lenses and f-numbers? A 2 in. lens, with its aperture set to a $\frac{1}{2}$ in. diameter is said to be set to $f4$ (2 divided by $\frac{1}{2}$). The light transmitted by the lens has to travel two inches (the focal length of the lens) to the film.

A 4 in. lens set to $f4$ has a 1 in. diameter aperture. It is evident from simple mathematics that an aperture of 1 in. diameter will admit four times as much light as an aperture of $\frac{1}{2}$ in. diameter. But in this case the light has to travel 4 in.—twice as far as with the 2 in. lens. Because it has to travel twice as far, the light loses three-quarters of its intensity. It starts off with four times as much as is admitted by th 2 in. lens but finishes up with the same amount. So the $f4$ of the 2 in. lens actually puts on to the film the same amount of light as the $f4$ of the 4-in. lens, although the one is, in area, four times as great as the other (twice the diameter).

The same principle applies to all f-numbers and all focal lengths. The f-number gives an indication of the amount of light transmitted by the lens. Lenses of different focal lengths have apertures that vary in size for the same f-number, but where the f-number is the same the light transmission is always the same.

To that, however, we have to add the qualification—in theory. Lenses are made of glass. Glass reflects light as well as transmitting it. Not all the light collected by the lens actually passes through it and the loss by reflection varies from lens to lens.

We simplified matters a little in referring to the physical size of the aperture. The diameter that governs the f-number is actually that of the bundle of light rays which enters the lens and passes through the aperture. When the lens is stopped down (a smaller

aperture is used), some of the light rays collected by the front glass are cut off by the diaphragm and do not pass through the aperture. As the diaphragm containing the aperture is situated within the lens, its diameter is usually rather less than that of the diameter of the bundle of image forming light rays. That is just for the record: it does not affect the principle.

Relationship between *f*-numbers

Another aspect of *f*-numbers is their relationship one to another. They run in the progression 1.0, 1.4, 2, 2.8, 4, 5.6, 8, 11, 16, 22, etc. If you have a mathematical bent you will realize that each of these numbers is the previous one multiplied by the square root of two (allowing for a little rounding off). There is, of course, a reason for this, too.

Having started with the convenient system of relating the size of the aperture to focal length so that the same *f*-number could denote the same light transmission, it was necessary to relate each *f*-number to the next by a logical and usable progression. The most practicable method was to make each aperture half the size (area) of the larger one, so that it transmitted half as much light. It just so happens that if you want to halve the area of a circle, you divide its diameter by the square root of two. So, if you want to provide an *f*-number which will divide into the focal length so as to give an aperture half that represented by a previous one, you multiply that first *f*-number by the square root of two.

If your mathematics is a little rusty that may all sound terribly complicated but it is worth reading it over a few times and fixing the principle in your mind. It is much easier to understand than to explain. Not that it really matters very much whether you understand it or not.

All you really have to remember about the aperture at this stage is that each *f*-number represents a light transmission double that of the next smaller *f*-number.

Aperture control

In most modern lenses the aperture is controlled by a rotating ring on the lens barrel which clicks into position at each *f*-number. The click-stop, as it is called, is convenient both for making sure that the

setting is as accurate as possible and for working in the dark. You simply turn the ring to its limit one way or the other and then count the clicks as you turn it back to the setting required.

Many lenses now also have click-stop positions for half-stops—intermediate settings between each *f*-number. These are useful for colour film when you want to make two or three closely related exposures to ensure the best possible colour rendering.

Don't let anyone kid you that they calculate their exposure so accurately that a certain half-stop setting is the correct exposure. The actual light transmission of different lenses at the same *f*-number setting can vary by at least a half-stop and shutter speeds are even less reliable. Even the film manufacturers will not guarantee the speed of their film within such fine limits. The half-stop has no real use in black and white work.

Shutter control
The shutter works in conjunction with the aperture in controlling exposure. Its function is much easier to understand and its markings are quite straightforward.

In the early days of photography the shutter was unnecessary. Photographic emulsions, then on glass plates, had such low sensitivity that exposures of many seconds, or even minutes, were required. These were effected by removing and replacing a cover on the lens—the lens cap. Now, emulsions are so fast that exposures of 1/500 sec. are commonplace. So the mechanical shutter is obligatory.

Between-lens shutter
Present day shutters take various forms but there are two basic types. The first is the blade, leaf or between-lens shutter. It has no one universally accepted name. It consists of leaves of metal arranged to open from the centre outwards to form a more or less circular hole through which the light can pass on its way to the film. Its most usual position is within the lens, close to the iris diaphragm which provides the aperture. Indeed, in some cameras, one structure performs both tasks.

When the release is operated, this type of shutter opens to its full extent almost instantaneously and closes again after the period of time for which it is set has elapsed. The blades move very fast

indeed, first in one direction and then in the other. This arrangement is an advantage with flash (see page 150) but is a slight disadvantage as far as size and maximum speed are concerned.

The blade shutter cannot generally give a maximum speed faster than 1/500 sec. The reversal of motion it has to undertake sets definite limits on its performance. Nor can it be made very large.

On the other hand, it is already too large—in the sense that it needs room for its blades to move outwards—to be set right in front of the film, which is really the ideal position for a shutter.

Focal plane shutter

This requirement is where the other type of shutter has the advantage. The focal plane shutter started life as a single, long blind wound on two rollers with several slits in it of varying width. As the shutter was released, one of the slits was caused to move across the film and expose it piecemeal. The narrower the slit, the less exposure each part of the film received.

The tension of the blind could also be adjusted to give a very wide range of speeds governed both by the width of the slit and the time it took to traverse the film. If the slit moved slowly, the film received a greater exposure. This type of shutter could give speeds up to 1/1000 sec. many many years ago.

The principle of the modern focal plane shutter is still very similar. The major differences are that it now has two blinds (one following the other across the film) and the tension is constant. Variations in speed are effected purely by the degree of separation between the two blinds—the counterpart of the slit.

In addition, the modern shutter is what is known as self-capping: there is no separation between the blinds while the shutter is being tensioned. So the film is fully protected against the light except when an exposure is actually being made.

The blinds are usually made from rubberized fabric but occasionally of metal. One or two models have a rotary or semi-rotary action. They are still being modified and improved—mainly to make them more versatile for flash work. But the general principle remains the same.

Most modern focal plane shutters give a top speed of 1/1000 sec. but even 1/2000 sec. has been reached.

1

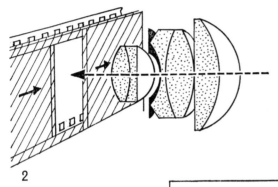

1 2 4 8 15 30 60 125 250 500

2

1 2 4 8 15 30 60 125 250 500 1000 2000

3 $\frac{1}{50}$ $\frac{1}{125}$ $\frac{1}{1000}$

The blade action of the between-lens shutter (1) limits its top speed to about 1/500 sec. The shutter also leaves the film uncovered when the lens is removed. The focal plane shutter (2) is behind the lens, which can be removed without exposing the film. Its motion permits higher top speeds. The focal plane shutter exposes the film piece-meal at higher speeds (3) generally only giving instantaneous exposure of the whole image area at speeds of 1/60 sec. or more.

135

The main advantage of the focal plane shutter is that it shields the film from light even when the lens is removed. Thus, it presents no obstacles to the interchangeability of lenses.

With the diaphragm shutter special arrangements have to be made to protect the film when the lens is removed or interchangeability is confined to the front part of the lens only. Alternatively the shutter has to be placed behind the lens. Each of these arrangements is a compromise. Each of them imposes its restrictions on the use of lenses above a medium-long focal length. Both types of shutter are generally spring driven but some recent cameras are fitted with electronically controlled shutters. Electronics, of course, is the word of the age and it was inevitable that it had to come into the camera world. It was unfortunate, too, because it brought yet another gimmick into a field that is already riddled with them.

Electronic shutter
The excuse for the electronic shutter is that it gives exact shutter speeds as marked—which no ordinary shutter normally does. It can also give a lot of extremely slow speeds—down to 30 seconds or so.

Now it is perfectly true that one of the obstacles to making the calculation of exposure an exact science is the uncertain action of the ordinary spring-driven shutter. It is not at all uncommon for the faster speeds to be considerably less fast than they are supposed to be. If a shutter marked to give 1/500 sec. actually gave 1/450 sec., it would be considered a good one.

Nevertheless, on the good shutter, the variations will not exceed 20 per cent and will usually be much less. Such a variation in exposure would be of no importance whatever on black-and-white film and would call for special equipment to detect it even on colour reversal film.

Moreover, it is a simple matter to have shutter speeds measured (electronically, if you wish) and to use them according to the measured speeds if such critical standards are really thought necessary. In practice, this is only likely to be needed in controlled laboratory experiments.

To go to the extent of introducing transistor circuits into cameras for everyday photography is truly akin to taking a sledgehammer to

a walnut. The only real advantage of the electronic shutter (which is, in fact, a mechanical shutter with electronic timing) is that it permits simpler and more direct exposure control with meter systems.

How they affect exposure

Together, the shutter speed and the aperture control exposure. They give a wide range of control. A camera with shutter speeds from one second to 1/500 sec. and apertures from f2.8 to f22 can give a maximum exposure 32,000 times greater than its minimum exposure. It can use any one of 70 different combinations to give various exposures between those limits.

Nevertheless, those 70 different combinations of aperture and shutter speed do not give 70 different exposures but only 16. They consist of four groups of seven that give the same exposure and two groups each of 6, 5, 4, 3 and 2 settings which give 10 different levels of exposure, plus two odd men out—the maximum and the minimum.

One of the groups of seven, for instance, is 1/500 at f2.8, 1/250 at f4, 1/125 at f5.6, 1/60 at f8, 1/30 at f11, 1/15 at f16 and 1/8 at f22. These each give the same effective exposure because, as the aperture is decreased to halve the amount of light admitted, so the shutter speed is lengthened to double the time for which the light is allowed to act.

Exposure values

For the purpose of exposure it is possible to give this whole range from 1/500 at f2.8 to 1/8 at f22 a single identifying figure. Similarly, each of the other 15 groups could be denoted by figures. This has actually been done and the resulting figures are known as exposure values or light values. The 1/500 at f2.8 group, for example has been given the figure 12. The 1 sec. at f2.8 group is indicated by the figure 3. The full range runs from 1, which denotes the range of settings giving the equivalent of 1 sec. at f1.4, to 18, which denotes 1/500 sec. at f22 and its equivalents.

Groups 1 and 2 have no application for the camera we have envisaged, i.e. with shutter speeds from 1 sec. to 1/500 sec. and apertures from f2.8 to f22.

The point of this exposure value system is that, instead of saying you could give an exposure of 1/125 at f8 to a particular subject,

you can say that it needed an exposure value of 13. You can then look up the various exposures that correspond to EV 13 and select the one with the aperture or shutter speed you actually want to use.

That is not really any great advantage because most meters can give such a reading direct. But when this system was taken up some years ago by a number of camera manufacturers it was made a little more practical by providing a device on some models which locked the shutter speed and aperture controls together. Once a combination to give the correct exposure had been set, you could alter either aperture or shutter speed at will and still maintain the same exposure. The idea was sound but it made it rather difficult to use the camera in the orthodox manner because you had to release the lock every time you wanted to make a fresh setting. That tended to be a tedious and often awkward operation and the additional row of figures on the camera made it look even more baffling. Moreover, such an arrangement is not possible with focal-plane shutters. The system was finally killed off by exposure coupling with built in meters.

Using aperture and shutter speeds

The value of a range of settings giving the same exposure is evident in many ways. To take the shutter speed first, although 1/500 sec. at f2.8 and 1/8 sec. at f22 give the same exposure, you would not use the slower shutter speed if you were hand-holding the camera or if the subject were moving.

The difference in aperture settings as we have seen (page 126) controls depth of field.

In fact, your 70 different combinations of aperture and shutter speed give you greater control over the type of picture you can take than over the actual exposure. The 16 different exposure levels are ample to cope with most subjects you encounter. There may be occasions when you need more exposure but that is easily managed on most cameras by using the "B" setting, which enables you to open the shutter and keep it open for as long as you like.

Shutter speeds

Shutter speed markings are quite straightforward. They are shown as whole numbers for convenience but are, in fact, fractions: 500 = 1/500; 2 = $\frac{1}{2}$ and so on.

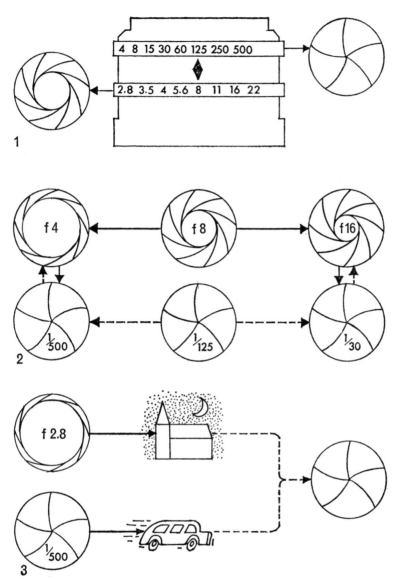

4 8 15 30 60 125 250 500

2.8 3.5 4 5.6 8 11 16 22

1

f 4 f 8 f 16

$\frac{1}{500}$ $\frac{1}{125}$ $\frac{1}{30}$

2

f 2.8

$\frac{1}{500}$

3

Shutter speed and aperture controls (1) are graduated to halve or double the effect of each mark. Thus, the same effective exposure is obtained with various combinations of settings (2). There are other considerations, however. When the light is poor, you can let as much as possible in by using a wide aperture (3) *and* a long shutter speed. But, if there is movement in the scene, the shutter speed setting is paramount.

The simplest shutters on the most inexpensive cameras have only one speed, which is generally in the region of 1/40 sec. As the price goes up so the camera becomes more versatile and uses a more ambitious shutter. Many of the middling to expensive cameras now carry a full range of speeds from 1 second to 1/1000 sec. These two extremes are rarely exceeded (except at the slow end of electronic shutters) but there have been cameras with slow speeds down to 12 seconds without electronic assistance and others with a top speed of 1/2000 sec.

In the normal range, shutter speeds follow the same principle as aperture settings, i.e. each successive setting gives half the exposure of the previous one. Earlier cameras had various markings which did not follow this principle so closely but the present standard range is 1, 1/2, 1/4, 1/8, 1/15, 1/30, 1/60, 1/125, 1/250, 1/500, 1/1000.

Finding the right combination

Because of the relationship between aperture and shutter speed settings the selection of different combinations to give the same exposure is simplified. Before you can decide which combination to use, however, you have to determine the actual level of exposure required. This is far from the complicated business it is sometimes made out to be.

Every film of reputable manufacture is supplied with a leaflet containing the manufacturer's advice on exposure levels in various light conditions. For the vast majority of photographic subjects, this leaflet, used with ordinary common sense, gives all the exposure information required.

Common sense is necessary because the leaflet does not give all the settings possible for a given subject. It may recommend a setting of 1/125 sec. at f11. You are expected to read into that recommendation that 1/60 sec. at f16, 1/500 sec. at f5.6 and any other combination giving the same exposure can also be used if circumstances demand an aperture different from f11 or a shutter speed different from 1/125 sec.

The simple recommendations of the manufacturer's leaflet can be extended to form exposure tables with various degrees of elaboration. There is even a set of tables approved by the British Standards Institution which takes into consideration such matters as geo-

graphical position, time of day, season of year, etc. These tables, again used with common sense, can be extraordinarily accurate, but they are rather time-consuming in use and not very convenient to carry around.

The best guide to correct exposure is, without doubt, experience. The photographer who consistently uses the same film (or perhaps, two films, according to type of subject), processed in the same manner, will never make serious miscalculations in exposure with black and white material. He may make mistakes, but these are due to carelessness or mental aberration and would occur with any method. Even with colour reversal film, which is less tolerant of variations in exposure, experience will rarely let you down.

When lighting conditions are difficult, which usually means low light levels, experience is the *only* true guide. The exposure meter, which we shall consider next, is unreliable in such conditions and is often unusable. Experience will teach you to assess the depth of the shadows, to appreciate the effect of high or low contrast and to bias your exposure according to the type of result you want. It will also teach you that, in very low light, your results will inevitably falsify the tones of the original and that there are various exposures that will give printable, but different, negatives. You will learn to make more than one exposure of such subjects, because you know that it is absolutely impossible to predict exactly the result that any particular exposure will give.

One of the oldest methods of calculating exposure is to treat the film speed as a shutter speed at ƒ16 in bright summer sunlight. In other words, using a 125 ASA rated film in those light conditions, you would give an exposure of 1/125 sec. at ƒ16 or 1/500 sec. at ƒ8 or 1/60 sec. at ƒ22, etc. Experience tells you whether to vary this basic exposure according to type of subject, different lighting conditions, method of processing and so on. Experience, however, takes time to acquire. Most people prefer to take a short cut by using an exposure meter.

Built-in meters

One of the biggest surprises photographic theorists ever encountered was the success of the built-in, coupled exposure meter. This almost completely eradicated the exposure problem, and it became possible

for the totally inexperienced photographer to wander abroad with a simple 35 mm camera and come back with a full load of perfectly exposed pictures—even in colour.

If he had been given a separate exposure meter and the usual advice on how to use it, the chances are that at least half his shots would have been spoiled by exposure errors.

Many of these errors would have been caused by the well-meaning, ill-considered advice that the exposure meter is an instrument without a brain that has to be used with intelligence. It is true enough, of course, that the exposure meter is a purely mechanical device which is incapable of picking out any particular part of the scene in front of it. It adds up all the various densities of light falling on its light-sensitive cell and provides the answer in the form of a single reading. It is impervious to the fact that some parts of the scene reflect a great deal of light and others reflect very little. It is concerned only with the total effect.

Moreover, its manufacturer calibrates it in a way that expects all these various densities to average out to a medium density. It then recommends an exposure that will produce the same effect on the film, i.e. when developed, the film will provide a range of densities that average out to a medium density. When correctly handled, a black-and-white negative so produced will provide a print with the same characteristic.

This is, in fact, what is usually required, because most photographic subjects do, indeed, have an average distribution of tones. With these subjects, the built-in meter works perfectly aud exposure errors are rare.

The meter can fail

Nevertheless, there are occasions when it fails. This is when the subject does not consist of an average distribution of tones. Consider, the extreme for example—a sheet of white blotting paper. What will the meter make of that?

Remember, the meter has been told (by its calibrator) that everything it sees will average out to a mid-tone and that it must recommend an exposure to reproduce that mid-tone. What else can it do but recommend you to give an exposure that will reproduce your white blotting paper as a mid-grey?

If you think of this in terms of black and white film, you will find it difficult to believe, because, of course, you can print any even density on a negative to produce a pure white on the print. But you can make a simple practical test.

Take two large objects of non-reflecting material (blotting paper would be ideal) of equal size—one white, the other as dark as you can get. Arrange them so that you can comfortably include equal areas of each of them to fill your viewfinder screen from reasonable shooting distances. Light them evenly. Diffused daylight outdoors would be ideal.

Take a reflected light reading (that is, a reading directly off the subject in the normal way) so that equal areas of each object (and nothing else) are included in the field of view of the meter. (This is one time when the through-the-lens meter would be ideal.) Make your first exposure including equal areas of each object and using the exposure recommended by the meter.

Next take a reading of the white object only. Make your second exposure at that reading, including only the white object.

Repeat for the dark-coloured object.

Process the films in your usual manner and examine the negatives.

You should find that your first exposure contains equal areas of almost clear film and parts with a fair density. Your meter correctly interpreted the scene as one containing a range of tones which averaged out to a mid-grey, and recommended an exposure to produce a comparable result on the film.

But what of the other two exposures? If you carried out the experiment carefully and accurately, you should find that these two negatives are almost identical. Yet one subject was dark and the other was light. How come?

In both cases, the meter was misinformed. Its calibrator had told it that the scene in front of it would integrate (as the technicians put it) to mid-grey. So it advised you to overexpose the dark subject to transform it into the mid-grey it thought you wanted and to under-expose the white subject to the same end.

Local readings are useless

If you still find this difficult to accept, try thinking of it in terms of colour reversal film, instead of black-and-white or even negative

colour. Take a more realistic example this time. You may have a predominantly light-toned subject, such as a model in a light-coloured dress, posed against rather dark foliage. Your object may be to photograph the dress. You may think that, the dress being the most important part of the subject, you should take your reading from that and let the other tones look after themselves. That is often called a local reading.

You would be wrong. Again, the meter would read the light reflected from the light-coloured dress and recommend that a sufficient amount of that light be allowed to reach the film to register the dress as a mid-grey. In black-and-white, the error might not be very noticeable. You would tend to lose detail in the shadows but that would probably not matter. The underexposure of the dress might actually allow it to print quite well.

In colour reversal, the story would be entirely different. The meter's recommendation for a mid-grey would be a recommendation that the light colour of the dress be reproduced in a darker tone—and that is what would happen. A delicate pastel pink would become decidedly more rosy. The greens of the foliage would also become much deeper, even to the extent, perhaps, of reproducing virtually black.

If, however, this had been a subject in which the darker tones were more important than the lighter and you had based your exposure accordingly, the meter would have recommended you to over-expose.

Again, this might not be important in black-and-white, although there would be a danger that the lighter tones would be almost completely burnt out and become difficult to print. In colour, the overexposure would cause the darker tones to be rendered several shades lighter, which might or might not be acceptable. The lighter tones, if of delicate colour, might lose their colour altogether. This time the pastel pink might reproduce as almost white (which is why you are often advised to base your exposure for colour material on the highlights).

This is the great disadvantage of the reflected light reading. Unless the principles involved are fully understood and the meter used accordingly, it can give very unsatisfactory results. Fortunately, most subjects do integrate to a mid-grey (another way of saying that

The exposure meter (1) measures variations in electrical current and recommends as an exposure that will produce a tone or range of tones averaging out to a mid-grey. Thus, the straightforward reflected-light reading (2) should not include too much sky area and a reading for a portrait should be taken from an artificial mid-tone (3). Close-up readings (4) are used to check the brightness range. Incident-light readings (5) are a substitute for mid-tone readings.

they are evenly balanced in tone) and the straightforward reflected-light reading usually works very well.

The non-average subject

If you have followed the discussion so far, the correct approach to the non-average subject may be obvious to you. No matter what the distribution of tones in the subject, you should always base your exposure on a mid-grey. If there is no mid-grey in the subject, then you must create one.

With practice you can do this mentally. If the subject is predominantly very light in tone, you remember that your meter reading recommends underexposure. So you give one or two stops more exposure than the meter recommends according to the lightness in tone.

If the subject is predominantly dark in tone, you give one, two or even three stops less exposure than the meter recommends. This may run counter to all your ideas about the light subject needing less exposure and the dark subject needing more. Indeed it does, because that is one of the greatest fallacies in photography. Given the same light conditions and the correct film speed rating, the tone of the subject should have no influence whatever on the exposure you give. The darker parts get the same exposure as the lighter parts if they are in the same picture. Why should there be any difference if you separate the tones into two or more pictures?

If your exposure is based on a mid-tone, the other tones fall into place naturally. You vary this method of working only when you wish to falsify the tone range, i.e. if you want to make a dark subject lighter or vice versa, or where the brightness range is too great for colour film (see page 201).

Incident-light readings

This same fallacy is often repeated when the incident light method of using an exposure meter is mentioned. When used in this way, the meter is fitted with a diffuser which both scrambles the light and reduces its intensity. It is pointed from the subject towards the camera position if fitted with a spherical diffuser and to a point mid-way between camera and light source if fitted with a flat diffuser. If the meter is calibrated correctly, the reading should then correspond

with that obtained by a reflected light reading from a mid-grey tone in the subject position. It would, in fact, be *the* mid-grey tone (see page 294) represented by the tone of a grey card that reflects 18 per cent of the light falling on it.

So, the meter used in this way should give the correct reading for all subjects—yet it is so often said that the reading should be adjusted to the tone of the subject. More exposure should be given to the lighter subject and less to the darker. For the reasons we have already explained, there is no logic in this whatsoever unless the subject is *so* dark or *so* bright that an exposure for a mid-tone could not also be correct for these extremes. That would be a very unusual subject.

We should perhaps qualify that rather dogmatic view by saying that there could be some sense in giving more exposure to the darker subject if you habitually obtain rather thin negatives. This means that you are pursuing the theme of basic minimum exposure (see page 74) to its limits and are rating the film a little too fast for safety in all conditions.

White card readings

When confronted with a subject that is dimly lit, the white card method of exposure determination is a convenient answer to the problem. Suppose, for example, you wish to photograph a rather dark church interior. It would be unwise to rely on an ordinary meter reading—even with the sensitive CdS meter. A more reliable reading could be obtained from a white card placed where the light is of average intensity. One reading should be made from this, taking care that the meter is held close enough to 'see' only the white card, but not so close as to cast a shadow. The exposure reading obtained in this way should be multiplied 6–8 times to give the setting required. This technique may also be put to use where readings are to be obtained in artificial light.

The same method is used where the subject to be photographed is a document or similar material. Where copies are required, for example, of printed material on a white or light coloured base, a straight exposure meter reading would be inaccurate. The light base would outweigh the small amount of dark print and the meter would give a reading calculated to reproduce that light base as near mid-grey. It would be much too high a reading to reproduce that

light tone as you want it—as pure white. Your exposure should, in fact, be about four times that indicated by the meter. It can, of course, be even more because you have no objection to burning out the highlights. It should not, however, be more than six times the meter reading or there will be a danger of irradiation spoiling the definition. In other words, the overexposure becomes such as to scatter the light within the emulsion so that it spreads out from the light areas into the dark—in this case softening the edges of the printed characters and rendering them less sharply.

8: Light in a Flash

Bulb and electronic flash are very different.
There are important differences, too,
between the synchronization
of focal plane and diaphragm shutters.
But exposure calculations are relatively easy.

Now that the focal plane shutter is so common—it is fitted to nearly
all 35 mm single-lens reflexes—flash has become a puzzle and a
disappointment to many. We can explain the puzzle but we can do
little about the disappointment.

There are two types of flash—bulb and electronic. They are very
different in principle, operation and cost.

The flashbulb is a development of the flashpowder that was so
widely used many years ago. It consists of inflammable metal wire
enclosed in a glass bulb containing oxygen. By passing an electric
current through the filament, which is covered with a priming paste,
the wire ignites and burns with explosive brilliance. At one time bulb
flash was considered to be of very short duration. If we think about it
now, it seems rather prolonged, because it lasts for about 1/50 sec.
whereas many modern shutters are capable of 1/1000 sec. exposures.

Flashbulb duration

By today's standards it is hardly even instantaneous either. From
the time the current is first switched on to the time the burning wire
reaches full brilliance another 1/50 sec. may have elapsed.

Firing the bulb

Flashbulbs can be ignited with quite low voltages—from 3v. to 20v. or so—but they need a current of about 2 amps. In early flash units they were often connected directly across small batteries. But as such batteries cannot deliver a high enough current for very long this means of firing was unreliable.

The modern flashgun gets round this problem by using a battery-capacitor circuit. The battery charges the capacitor (an electrical component able to hold an electrical charge). The charging current may be relatively slow and of insufficient power to fire the bulb but it will charge the capacitor to its full potential in the intervals between shots. When the flash is fired the capacitor discharges instantly through the bulb and ignites it. The capacitor takes longer to charge as the battery voltage falls but it can remain sufficiently rapid for the usual 15 or 22½ volt batteries to have a useful life of a year or more, depending on the amount of use they have.

Open flash and flash sync

Flash was originally used with what is known as the open-flash technique. This simply means that the shutter is opened, the flash is fired and then the shutter is closed again. With practice this routine can be complete in about half a second or so. It is still handy for cameras which have no flash facilities. But only when there is very little other light present and the subject is motionless, or nearly so. If there is sufficient light present to produce an image on the film in the period while the shutter is open the moving subject may produce a sharp image lit by the short flash and a blurred image lit by the existing light.

Open flash is rarely necessary now. Most cameras have synchronized shutters, which means that they have built-in electrical contacts to fire the flash at the right moment. The right moment is *before* the shutter is wide open, so that the peak brilliance of the bulb (allowing for the build-up) coincides with the peak opening of the shutter.

When the shutter is synchronized in this way, any speed can be set, provided it is the right kind of shutter. But, as the total duration of the flash may be 1/50 sec. or longer at the faster speeds only part of the total flash output is used (part of the build-up and part of the

decay are cut off). This type of synchronization is known as M-synchronization and it actually requires that the flash contacts be closed before the shutter blades even begin to open.

Focal plane synchronization

M-synchronization is not available on all cameras and it cannot be provided for focal plane shutters. The reason for this is that the focal plane shutter works on an entirely different principle from the blade shutter (see page 133). The slit of the focal plane shutter takes a fixed time to pass across the film and that time is quite long—usually in the region of 1/40 to 1/50 sec., although there are some of more modern design which move faster.

It would seem from this that it is just possible to squeeze the flash into any shutter speed. Unfortunately, however, the 1/50 sec. or so duration of the flash does not consist of even brilliance. The light builds up to a sharp peak and then rapidly falls away again. So the light varies in strength as the slit moves across the film and the result is uneven exposure.

If the peak brilliance of the flash were to last longer, the faster shutter speeds could be used. This is, in fact, possible. Special focal plane bulbs are manufactured for use with shutters which are synchronized to make the electrical contact before the first blind begins to move. The bulb builds up to a peak which lasts long enough for the slit to move across the film. Thus, any shutter speed is possible. This is FP synchronization, frequently marked F on modern cameras and, rather misleadingly marked M on others. Focal plane bulbs, however, are more expensive than the ordinary type.

With ordinary bulbs a focal plane shutter slit must be at its maximum with the film completely uncovered when the flash ignites. It must stay uncovered throughout most of the build-up and decay of the light.

There is a limit to the maximum speed setting with bulbs which varies from one camera to another. On many it is about 1/30 sec.—sometimes slower, sometimes faster. The actual figure is given in the manufacturer's instruction book or in the relevant Focal *Camera Guide*. If neither is obtainable it can be ascertained by making flash exposures of any subject at speeds ranging from 1/15 sec. upwards. When you reach the first unsuitable speed, you will see that a strip of

the film remains unexposed where the second blind has started to cover the film before the flash has fired.

To ensure that the shutter blinds are fully open when the flash is fired, the flash contacts are closed when the first blind reaches the end of its travel. A flash fired at that moment will illuminate the whole film area evenly only if it can emit practically all its light before the second blind begins to move. As flashbulbs take time to build up, the suitable shutter speed is the next slower to the highest of those which uncover the film completely.

It might be thought that it would be more satisfactory to close the contacts before the blind reaches the end of its run. Then the flash-bulb could be fired at a faster speed setting. This, indeed, could be done, but when we come to deal with electronic flash we will see why it is not.

X-synchronization

The type of synchronization which allows flashbulbs to be used only at the slower shutter speeds (on focal plane or blade shutters) is known as X-synchronization. On the blade shutter the flash contacts are closed as the shutter blades reach the fully open position. Here again, only the slower speeds can work because at faster speeds, the shutter blades start to close again before the flash has given any appreciable amount of light.

At really fast speeds, the shutter is fully closed again before the flash has fired at all.

X-synchronization is the most common form. Where a shutter has only one method of synchronization it is nearly always the X type. M-synchronization is rarely found alone but may be available as an alternative, selected by movement of a lever or other control on the blade shutter. Similarly FP-synchronization is sometimes available as an alternative on the focal plane shutter, generally via a second socket for the flashgun plug.

We said earlier that there were two types of flash. The flashbulb is one. The other is electronic flash.

Electronic flash

The greatest disadvantage of the flashbulb is that it can fire only once and so is rather expensive.

Electronic flash takes place inside a sealed tube. The flash itself is an electrical discharge which causes gases in the tube to glow. While electrical power is available, the tube can flash repeatedly—up to 10,000 times before it need be renewed. That is important, because it means that the cost per flash is only a fraction of that of the flashbulb. But the cost of the equipment is much greater than that of the bulb gun and so is the weight.

Another valid comparison with the flashbulb concerns the duration of the flash. Whereas a bulb may emit a varying amount of light over a total period of about 1/50 sec., electronic flash is genuinely high speed. The early guns gave a flash lasting about 1/5000 to 1/10000 sec. On more recent equipment the flash lasts much longer but it is still usually in the region of 1/800 sec. or faster. Electronic flash is *really* instantaneous because, for all practical purposes, the flash has no build-up period; it gives its full light immediately at the moment the contacts are closed.

This brings us back to the point we made earlier about synchronization. With X-synchronization, the blade shutter closes the flash contacts when the shutter blades are fully open. The focal plane shutter closes the contacts just as the first blind reaches the end of its travel. Thus, on the blade shutter, electronic flash is suitable for any speed and, unlike the flashbulb, it gives its full light output at all speeds up to 1/500 sec. and sometimes faster.

With the focal plane shutter, things are different. As we have explained, at shutter speeds faster than about 1/60 sec., the focal plane shutter exposes the film strip by strip. These speeds can only be used with a flash that has a fairly long peak. That, the electronic flash certainly has not. So, with the focal plane shutter, electronic flash will only synchronize correctly at the slower shutter speeds when the film is fully uncovered. The lack of a buildup period for electronic flash makes it impossible for the flash contacts to be closed before the blind reaches the end of its travel. But it does allow exposures at the fastest speed at which the film is fully uncovered, whereas bulbs have to be used at the next slower speed.

M-synchronization of blade shutters and FP-synchronization of focal plane shutters both close the flash contacts while the film is still covered by the shutter. Both are therefore unsuitable for electronic flash.

Light output and power

The cost and weight of electronic flashguns have been reduced in recent years and genuinely pocket-sized models are now available in large numbers. Unfortunately, as the cost and weight went down, so did the light output. The modern small gun gives much less light than the smallest flashbulb and cannot really be taken seriously as a main light source. As it is relatively cheap and quite portable, however, it can serve as a fill-in light to relieve dark shadow areas in heavily sun-lit shots, or in some interiors. As a main light it would have to be positioned within three or four feet of the subject.

The power factor is important. It is also rather confusing. The light output of a flashbulb is usually expressed in lumen-seconds. But the power of an electronic flash unit is normally expressed in watt-seconds (or joules) if it is expressed at all. This is not very satisfactory because the watt-second figure is simply a mathematical calculation based on the storage ability of the capacitor and the voltage applied to it. It does not give a direct indication of actual light output, which can vary with the tube construction, reflector efficiency and various other more complicated factors.

A smaller tube, which will generally also be a lower-voltage tube, tends to be more efficient in light output than a larger tube. It may, in fact, give about 45 lumens to the watt (if the electricians will forgive the lack of true analogy)—from which you can calculate that the 100-joule (or watt-second) unit might give 4,500 lumen seconds total output. This means, in effect, that it gives the equivalent of 4,500 lumens for a duration of one second—just as the 100 watt-second figure implies that the power is the same as 100 watts for a duration of one second.

As the electronic flash actually lasts for something in the region of 1/800 sec., the light is theoretically equivalent to that given by 800 100-watt lamps—which is about the same as 100 No. 2 Photofloods. But this is indeed theoretical. Watts are a unit of power or energy and that energy is dissipated in both heat and light. And different light sources have a different relative distribution of heat and light.

We can get a rough idea of the real power of an electronic outfit when it is expressed in joules by using the 45 lumens per watt conversion and comparing that with the published figures for various flashbulbs. Thus, the 100-joule outfit would give, as we have noted,

about 4,500 lumen seconds. The No. 1 flashbulb, such as the PF1, is rated at about 7,500 lumen seconds. That is the output of the flash-bulb in all directions. Some allowance must be made for the fact that all this light does not fall directly on the subject. The practical output depends on the efficiency of the reflector used.

Guide numbers are more reliable

Nowadays, however, neither electronic flashguns nor flashbulbs as supplied to the photographer are given either joule or lumen second figures. Their power is stated by means of a guide number or series of guide numbers.

The guide number system is quite straightforward and works perfectly at normal shooting distances provided the guide number is carefully ascertained by the user. It depends on the facts that we have already discussed, namely that a doubling of the f-number of a lens denotes a four times reduction in light transmission and that a doubling of the distance of a light source denotes a four-times reduction in the light falling on a given area. This is very convenient because you can multiply the f-number and distance together and always come up with the same answer for the same level of exposure.

If, for example, you have a subject lit by a lamp 5 ft away and your aperture is $f8$, the product of these two figures is 40. If you double the distance of the lamp, you know that the light on the subject is only one-quarter of its previous intensity and that you would have to open your lens by two stops to maintain the same exposure. The new figures would be 10 ft and $f4$, again giving a product of 40.

Thus, you have only to find the correct exposure with a given flash unit once, multiply the f-number and distance together and you have a figure that serves as a guide number for all other exposures with that unit, with a film of the same speed and in similar conditions. Remember that the conditions are important.

If you use flash in a small light-walled room your guide number could well be double that in a large hall with no nearby reflecting surfaces. But you have to check that for yourself. Manufacturers figures can be very optimistic and should not be accepted blindly. In any event, they always imply what they regard as "normal conditions", i.e. small rooms with good reflecting surfaces. The manufacturers may give you a guide number of 45 for your small flashgun with a

certain slow speed colour film. From this you know that it should give you correct exposure when the flash is 10 ft from the subject if you use an aperture of *f*4.5. Or, if you would like an aperture of *f*11, you have to place the flash within about 4 ft of the subject. When calculating guide numbers, don't forget that it is the flash-to-subject distance that counts, not the camera-to-subject distance. Where the required flash-to-subject distance is inconveniently long or short, the flash can be operated away from the camera by means of an extension lead—one of the most useful of all flash accessories.

How to calculate guide numbers

With electronic flashguns, one guide number for each film speed is enough. Even if you know that guide number for one film speed only, you can easily calculate others. Doubling the guide number is the same as doubling the flash distance or the aperture. That means a four times increase in exposure—or the same exposure with a film four times as fast. So doubling the guide number makes it suitable for use with a film of four times the speed.

These calculations are, of course, related to the inverse square law that applies to illumination and to aperture numbers (page 130). Doubling the aperture number means quartering the light transmission. Halving the light transmission involves multiplying the aperture number by 1.4. So the same applies to guide numbers. If you know the guide number for one film speed, you multiply it by 1.4 to make it suitable for use with a film of twice the speed. In practice, it is easier and sufficiently accurate to multiply by $1\frac{1}{2}$.

The 1.4 factor is our old friend the square root of two and it gives the clue to calculating guide numbers for other film speeds that do not conveniently work out to twice or four times the speed for which you know the guide number. The figure you have to multiply the guide number by is the square root of the relationship between the known and the unknown figure. If you know the guide number for a 25 ASA film and want to know the guide number for a 64 ASA film, you multiply the known guide number by the square root of 64/25.

The unit for you

Choosing a flash unit is a tricky business. Now that electronic flash is no longer synonymous with bulk and high cost, there is a tendency

$$\frac{G.N.80}{10} = f8$$

Guide Number 80

10ft

1

$$\frac{G.N.80 \times 2}{8} = 20$$

f8

20ft

2

For flash exposures, flash distance × f-number is a constant and can therefore be expressed as a guide number for a given light output.

With a guide number of 80, for example, and an aperture of f8, flash distance must be 10 ft (1). For fill-in flash (2) the full power is not required, so the guide number is doubled and divided by the aperture required for the daylight conditions. This may call for an extension flash lead.

157

to ignore the humble flashbulb. The reason, prejudice apart, is often based on false economics.

It is true that the flashbulb is expendable and you can immediately add to the cost of every shot an amount in excess of what you spend on the film. But the cost of the mechanism to fire the bulb (the flash-gun) can be very low indeed. The battery it uses is also cheap and has long life. There is virtually nothing to go wrong with the equipment.

The cheapest electronic flashgun, on the other hand, still costs as much as 200 or so bulbs. It may be powered by dry batteries which it consumes at an alarming rate. It may have a rechargeable battery, which needs many hours recharging after every use. It has a compli-cated electrical circuit which is reasonably robust but far from infallible. It uses high voltages and there have been cheap models that were positively dangerous.

The bulb gun gives much more light with even the smallest bulbs and can take at least one larger size of bulb to give an output that only a really expensive and bulky electronic unit could equal.

If, therefore, you don't often need flash and 2–300 bulbs are likely to last you for a considerable time, electronic flash is not for you. If you want a flash with a reasonable light output, the *cheap* electronic unit is not for you. You should still stick to bulbs or buy a larger, more powerful unit at four to five times the price of the cheap ones and with about the same increase in bulk and weight.

With all electronic flash units—and this, again, applies particularly to the cheaper ones—you have to be on your guard against unreliable guide numbers, state of readiness indicators and quoted recycling times.

The recycling time is the time required by the capacitor in the electronic flashgun to build up enough power to fire the tube. It is often quoted as 7–8 seconds but this relies on the maximum charging current being available. In fact, the current flowing from the battery decreases after each flash and, as the batteries are usually very small and therefore of limited capacity, the rate of decrease is often signific-ant. The recycling time may well stretch to 20–30 seconds or more after only a dozen or so flashes. Even before the battery reaches exhaustion point, which is usually after 50–60 flashes, the recycling time may run into minutes.

To show that the capacitor has attained a sufficient charge and

that the flash can be fired an indication is given by the glow of a neon lamp and/or an audible signal. It is normal practice in the cheaper units to arrange for the neon to glow when the capacitor reaches 80 per cent of its full charge. It is possible, however, for the manufacturer to arrange a lower setting to give an *apparently* faster recycling time. In some cases it is wise to delay firing the flash until the neon has been alight for at least half the time it took to glow. If you fire at the moment the neon first glows, you risk getting less than the full power of the flash. This point is worth checking with any flash outfit.

Your choice of equipment must be made carefully. The comparatively low price and small size of the modern electronic flash make it tempting. The much publicized ability of the electronic tube to flash repeatedly without renewal is undoubtedly a convenience.

Against those advantages you have to set the considerably smaller size and the lower bulk and weight of the expendable bulb unit, its greater light output potential, complete reliability and absence of recycling time and recharging problems. Of these, the light output is most important. An electronic flash that gives at least the output of a No. 1 or PF1 bulb is a real asset to the photographer who takes flash work seriously. But equipment like that is expensive and still rather bulky.

With many inexpensive cameras, the choice is virtually made for you, because they have built-in flash units, attachments for flashcubes or striker mechanisms for Magicubes.

The ordinary flashcube is, in effect, four flashbulbs, each with its own reflector, built into a cube that can be rapidly rotated on the camera as the film is advanced, so that four flash shots can be fired in rapid succession.

The Magicube is similar but does not require a battery because it is fired by a striker arrangement that harks back to the old tinder box.

Flashcubes and Magicubes can be used only on cameras with the appropriate mechanisms built in.

9: Flash in Practice

The flashgun is often most effective
when removed from the camera.
It may need help from reflectors.
It may simply act as a fill-in with other lighting.
Good flash pictures need careful planning.

Flash is extremely easy to use. Most of the difficulties encountered are created by the photographer, who finds it difficult to realize that there is really so very little to it. The complicated calculations of angles and factors so often recommended are rarely necessary in practice.

The principles are the same whether bulb or electronic is preferred. With bulbs, however, there is generally a choice of types.

Bulb types and sizes

There are various types of flashbulb, of which the most popular are the AG1 and PF1 types. The PF actually stands for Photoflux, which is a Philips trade name but we refer to it here as synonymous with the No. 1 or Type 1 or any similar bulb. The PF1 was the standard small bulb for some time. Originally having a small, bayonet-type fitting like a miniature domestic lamp, it is now universally a capless variety with wire leads from the filament projecting out of the glass envelope to press against spring contacts in the flashgun. It has a satisfactory light output for most purposes, enabling average colour shots on, for example, 50 ASA colour film to be made at an aperture of $f8$ from a distance of 8–10 ft.

LIFE AND MOVEMENT

The living world around us provides an enormous fund of picture-making possibilities. Animals and birds, captive or free, sport, transport and even bubbling water all convey the essence of life and movement.

The presentation of animal life is usually fairly straightforward as in the case of the zoo elephant above. The animal itself *is* the picture, or the most important part of it. The emphasis is on characteristics, activities and habitat, rather than

(*continued on p. 164*)

163

LIFE AND MOVEMENT

(*continued from p. 161*)

form, shape or mood. The photographer's skill is in catching the characteristic expression or "pose" (*below*).

Movement is difficult to show in still pictures (pp. 166 and 167). It has to be implied in animals and riders frozen at a point in time (p. 168) by indications such as tautened muscles or tilted bodies defying the force of gravity. In less mobile objects, it can be hinted at by the lines of the composition or by natural pointers like smoke trails, bow waves, etc.

In sports photography, you can take liberties with your subject that would not be permissible in a straight animal shot. Horse and rider on page 165 are shot from low down at fairly close range with the accompanying inevitable distortion but the effort of the jump is perfectly conveyed.

(*continued on p. 166*)

LIFE AND MOVEMENT

(*continued from p. 164*)

The riders on page 168, on the other hand, have been turned into a picture in the darkroom. The conditions cut one rider in half and the photographer did the rest. This would not suit the sports enthusiast but the photographer was more concerned with adding the personal comment.

It is the individual approach that makes photographs of commonplace activities more than commonplace pictures.

Photos by: Harald Mante (pp. 161 and 168), I. Janza (p. 162), Agfa-Gevaert (pp. 163 and 165), Miroslav Posepny (p. 164), Michael O'Cleary (pp. 166 and 167).

Rivalling the PF1 in popularity is the newer and smaller AG1 of the American capless variety. The smallest flashguns often take this bulb, also built-in units and the flashcube. It can be fitted into the PF1 capless socket with a special adaptor. It has a light output only a little less than that of the PF1 so it is a very versatile bulb indeed. The average jacket pocket can accommodate a few dozen without inconvenience.

FLASHBULB EQUIVALENTS

Philips PF range	American GEC and Westinghouse	American Sylvania
Super AG1B	AG1B	AG1B
PF1B	M2B	Bantam 8B
PF5B	No 5B, M5B	Press 25B, M25B
PF60	No. 22	Type 2
PF100	No. 50	Type 3
PF6B	No. 6B	FP26B

These are equivalents in performance and output but not necessarily in dimensions or cap fitting. *From Philips Lighting Catalogue.*

There are larger bulbs, from the PF5, with an output about three times greater than the PF1, to the PF100, giving about 13–14 times the light of the PF1. There are also special focal plane bulbs which burn at peak brilliance for longer than the ordinary bulb and can therefore be synchronized with the faster speeds of focal plane shutters.

Generally, however, the larger bulbs can be used only in special flashguns fitted with Edison screw contacts. In the Philips range, only the PF5 and one focal plane bulb, the PF6B, are capless.

Flash and colour temperature

The B after a flashbulb number indicates that its glass envelope is tinted blue to give the light a colour temperature of about 5,500 K. This makes it suitable for flash with daylight colour films (page 86). In fact, the smaller bulbs are now generally only available in the blue-tinted variety which is appropriate for all films, black-and-white or colour, transparency or negative.

Electronic flash is always a rather blue light. It is deliberately made that way to suit daylight colour films. The advantage of blue light, whether bulb or electronic, is that you can mix it with daylight. With colour film you must have only one type of light source. If you take

an indoor shot, for instance, and the shadows are too heavy, you cannot, as with black-and-white film, switch on a domestic lamp or a photoflood to boost the interior lighting. The daylight is bluish, while red and yellow predominate in artificial light. The result, on daylight film, would be a reasonably natural colouring of the parts of the subject lit through the windows but a red or yellow tinge or cast over those parts lit by the lamp. Blue flashbulbs and electronic flash overcome that problem. You *can* mix their light with daylight.

This is of service outdoors, too. You may find that direct sunlight casts rather heavy shadows, particularly in portraits. A weak flash can lighten those shadows.

Flash in daylight

This is sometimes called the synchro-sunlight technique and it is often made unnecessarily complicated. All it really means is that you want to employ the flash to lighten parts of the subject that would otherwise be rendered in almost unrelieved shadow. But in this case you still want them to be shadows, so you wouldn't give a full flash exposure as indicated by the guide number. What do you do? In practice, you simply double the guide number, which, as you know, is the same as rating your film four times faster. Your film gets rather less than a quarter of the light from the flash that it would get with a normal flash exposure. And you will find that about right in most circumstances. In fact, the film probably gets a good deal less than a quarter of the normal light from the flash owing to the absence of reflecting surfaces, but the effect is not so noticeable in daylight because no part of the subject is lit only by the flash.

Naturally, you have to combine this reduced flash exposure with the exposure required for the daylit parts of the subject. That is straightforward enough with the between-lens shutter that is M-synchronized for bulbs, or with electronic flash. You might find that your meter indicates 1/125 sec. at $f8$. Give that exposure and divide the doubled guide number by 8 to find your required flash distance.

If, however, your shutter or synchronization is such that you have to set a certain speed for flash shots, then calculate the daylight exposure at that shutter speed. With a focal plane shutter or an X-synchronized between-lens shutter, flashbulbs may be confined to 1/30 sec. This can be awkward, because fill-in flash is normally

required on account of bright sunlight and with today's films a shutter speed of 1/30 sec. in bright sunlight is often not possible. In the above case, however, where your meter indicated 1/125 sec. at $f8$, you recalculate to 1/30 sec. at $f16$. Then you proceed as before, but this time dividing the doubled guide number by 16.

Most difficulties with this type of fill-in flash arise with focal plane shutters. You can use their fast speeds for flash work only if you have focal plane bulbs, which are rather expensive. What this means in practice is that you cannot fall back on synchro-sunlight techniques with the focal plane shutter if your subject is moving. The 1/30 sec. exposure to the daylight will almost certainly produce blur in the moving subject.

There are exceptions. Some focal plane shutters can be set at faster speeds with both electronic flash and bulbs (many are now synchronized at 1/100 sec. for electronic flash). On others, ordinary bulbs connected to the F or FP socket will give reasonably even lighting for black-and-white work. Shutters differ considerably in this respect and you must consult your instruction manual or conduct tests for yourself.

Placing the flash at the required distance is another problem you might encounter. Sometimes this is inconvenient from a practical point of view. If you have a guide number of 80, for example, and your shooting aperture works out to $f11$, the flash distance would need to be 160/11, or about 15 ft. That could be awkward if you were taking a portrait from about 8 ft with the flash attached to the camera by its very short lead.

The most satisfactory answer is an extension lead, which you should have, anyway, because for most shots the flash is better positioned off the camera.

That does not apply so much to fill-in work and if you have no extension lead you have to find an alternative solution. What you want to do is to cut down the power of the flash. This you can easily do by draping a handkerchief over the flashgun. Roughly speaking, two thicknesses of a normal clean white handkerchief will just about halve the light output but, of course, you have to experiment with your own equipment. If you intend to do much of this type of work it would be worth making a diffuser especially for this purpose. You could use muslin, tracing paper or any similar material stretched over

a wire framework and shaped in such a way as to fit over your flash unit.

Your main consideration with this type of flash work is to retain a natural lighting effect. There is more danger of too much flash than too little. If the fill-in is insufficient, the shadows are rather too deep, but the shot is rarely ruined. If the fill-in is too strong, the effect is utterly unnatural. The shadows are raised almost to highlight status and the actual highlights are burnt out where the flash adds to the daylight exposure. By comparison, the background looks unnaturally dark.

Bounce and reflectors

One method of using flash indoors is to bounce its light from a reflecting surface. That provides a softer, more even illumination and eliminates the harsh shadows a direct flash might give. You can bounce the light from the ceiling, a wall, a specially prepared or improvised reflector or even from your own light-coloured clothing. The only point you need to remember is that the light then travels a greater distance—from flash unit to reflecting surface and then to the subject. You take that distance as your flash-to-subject distance to be divided into the guide number.

You may be told that you must allow for the light absorbed by the reflecting surface. That is rarely necessary. The softer lighting allows slightly less exposure and, in many cases, some direct light from the flash also reaches the subject to cancel out any losses.

You do have to be careful, however, with colour films. The reflector must be white or neutral-coloured. A reflector of strong colour changes the colour of the light reflected from it and so affects the colour rendering of the subject.

Bounced flash is very effective for female and child portraits and in all other cases where deep shadows would be inappropriate. The larger the reflecting surface, the more diffuse the light and the less obvious any texture or small irregularities in the subject.

It is a technique requiring a reasonably powerful flash. The low-power, pocketable electronic flashguns are quite unsuitable. A PF1 or similar bulb can be used if the reflector is reasonably close to the subject and an electronic flash of 60 watt-second power might be just strong enough.

A good bounce method is to place the reflector in front of the subject and direct the flash at it with its back to the subject. The reflector should be large and the flash close to it, or some light might shine straight into the lens. Special units are made for this purpose and the reflector is then usually in the form of a white umbrella. A large piece of white-painted hardboard would be equally effective.

Multiple flash exposures

If you work with two or more flash heads, you can thoroughly confuse yourself with complicated exposure calculations. Again, this is hardly ever necessary. If your second and/or third flash is well outside a 45 degree angle from a line drawn straight through the lens from back to front, you can disregard it. It is simply lightening the shadows, and adding very little to the general level of illumination. Base your exposure solely on the lamp or lamps within the 45 degree angle, and if one of those is much nearer than the other, on that one only.

If you have two lamps at equal distances within the 45 degree angle, use about 1½ times the guide number. Work on the principle that doubling the strength of the light is the same as doubling the speed of the film. That means multiplying the guide number by the square root of two.

Backlights, sidelights, background lights, etc. can be ignored. If your subject is totally back or sidelit, however, you have a problem that is outside the guide number system. You can only solve it by experiment or experience. It would be best to make several exposures based on about two-thirds of the guide number downwards. Much depends on the type of result you are seeking.

Using a reflector

Serious flash work is really only possible with more than one light, but you can occasionally make do with one light plus a reflector carefully placed to lighten the shadows. Experiment with an ordinary or photoflood lamp first, moving the reflector around until it appears to give the effect you require. You will probably get the best effect for an orthodox portrait, for example, with the flash within about 30–40 degrees of the lens axis and a foot or two higher than the subject's head. The reflector can then be placed close to the subject on the

opposite side to the lamp, at about waist or chest level and angled upwards.

Exposure is based purely on the flash guide number. Take no account of the reflector.

The reflector is still handy if you have two lamps because it can be used in the way just described while the other flash provides background or effect lighting. In colour, particularly, you are likely to require light on the background. It is no good choosing a delicately tinted backdrop to set off your subject's colouring only to find that exposure for the subject seriously underexposes the background and distorts its colour.

If you want the background to reproduce as you see it, you have to light it to the same strength as the main subject. That applies even in black-and-white but the only distortion then is in tone and you may well decide that a darker tone in the background is acceptable.

On the other hand, if you know your colour film's characteristics you can produce a pastel green or blue on a white background by deliberate underexposure.

Multiple flash with one unit

With static subjects you can make one flashgun do the work of two or more. As long as neither the subject nor the camera moves, you can light various parts of the scene with separate flashes. Take an interior for example. One flash cannot provide an even flood to illuminate the foreground, a distant wall and the ceiling. But you can leave the shutter open on the B or T setting (using a locking cable release if necessary) and direct your flash at each part of the scene in turn, firing it by the open-flash button. It's tricky and needs some practice. You have to keep out of the light yourself and the exposure is by no means easy to calculate because some light is bound to spill from one area into another. With black-and-white film you can probably use the guide number for a single flash but with colour, experiment around a guide number increased by about 15–30 per cent.

Don't try this technique if there are windows through which daylight is streaming. They will become heavily overexposed and so will any daylit parts of the scene.

You can use the single flash similarly to increase the power of your light. The little pocket electronic guns, for example, can be

flashed repeatedly at the same subject if their power is insufficient for the task in hand. Perhaps you have to flash from 8 ft and need an aperture of $f11$ to be sure of sufficient depth of field. You need a guide number of 88 but your unit's guide number is 45.

You know that doubling the guide number makes it suitable for a film four times as fast, so with that film, you need four times the exposure. You can give your subject four flashes.

Flash is a compromise

You should not resort to flash as a matter of course whenever the light is rather dim. It is difficult to make a flashlit subject look natural. If you are photographing a performer in a night club, for example, you might get a beautifully sharp, well-lit picture by means of flash but you will lose the typical atmosphere of the dimly lit scene, probably with smoke-laden air. (In such conditions you might even get a terrible result with flash, because smoke is a notable diffuser and scrambler of light.) It would be better to choose your moment carefully and perhaps sacrifice some quality by giving a longer exposure under the existing light.

Likewise, you do not automatically turn to the synchro-sunlight technique (see page 170) whenever you take an outdoor portrait and the sun is shining brightly. You can usually move your model into the shade, where you will find that the lighting is pleasantly soft.

It should hardly be necessary to mention that you do not use flash to photograph a stained glass window, or the television screen or the seafront fairy lights. You can, in fact, benefit from flash *in conjunction with* all these. You could arrange a weak flash, for example, to show children watching the television screen provided none of the light from the flash reaches the screen. You would have to find the right shutter speed, too. For British television, that is ideally 1/25 sec., although you can use longer speeds on static pictures. For colour television, daylight-type film is generally suitable, but on 50ASA film you are likely to need an aperture of $f2$ or greater.

The amateur should look upon flash as a compromise light source, to be brought in only when absolutely necessary. This is in line with the type of equipment he normally buys. If he can afford expensive professional or semi-professional flashguns, then he can try to emulate the professional and use flash for all his portraits, child

studies, some animals and in fact almost any reasonably active studio-like shots.

The flash unit with two or three heads and perhaps reflector and spotlight attachments has revolutionized this type of photography. Where the model at one time posed rather sedately and often life-lessly, she can now move rapidly from pose to pose and provide 20 or 36 pictures in little more than a minute or so. The quality of the lighting may not always satisfy the purist but the pictures undoubtedly gain in spontaneity and life. The model is flooded with light and the photographer can shoot rapidly with a hand-held camera from a variety of angles.

Don't try it with low-priced amateur equipment. Photofloods (see page 177) are cheap and window light (see page 184) cheaper still.

10: Lamps and Lighting

When you control your own lighting,
you have to know what you are doing.
One lamp is rarely enough.
You may need a fill-in, an effect light
and background illumination.
Then you must work out the exposure.

So many people come unstuck with artificial lighting that it is worth trying to pin down the reasons for their lack of success. The first, undoubtedly, is unsuitable equipment. And the first unsuitable item is often the lamp.

Choosing a light source

Don't be tempted, at their present stage of development, to buy the special tungsten-halogen lamps which have admitted advantages in their more refined form for colour cine work. Those available on the amateur market were at one time called Sun Guns, although that is actually an American trade name. These lamps are very expensive indeed and some of the early models were positively dangerous in the heat they generated. The light they give is often uneven. Despite the Sun Gun name, they give tungsten-type lighting unsuitable for daylight colour film.

The older photoflood lamp is much more reliable in the hands of an amateur but even then it is worth thinking twice about. Photographic studios need powerful lamps for a variety of reasons but photofloods get very hot. They are uncomfortable for the sitter and

they have to be handled with extreme caution. If you move a photo-flood around while it is hot you may shorten its already short life quite significantly. Moreover, the single photoflood gives a very harsh light. It is better arranged in banks with some diffusion and plenty of fill-in.

Alternatively ordinary domestic lamps of 150–200 watts can be used relatively close to the sitter with little discomfort. They have a long life and are not so susceptible to damage by movement. They are quite inexpensive and easily replaced at short notice. Nevertheless, photofloods have their advantages.

Photofloods are cheap

Photoflood lamps look like ordinary small domestic bulbs and they cost very little more. They are overrun, which means that their specially strengthened filaments run at a much higher temperature than those of ordinary bulbs. That has two results. The lamp burns brighter but it has a much shorter life. Whereas the ordinary domestic lamp is said to have a life of 1,000 hours in normal use, the No. 1 photoflood, rated at 275 watts but giving the equivalent of 700–800 watts in light output, has a life of only about 2–3 hours. The No. 2 photoflood, rated at 500 watts, gives the equivalent of about 1,500 watts and lasts for 5–6 hours.

Although the life of these lamps may appear short, it is quite long in terms of exposure—and, ideally, you should only switch them to full power for the actual exposure. You can do that by wiring them to a series-parallel switch (available from electrical equipment or domestic hardware suppliers) so that they can be run at low power for positioning and then switched to full power just before you release the shutter.

Reflectors and stands

Whatever kind of lamp you use, it is only part of the necessary equipment. The lamp must be housed in an efficient reflector and one at least should be on a telescopic stand extending to 7 ft or more.

This stand is absolutely essential. There are innumerable clip-on or free standing small units available which can be attached to chair backs, picture rails, etc. but they invariably impose unacceptable restrictions on indoor lighting set-ups. The result is that you place the

light as near as you can to where you would like to put it—and this is one case where near enough just is not good enough.

Main, or modelling light

If you have a stand, or preferably two, you can place your main light carefully to give a pleasant modelling to the face. This is somewhere within a 30–40 deg. angle from a line drawn from lens to subject, both sideways and upwards, so that the light comes from the natural direction of above the subject's head. It should not be so steeply angled upwards that it throws long shadows under nose and chin. The nose shadow should not generally cross the mouth.

If you now look at the subject through half-closed eyes you will realise that one side of the face is much darker than the other and the various small shadows are quite marked. This is not usually acceptable, so you have to lighten those shadows with a second lamp.

Fill-in light

The second lamp can be placed on or very near the camera-subject axis. From that position it throws light on to every visible part of the subject and therefore reduces the strength of every shadow.

It must not eliminate the shadows, or it will destroy the modelling. It must raise them just sufficiently to render as a mid-to-dark tone, according to the result required. A reasonable basis for experiment is to make this second or fill-in light one-quarter the strength of the main light. That you do simply by placing it twice as far from the subject as the main light (assuming lamps of the same power).

Use just two lamps in that way and you will get a quite passably lit portrait. Whether it is a good portrait depends on the pose, the expression and the photogenic or other qualities of the model, but it will be adequately lit.

For a more professional looking result you need another lamp and a spotlight—the lamp to light the background and the spot to put some life into the hair. A genuine spotlight is preferable but you can use a suitably shaded ordinary lamp.

Background lighting

The background light has to be hidden behind the model as a rule unless you have a powerful lamp that can be used at a sufficient

distance to prevent noticeably uneven illumination. That can suit some subjects, but not all. If the lamp is placed low down behind the model, it can shade off towards the top, which gives a pleasing effect.

The strength of the background lighting varies with the sitter. An orthodox approach is to put a light background behind a pre-dominantly dark subject—or a brunette—and a dark background behind a predominantly light subject—or a blonde. The subject then tends to stand out better from the background.

On the other hand, a dramatic male portrait mainly dark in tone—or low key, as it is often called—would look a bit odd against a light-toned background. Similarly, a blonde in white or a well-lit nude (possible high-key subjects) do not look their best on black backgrounds.

The background can have texture or pattern, either in itself or formed by placing something in front of the light. It should not, however, be obtrusive. A girl in a striped dress against a background of curtains with a large flower pattern might go down well with some but to the majority it would look shocking.

Effect lights

A spotlight directed on to the hair needs to be carefully focused and, perhaps, shaded to prevent light spilling over on to other parts of the subject. Various attachments can be clipped on to spotlights for this purpose.

The spot can also be directed from slightly behind the subject to provide rim-lighting, i.e. light creeping round from the back of the subject to form a more brightly lit edge visible from the front. That is a method frequently used to separate part of a low-key subject from its background.

Or you can use the spot to light the background itself and provide a spot-lit effect to the subject. Again, the effect must suit the subject, It might be suitable for a shot of a showgirl but it would look out of place in a child study.

The great advantage of the spotlight is that it can provide a concentrated beam to light a comparatively small part of the subject, but good spots of reasonable power are expensive. You can sometimes compromise by fitting a cardboard or black paper cone over a flood

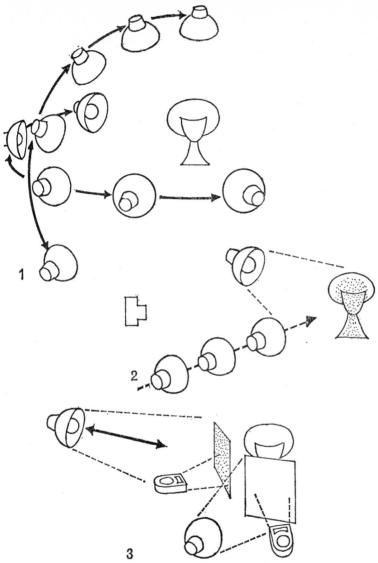

To experiment with lights, take a few shots with one lamp moved round the subject from front to back and then from below to above (1). The results show the effect of the key lamp position. Take more shots with a fill-in lamp at various distances (2). Important shadows should be no less than one quarter the strength of important highlights. Measure the balance (3) by taking readings from large white cards placed in shadow and highlight areas.

or you can angle and/or shade a flood so that only the edge of the beam catches the part of the subject you wish to accentuate.

Lighting technique

Good lighting is very much an acquired technique. It needs practice. You can learn a great deal by lighting a large ball or a dummy head, moving your lights around to find out just how their different positions alter the appearance of the subject.

Don't, however, switch on all the lights and move them haphazardly. One light does all the real work. That is the main or modelling light and you place it first. Then you place your fill-in to lighten the shadows to the required extent. Next comes any necessary effect light to raise the tone of an important feature, and finally the background lighting.

Using a reflector

A useful addition to the lighting can sometimes be provided by a reflector, which can be anything from a newspaper to a projection screen. A practical reflector is a large piece of hardboard painted matt white or silver. The effect of such a reflector can be quite startling. Placed fairly close to the subject on the opposite side to the main light it can lift the shadows considerably and may obviate the need for a fill-in light. A small mirror can sometimes be pressed into service to replace the spotlight by catching some of the main light and redirecting it as required.

Again, practical experiment is the only sure tutor. Make yourself a reflector—the larger the better—and try its effect with various lighting arrangements.

Guide numbers for photofloods

Exposure with lamps is relatively simple. In most cases you base it on one light only—the main or modelling light. The others have a significant effect only on the contrast of the subject—the depth of the shadows. The proportion by which they raise general illumination is very slight.

The easiest method of calculating exposure is by guide numbers. It is rather strange that the guide number system is so well known for

flash yet is rarely considered for other lamps. The main reason, presumably, is that the orthodox lamp is a continuous light source and therefore the guide number changes with every change of shutter speed as well as film speed.

That is no great problem, however. The No. 1 Photoflood for example has a guide number of about 56 for a 100 ASA film at a shutter speed of $\frac{1}{4}$ sec. You can easily calculate other exposures from that. If your lamp is at 10 ft under those conditions, you can use an aperture of $f5.6$. If you want to give a shorter exposure, say 1/15 sec., the calculation is equally simple. Cutting the exposure time to 1/4 calls for a light four times as powerful to maintain the same exposure and you know from the inverse square law (page 130) that you get four times the light if you halve the f-number or halve the distance of the lamp. So you either open up the lens to $f2.8$ or move the lamp to 5 ft.

PHOTOFLOOD GUIDE NUMBERS
(for shutter speed at $\frac{1}{4}$ second)

Lamp	Film speed (ASA)						
	25–32	40–50	64–80	100–125	160–200	250–300	400–500
No. 1	28	35	44	56	70	88	110
No. 2	50	64	82	102	128	165	204

Base exposure on the nearest main, or modelling lamp. For two lamps used at the same distance, increase guide number by 40 per cent. *From Philips Lighting Catalogue.*

This is the same as using a different guide number, of course. At 5 ft and $f5.6$ or at 10 ft and $f2.8$, your guide number is 28, which is what you would expect. The guide number is halved when you reduce your shutter speed to one quarter. On the inverse square law principle, it is divided by 1.4 when you halve the shutter speed. So the guide number of 56 at $\frac{1}{4}$ sec. becomes 40 at a shutter speed of 1/8 sec.

In practice, you only need to know one guide number for one shutter speed with the film you use. Other exposures can be calculated from that without difficulty.

As an example, take a lighting set up of one No. 1 photoflood as a main light at the orthodox 30–40 deg. angle, 6 ft from the subject. The fill-in light is another No. 1 photoflood at 12 ft from the subject just above the camera. A spot highlights the hair and a third photoflood lights the background.

You are using a 64 ASA film which gives you a guide number of 44 for a shutter speed of $\frac{1}{4}$ sec.

The spot and background lights have no effect on the general illumination. So all you have to do is to divide the guide number (44) by the distance of the main light from the subject (6). The aperture required is $f7.3$, which is near enough to $f8$ to make no difference.

Fill-in and exposure

You may be tempted to believe that the fill-in light at 12 ft adds to the general illumination. But consider the facts. If the fill-in light were in the same position as the main light, it would double the strength of the light. You would have to multiply the guide number by 1.4. In fact, the fill-in lamp is twice as far away and is therefore adding only 25 per cent to the general light level. In terms of the inverse square law again, this means that the guide number should be increased by $\sqrt{5/4}$ or 1.12. If you multiply 44 by 1.12 you get 49.28. Then go back and make your original calculation by dividing 49.28 by 6 and you still arrive at $f8$ for all practical purposes.

Moreover, the fill-in light does not illuminate exactly the same parts of the subject as the main light. It has its greatest effect on the shadows and it would be rather pointless to put more light into the shadows and then reduce the exposure.

The only time when you need take any account of the fill-in lamp for exposure purposes is when you are lighting your subject very flatly, perhaps for colour. Even then, the maximum effect can only be one stop less exposure because that would mean that the fill-in lamp was at the same distance as the main lamp. It is then no longer a fill-in lamp. The maximum in practice is likely to be no more than 1/3 stop down and that takes some calculating. You could, perhaps, give half a stop less and keep the developing time on the full side. In colour, the fractional underexposure could be beneficial rather than otherwise, but only give that half stop less when your fill-in light is really strong.

Available light

Artificial light photography does not consist entirely of work with floods and spots. You can also work by the existing light in domestic or other surroundings or by daylight augmented by artificial light.

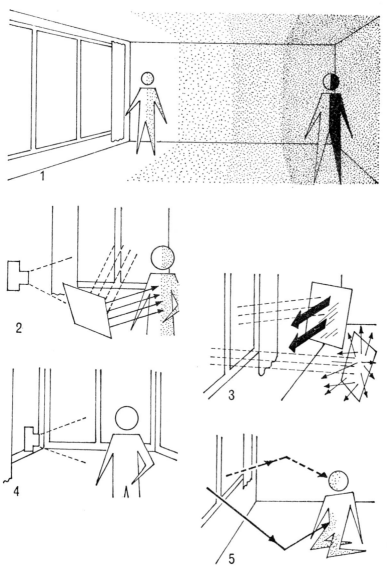

Daylight through a window diminishes in strength with increasing distance (1).
A reflecting surface (2) can be used to lighten some of the shadows it casts. A
shiny reflector (3) gives a directional light suitable as an effect light. A matt
surface is more suitable as a fill-in. A bay window (4) gives adequate lighting
without a reflector if the subject is placed within the bay. Reflected light can be
tricky with colour materials (5). It might throw unnatural colour casts.

The formal portrait with carefully arranged lighting is, in fact, tending to become confined to the exhibition worker and the rather old-fashioned portrait studio. The modern tendency is to portray people in more or less normal surroundings. Exposure here does indeed become tricky because the lighting is usually rather contrasty owing to the lack of carefully arranged fill-in lamps. You tend to get a few highlights and large areas of shadow. Room lighting for example, usually comes from above and is relatively close to the subject. The face may be lit to a reasonable level while the lower part of the body sinks into near darkness because the light falls off rapidly with increasing distance.

You can improve matters with carefully placed fill-in lights or reflectors. The reflector can even appear in the picture. A picture of a child drawing, for instance, can come out quite well with just one overhead lamp if he is positioned so that the light is thrown up into his face by reflection from his drawing surface. Alternatively, a large reflector can be placed just out of the picture area to serve the same purpose and perhaps to light the rest of the body as well.

If you use a lamp as fill-in, be careful to keep its strength down. You don't want it to form the main light. Its function is to lighten the shadows but not to destroy the character of the natural lighting. Nevertheless, it may need to be rather stronger compared with the strength of the main light than for orthodox portraiture—because you are aiming to raise the general level of illumination. Available light subjects in colour should be taken on artificial light film and even the normal lamps should preferably be replaced by photofloods. Domestic lamps give a rather more yellow light than photofloods and indoor pictures in domestic lighting may look too yellow or orange in colour.

If the existing light is daylight through a window, you can use lamps to provide the fill-in only on black-and-white film. Colour film responds differently to the two types of light (page 86). Again, with lamps take care that they do not overpower the daylight.

Exposure principles are a little different from those for more orthodox work. This time, the whole face is quite often in shadow and the fill-in brings it up to a more acceptable lighting level. Moreover, you may be using the fill-in almost as a main light for parts of the subject that are in really deep shadow. Exposure is generally based on a direct reflected light reading of the subject's face.

Reciprocity failure

Should your exposure become rather long because of low light conditions, you may run into failure of the reciprocity law. This law says, in effect, that light falling on the film exposes it to the same degree when the product of time (shutter speed) and intensity (aperture) are the same. In practice, the law fails when the time is unduly long or short. You might find from a meter reading, for example, that the exposure required is about $\frac{1}{2}$ sec. at $f2$. You want to use $f11$. The straight conversion is $\frac{1}{2}$ sec. at $f2 = 16$ sec. at $f11$. The odds are, however, that with such a long exposure, you would get reciprocity troubles and your actual exposure might need to be 30 sec. or more.

Do not worry unduly about these matters, however. If you ever have to give an exposure in the region of 16 seconds (or even 2 seconds) you would be foolish in the extreme just to make one exposure and hope for the best. Make several of widely varying duration and choose the result that more nearly meets your requirements.

11: Watch Your Colours

Colour can be riotous or subdued. It can clash
or it can harmonize.
It can convey or destroy a mood.
Its reproduction can be false—but who knows if it is true?

The average person takes colour for granted. Snow is white, grass is green, London buses are red and they never change. In fact, they change quite a lot.

Colour is reflected light

The colour of an object depends very much on the colour content of the light shining on it. This is very obvious in streets using sodium lighting, where the colours of cars, street furniture, buildings etc. are virtually indistinguishable. That is because sodium lighting is almost monochromatic.

Daylight contains light of all colours in the visible spectrum and can therefore create an enormous range of colours in objects capable of reflecting them. The colour content of daylight varies, however, and an object in the early morning light is significantly different in colour from the same object lit by the midday sun. There is proportionately more red and yellow in morning and evening light and more blue in midday light. On the other hand, an overcast sky, even in morning and evening, can subdue the red and emphasize the blue.

Most people do not notice these changes. Their white car, for

instance, is always white to them. If, in a photograph, it shows a tinge of pink or blue, they think there is something wrong with the film.

The brain rules the eye
In fact, the film shows the true picture. The human eye is not so discerning. The impression it obtains is corrected by the brain, which knows that the car is white and refuses to accept any indication that it is not.

Suppose, however, that it were somebody else's car and that it were lit only by sodium lighting. The brain would have to accept the evidence of the eye, which would not be able to tell whether the car was white, cream or almost any other light tone.

Similarly, the brain rejects any suggestion that an object of a single colour can, in fact, show two colours, unless the effect is very obvious. If, for example, you shine strongly coloured lights on to a white object, the brain is quite happy to accept that those colours are reflected and visible, because it can see the reason for them. If, however, you set up a portrait indoors using window lighting and a photoflood to lighten the shadows, your brain will ignore the pronounced difference in colour between the daylit and artificially lit parts.

The colour film cannot do this. It records the fact that the daylight has a higher blue content than the tungsten lamp. If it is a daylight-type film, it will show reasonably natural colour on the window-lit side of the subject but a distinctly reddish or yellowish overtone on the lamp-lit side.

That is why you cannot mix dissimilar light sources in the same picture.

The question of true colour
The point of all this is to emphasize that there is no such thing as true colour unless all comparisons are made in exactly the same lighting conditions. Even then we cannot be sure that the majority of people see colours in exactly the same way. We know that many people have some degree of colour blindness but it is possible that even more see slight variations that others do not. Yet again, some people are more aware of colour than others. Probably most people would, without

being able to make a direct comparison, accept a colour reproduction as accurate, even though it showed quite distinct variations from the original. Others would spot the variation immediately. They have a better colour memory.

For most people, therefore, there is very little to choose between the various reputable colour films available. Each has its own particular characteristics (see page 85) and the film most suited to your requirements is not the one that somebody tells you gives the most accurate colour rendering but the one that provides the results you like.

Nature is drab

When you come to using the film, you will probably be surprised at the lack of colour around you. Most landscapes, for example, consist largely of greens and browns with very little strong colour. City scenes are often even more drab. You usually have to make a conscious effort to introduce some bright hues into these scenes.

It takes time to learn that the subdued colour is natural and that too much vivid colour in a picture can be disastrous. The best colour pictures are often fairly subdued in the background with one or two pronounced colours making up the main subject. Or, as in landscapes, they may be generally restful throughout with a small splash of more vivid colour to break the monotony.

Behaviour of colour

You have to avoid a clash of colours. This simply follows normal practice in dress, furnishing, etc. but it is surprising how many people ignore it in colour photographs. The colour should follow the mood of the picture. A dreamy glamour portrait of a pale-skinned ethereal blonde would look a little odd if she were swathed in a purple spotted dress against a scarlet background. Brilliant, contrasty colours are quite suitable where the mood is one of life and gaiety but are out of place if the effect is supposed to be restful and soothing.

Colours have another quality that is particularly apparent in colour slides. Those at the red end of the spectrum look nearer to you than those at the blue end. A blue spot appears to sink into a red background, while a red spot stands out from a blue background. (This is particularly noticeable when colour transparencies are

The sun varies in direction (1). Early or late (a) it gives strong sidelighting and long shadows. In mid-morning or mid-afternoon (b) it approaches the ideal. At midday (c) shadows are unpleasantly short and deep. Sunlight varies in strength and colour (2). It is weaker and yellower towards the beginning and end of the day. It varies with weather conditions (3). In a clear sky, it gives hard, brilliant lighting. With cloud about, the effect is softer and more pleasing.

191

examined in hand viewers. The simple magnifying lens exaggerates the effect considerably.) Thus, bluish backgrounds tend to add depth to a picture and the tendency is increased if the subject has large areas of red or orange. Backgrounds predominantly red, on the other hand, tend to crowd in behind the subject.

Strong backgrounds attract interest away from the subject and subdue its own colours. There is also the danger that they will throw coloured reflections on to the subject.

Exposure is not so different

Exposure for colour is more critical than for black-and-white. Very thin or very dense black-and-white negatives can, with skill, be printed to provide a reasonable image. The badly overexposed colour slide, however, reduces the colour saturation and presents it so that it appears far less vividly than in life. The underexposed colour slide can be so dense that the image is hardly visible. Even if strong light is directed through it, a distortion of the colour rendering, particularly in reds, is most noticeable and the picture looks grainy.

Nevertheless, exposure is not so critical that it need deter you from using colour. Most automatic cameras will give very satisfactory results indeed unless the lighting is very unusual. Rule of thumb methods and exposure tables based on film speed are equally successful for the majority of subjects. With an exposure meter, the straightforward reflected light reading gives an accurate enough result in all ordinary conditions.

Generally, slight underexposure is to be preferred to overexposure, but that really depends on the subject. Underexposure gives brighter colours and can sometimes be used deliberately for that purpose in dull lighting. Overexposure within reason has comparatively little effect on bright deep colours but reduces the paler shades to pastels. This, too, can be effective if deliberately controlled. Bright red, orange, yellow, etc., remain prominent while flesh tones, sea and sky, light-toned clothing and draperies, etc. become misty, indeterminate and almost colourless.

Brightness and contrast

Contrast is one of the greatest problems in colour exposure. While the colour transparency can handle tremendous brightness differences

COLOUR AND MOOD

Colour adds a dimension to photography that is incalculable in its effect. To those who know the English scene, the picture above could be as effective in black-and-white. For others, the colour makes the picture.

In less traditional subjects, such as the bottles on page 195, or the tourists on page 196, the accuracy of the colour is of no importance. Nor is it in the 'mood' picture on page 198 of a remote landing stage. The photographer has manipulated the colour for his own purposes.

He can even create his own colours. The pattern on page 199 was formed by reflections from a red boat but the blue has been considerably strengthened in the process of making the colour print. The racing car print on page 200 derives from tonally separated black-and-white negatives successively printed on to colour paper.

(*continued on p. 196*)

(*continued from p. 193*)

Lighting plays an important part. The isolated bloom on page 194 stands out from a totally unlit background. The delicate rendering of a young girl's face and hair on page 197 called for an all-over flood of light admirably provided by a powerful flash and umbrella reflector.

The essence of all these pictures is a restraint in the use of colour and careful matching of colour to mood and subject. It is not only clashes of colour that should be avoided but clashes of colour and mood.

Photos by: Kenneth Scowen (p.193), I. Janza (pp.194 and 195), Klaus Kempin (pp.196, 198, 199 and 200), Leslie Turtle (p.197).

and still show detail in both highlights and shadows, it cannot render colours truly at both ends of the range. It shows the effects of either under- or over-exposure or, in extreme cases, of both. Highlights might lose nearly all their colour while colours in the shadow areas could be considerably degraded and distorted. This effect is much more pronounced in colour prints.

The only satisfactory solution is to avoid such contrast as far as possible. Where this is not possible you have to choose the most important part of the picture. If it is in the highlight area, give a relatively short exposure based on a lighter mid-tone so that highlights and mid-tones are correctly rendered and the shadows are left to go, perhaps, totally black.

If you are more interested in the detail in the shadow areas, the exposure has to be based on a darker mid-tone or even on a direct reading of the shadows themselves, allowing the highlights to lose colour and perhaps detail as well. You may, in fact, find that, given adequate exposure, the colour film produced more colour in the shadow areas than you knew was there. The eye is not very efficient at distinguishing colour in low-light conditions.

People in colour

A portrait, by which we mean a picture intended to be a likeness of the subject, must always be given an exposure as if for an average scene, i.e. a reading from a mid-tone or a standard grey card. Any other exposure is liable to distort the flesh colouring and destroy the likeness.

This does not necessarily hold for all pictures containing people. The fashion shot, for example, designed perhaps for the mail order catalogue, must be exposed (possibly to filtered light) to render colour, detail, tone, shape, etc. of the clothing. This could, and frequently does, produce marked distortion of flesh tones and even hair colouring, but these are unimportant.

Lighting

All colour exposures are, after all, a compromise. If there is truly, as is so often stated, only half a stop latitude for correct exposure, the brightness range of the subject should never exceed 2:1. This is virtually impossible, but it highlights the fact that the lighting ratio

should be kept as low as possible. A 4:1 ratio is often quoted, meaning that the main light should be no more than four times the strength of the fill-in. This is actually about the limit for a well-lit colour picture and a ratio of 2:1 is preferable.

Unlike black-and-white, the colour picture can even use completely flat lighting. Tone difference is taken care of by colour difference and even modelling is to some extent provided by subtle colour variations. Flat, or almost flat, lighting is, in fact, the only type that can guarantee reasonable accuracy in colour rendering in all parts of the picture. The results of this approach are far from dramatic and it is usually confined to publicity or catalogue-type illustrations.

Experimental colour

All we have said so far relates to orthodox photography. We hope all your photography—particularly colour photography—will not be orthodox. There is infinite room for experiment. It is still a sufficiently young aspect of photography to offer the challenge of breaking new ground. Results are not easily predictable without a great deal of experience, both in using and processing colour materials.

The possibilities are many. Colour materials can be exposed to monochromatic or nearly monochromatic lighting. Colours can be intentionally distorted.

Colour films can be solarized—and the colour of the fogging light affects the colour and extent of the result, owing to the three-layer structure and the fact that the fogging comes before the colour development.

One colour can be taken out of the film by using two coloured lights for the re-exposure instead of white light.

You can work out your own variations but, if you want to be able to repeat any effect you achieve, you must make copious notes as you go along. Even then, exact repetition is unlikely without very careful control of voltages, solution temperatures and make-up, etc. Slight variations in the film's colour sensitivity from batch to batch can also drastically affect results. And the results you get on one type of film are unlikely to be exactly repeatable on another.

12: What Filters Can Do

Filters are rarely necessary with modern films.
Before you buy one,
make sure you know exactly what you want it to do
and whether, in fact, it can do that.
It can often do more harm than good.

A photographic filter is a sheet of gelatine or glass or a glass-gelatine sandwich. Except for the UV filter and the polarizing screen (see pages 206–208), it is coloured to a greater or lesser degree to alter the colour composition of the light falling on the film. For use on the camera the filter is cut in the form of a disc and is attached to the front of the lens in a filter mount of suitable size. In that position, any glass used in the construction of the filter needs to be of high optical quality and must be kept clean and free from stratches. Gelatine is rarely used alone on the camera because it is easily damaged. It is usually sandwiched between glass discs to provide top quality, rather expensive filters. Low-cost filters are made from dyed-in-the-mass glass.

The usual colours of filters for black-and-white photography are yellow, green, orange, red and blue. They come in various strengths of colour, so you can choose between a light, medium or deep yellow, etc. The deeper the colour, the more light the filter absorbs.

The exact result of using a filter can rarely be predicted but the general effect is that it freely passes light of its own colour but absorbs, to varying degrees, light of other colours. White light can be

produced from red, green and blue light. A filter absorbs the other components of white light. Thus, red absorbs green and blue, blue absorbs green and red, and green absorbs blue and red.

What the filter does

The job of a filter is to modify the tones or colours of the image as transmitted to the film. This might be because the film cannot provide a natural result but, more often, it is because the photographer wishes to alter the relationship between the tones of the subject.

With black-and-white film, colour filters can alter the tonal rendering of coloured objects so that they will achieve a satisfactory separation in the black-and-white reproduction. It could be, for example, that a red and a green object are of such similar tone that in a black-and-white reproduction, they appear virtually identical. If you require one of the objects to stand out against the other, then you must use a filter. In the case of red on green, either a red filter would be needed to restrain the green and emphasize the red or a green filter for the opposite effect.

If, for example, you use a red filter to photograph a red rose against its green foliage, then the rose will appear very light in tone and the foliage quite dark. This is a falsification of tone values but it may provide the result you require.

There are drawbacks

You have to be careful, however, when using filters in this way. They may not always react predictably. The filters themselves, for instance, are not of pure colours. The colours in nature, likewise, are rarely pure. Either the red rose or the green foliage could contain some blue or yellow. If the rose is a bluish red and the foliage a yellowish green, the effect of the red filter may be much less marked.

Take another example. When photographing a building against a blue sky, you may decide to create a dramatic effect by using an orange or red filter. This will indeed darken the sky and perhaps give a pleasing result but if the building is of brick construction, the filter will probably lighten its tone considerably and that may not be acceptable. You must always consider the outcome of filtering, not only how it will influence the colour you intend to alter but also the other colours in the picture.

Another aspect of filters must constantly be borne in mind. The filter is invariably placed in front of the lens. However good it is, it must, in this position alter the performance of the lens. Filters do, in fact, vary considerably in optical quality. Most filters purchased by the amateur are dyed-in-the-mass glass. The glass is of reasonable quality but it is not optically perfect. The effect of this is usually neglible but it can be enough to reduce the crispness expected of your lens. The commonly used yellow filter, moreover, invariably flattens the contrast of landscape scenes. It modifies to a greater or lesser degree most tonal values in the picture and tends to level them out. Some photographers try to compensate for this by varying their exposures, but all that does is to reduce the characteristic of the filter, so it would have been better to avoid using it in the first place.

Exposure adjustment

You do have to adjust your exposure when you use a filter but it is important not to overdo the adjustment. Any coloured filter absorbs some of the light that would otherwise reach the film, so you cannot give the normal exposure recommended by charts or exposure meter readings. For that reason all coloured filters have a filter factor, i.e. a figure which indicates the extent to which the exposure has to be adjusted. The figure is simply a multiplication factor, indicating that the normal exposure has to be multiplied by that figure. The filter factor of 2, for example, means that the exposure has to be doubled. It does not mean that you have to give two stops extra exposure. Filters are thus designated as $2\times$ yellow, $3\times$ orange, etc.

Unfortunately, the precision of the filter factor tends to be pushed to ridiculous limits. For example, you may be given a factor of 1.2 or 1.6. It is rather difficult to work out how, with the average camera, a filter factor of 1.2 can be used at all or why 1.6 cannot be quoted as $1\frac{1}{2}$. For critical professional colour work, such precision may be necessary. For ordinary black-and-white work it is pointless, especially when you consider that different emulsions vary slightly in colour sensitivity. If you wished to pursue this argument to the logical ideal you should also take into account the colour temperature (see page 86) of the light source.

On a few cameras with built-in exposure meters, the "window" of the light-sensitive cell encircles the lens, and filters are designed to fit

over it. This means that the meter measures the light through the filter and thus gives the correct exposure, allowing you to disregard the filter factor. The same applies to meters taking readings through the lens of the single lens reflex.

This works well enough in practice although it can lead to un-expected results because exposure meter cells and photographic emulsions have different colour responses. It is not, in fact, recom-mended practice to take meter readings through filters. Cameras with meters on the front of the lens designed to read through filters when they are attached, tend to compromise in this respect.

Colour filters for black-and-white photography cannot be used in colour photography—unless you are seeking special, almost mono-chromatic effects. They are so strongly dyed that they impose a cast of their own colour over the whole film. The only strongly coloured filter generally used with colour film is the blue conversion filter designed to make daylight film suitable for use in artificial light, which conversion as we saw (page 87) is not recommended.

Ultra-violet filter

Popular filters for use with colour film are either colourless or faintly tinted. The colourless filter is the now quite well-known but some-what overrated UV type—more correctly called an ultra-violet absorbing type.

Ultra violet radiation (we should not call it light because it is not visible) is present to some extent in all daylight. It is, however, easily absorbed by the earth's atmosphere and by any glass. That is why you cannot acquire much of a tan from the sunlight streaming through your window. It is the ultra-violet that does much of the tanning.

Thus, by the time it has passed through the atmosphere and your camera lens, UV radiation is so weak that it has little effect on the film. But it can be strong enough to cause unsharp images, because the lens is not corrected for near UV rays, or in the case of colour film, to impose a blue cast over the whole subject. This effect is common when shooting at high altitudes or near large stretches of water where the atmosphere is usually clearer and does not impede UV radiation.

In these circumstances, a UV filter may be advisable—but it is not essential. Wherever possible make several trial exposures first. Some

lenses have a quite sufficient warming effect on colours without out-side assistance. Moreover mountain shots and seascapes are expected to contain a certain bluish quality, especially in the distance. This will appear natural to most people.

The UV filter is colourless and has no filter factor. The radiation it absorbs is not measured by the exposure meter and is not allowed for in exposure tables. In fact, if it gets through your lens in significant quantities it causes overexposure.

Some UV filters are, however, slightly tinted with salmon pink or straw yellow. To that extent, they act as ordinary coloured filters and act on visible blue light as well as UV radiation. They are sometimes known as haze or skylight filters and can be used whenever the day-light is of a bluish or "colder" quality and some "warming-up" of the colour may be considered desirable.

Morning and evening filter

The opposite effect can be obtained with a slightly blue-tinted filter. This is for use whenever the light appears rather red. It is often called a morning-and-evening filter because it is sometimes used by cine workers who are forced by circumstances to shoot early or late in the day, scenes which are supposed to be taking place in normal light.

This filter absorbs some of the excess red light and restores the lighting balance to something approaching midday conditions. This is rarely necessary for the still photographer. If he is taking photographs in early morning or late evening, he generally wants the results to look appropriate to those times. It would be senseless to use such a filter, for example, on a sunset or sunrise. It might, in fact, be more sensible to use the opposite filter—the pink one—to exaggerate the red of the rising or setting sun.

The blue filter could be justified, however, if you had to take a portrait or fashion shot in such conditions and wanted a normal rendering of flesh tones or fabric colours.

Colour-compensating types

Innumerable other filters of varying strengths can be used with colour film but very rarely are, except by professional photographers who are concerned with the really accurate rendering of particular

colours. These are colour-compensating filters which can be used to give almost any effect required. For ordinary photography, however, you would be well advised to use no filter at all with colour film unless you find, in given circumstances, that there is a definite distortion of colour or can reasonably anticipate that such distortion will occur. Only experience can tell you when a filter is necessary.

Polarizing screen

There is another special type of filter known as the polarising filter or screen. This has various uses. With black-and-white or colour film, it can, in some circumstances, cut out reflections from shiny surfaces and it can also be used to darken the tone or colour of a blue sky.

When light strikes a surface, it is reflected. From most surfaces, the reflected light shoots out in all directions and is known as random light. Some shiny surfaces, however, such as glass, water, paper, some paints, polishes, etc. emit reflections in one direction or plane only. Light moving in one plane only like this is known as polarized light and, when it takes the form of reflections from objects to be photographed, it can cause annoying flare effects, either completely obliterating detail or reducing contrast.

Certain crystals are able to polarize light and, by placing a screen made from such crystals over a light source it is possible to produce a polarized light beam. This screen acts like a sort of slotted filter, permitting only light moving in one plane to pass through it. Light moving in planes at an angle to the plane of the light passed is progressively impeded until, at right angles to the "slots", the light is completely obliterated.

Conversely, such a screen placed over a camera lens can, if positioned so that its slots are at right angles to polarized reflections, completely eliminate them, while allowing most of the ordinary, unpolarized image-forming light to pass freely.

Unfortunately, however, reflections of this nature are only perfectly polarized when the light from the reflected object strikes the reflecting surface at an angle of about 57 degrees from the normal (or perpendicular). It is only in these circumstances, therefore, that reflections can be completely eliminated. When the incident light strikes the reflecting surface at any other angle, the reflections are only partly polarized and can be only partly absorbed.

Thus, the polarizing screen can have little or no effect in a head-on shot, when the plane of the subject and the film plane are parallel, because the light from reflected objects is then striking the reflecting surface at 90 degrees. You have to move the camera round to between 30 and 40 degrees to the plane of the subject. There, you pick up different reflections, of course, but they are reflections that the polarizing screen can at least partially eliminate.

The effect of the polarizing screen on skylight is explained by the fact that light is reflected in the normal atmosphere from particles of dust, etc. This produces a light-scattering effect in which at least some of the reflections are partially polarized. The polarizing screen can cut out some of these reflections and thus, in effect, give the sky selectively less exposure than other parts of the picture. Thus, the polarizing filter can deepen the blue of the sky or, in black-and-white work, darken the tone of the sky area. Again, however, the polarizing screen can only be used to best advantage in this way at certain angles. Only when you shoot at right angles to the line of the sun is any marked difference apparent.

Polarized light can be an advantage in more advanced systems of photography, when the subject illumination is deliberately polarized by the introduction of a polarizing screen between light source and subject. Various interesting effects are then made possible by using another polarizing screen over the camera lens. This, however, goes into the realms of scientific photography and is really rather beyond the scope of this book. For the average amateur, the uses of the polarizing screen are so limited as to make the expense of its purchase hardly worth while.

The polarizing screen is usually tinted with a greenish grey colour that has no effect on colour rendering. As it absorbs rather a lot of light, however, it has a factor in the region of 4 to 6, depending on how it is used. The factor varies according to the subject and the distribution of random and polarized light and it is advisable to bracket exposures.

Polarizing screens suitable for use over the camera lens are extremely expensive—much more so than ordinary coloured filters—and their purchase should not be considered without a full understanding of what they can and cannot do.

Think before you buy

It is a wise rule to avoid the use of filters entirely except for experimental purposes and for occasions when you know exactly what you expect the filter to do. Modern films, both black-and-white and colour, can cope adequately with all normal subjects without the help of any filter whatever. It is only on very rare occasions that a filter is required for any corrective purpose. If you find that you can never get your skies to print properly, then consider first the possibility that you may be a little too generous with your exposure.

Filters may be necessary for specialized tasks, such as the black-and-white copying of faded or stained documents or photographs, the photography of stamps, watermarks and perhaps drawings, sketches or printed matter on coloured paper.

The document that has faded to a yellowish colour, for example, can sometimes be copied successfully through a yellow filter, but not if the writing, too, has faded to a similar colour. Stains may be made less noticeable or even be completely eliminated by copying through a strong filter of the same colour as the stain. Again, the effect on other parts of the picture may make a compromise necessary.

Where a stamp has a franking of interest which is partially obscured by the deeper colour of the stamp, a filter of the same colour as the stamp will usually bring out the franking clearly. But if it is a blue stamp and the envelope is yellow, the envelope might reproduce too dark to show up the franking when you shoot through a blue filter. In most such cases, a reasonable impression of the result of shooting through a filter can be obtained by looking at the subject through the filter to be used.

These examples show how the filter can falsify the actual tones of the subject and, in fact, the filter should always be thought of as a distorting agent. Its genuinely corrective uses are rare.

13: Close up and Closer

Close-up work has its own techniques and problems.
There are plenty of theories.
but practical experience is the best guide.
You can try it with any camera.

There is a limit to how close any lens can focus. The ultimate limitation is the actual measure of the focal length. When a lens is set to its infinity focusing position, rays of light entering it are more or less parallel and are bent by the lens to come to a focus in a plane one focal length behind the lens. The reverse also applies. When an object is one focal length in front of the lens, rays of light emanating from it diverge sharply to be collected by the lens and are then transmitted from the back of the lens as parallel rays. These parallel rays cannot come to a focus and therefore cannot form an image. Thus, any lens can form an image only of objects that are more than one focal length in front of it.

Normal focusing

In practice, the limitation is far greater. Focusing a camera lens consists of moving it towards or away from the film lying in the focal plane. The further forward you move the lens, the closer it focuses. To focus very close you have to move the lens quite a long way and the greater the focal length, the greater the focusing movement. That is difficult to arrange on modern cameras, in which the lens is usually

an integral, even if removable, part of the camera itself. Thus, the closest focusing range of the unaided camera lens rarely approaches the real close-up.

In most popular cameras, the focusing movement is built into the lens so that the whole lens moves along a tube to vary its distance from the film plane. It is impracticable to make this movement even as much as one focal length and it is usually a great deal less. To use such a camera for close up work, extra extension has to be interposed between the lens and the camera body.

Extension tubes and bellows

There are two methods of providing this extra extension: rigid tubes and extendible bellows. Extension tubes are simply metal tubes made so that one end fits into the camera body and the other accepts the lens. They are available in many sizes to fit various cameras and give a range of fixed close-up focusing distances.

Extension bellows are rather more versatile. They can be attached to the camera body and accept the lens in the same way as tubes but they provide infinite adjustment of the focused distance within the range prescribed by the size of the bellows.

Naturally, when tubes or bellows are attached, the camera can be used only at close range. The lens is separated from the camera by its focal length plus the length of the bellows or tube, which is frequently more than the normal focusing travel of the lens.

Extension bellows or tubes are easy to use on any camera that has a focusing screen presenting the picture as seen by the taking lens. On others, such as the rangefinder models, there are problems. The rangefinder, for example, becomes inoperative and the focused distance has to be calculated and measured. In practice, bellows are rarely used on such cameras. Extension tubes are made to precise measurements so that their effect on the focused distance can be stated. The object is then placed at that distance, as measured, and centred in the field by measurement or calculation.

What about fixed lenses?

So far, we have dealt with close-focusing methods which entail moving the lens in relation to the focal plane. If, however, your lens is permanently fixed to the camera, you cannot use these methods.

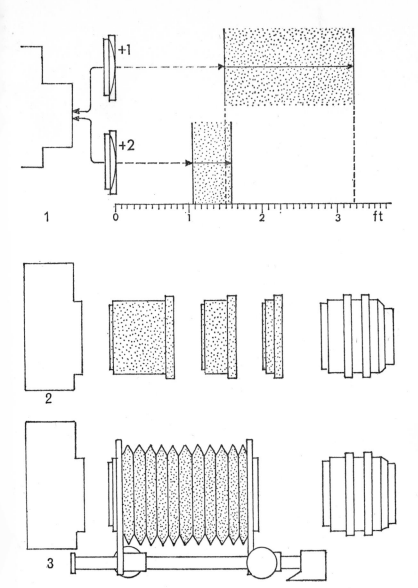

Close-up equipment for fixed-lens cameras is confined to supplementary lenses (1). These focus at their own focal length with the camera lens set to infinity and over a limited closer range by means of the camera lens focusing mechanism. If the camera lens is removable, extension tubes (2) or bellows (3) can be used to increase lens-film separation and thus allow the camera lens to focus closer objects.

There is, fortunately, an alternative. When set to infinity your lens is one focal length from the focal plane. As you focus on nearer subjects, you move it further away from the focal plane. You may find that when you reach a focused distance of about 3 ft, you can move the lens no further. With a 2-in. lens, the lens is then about 2⅛ in. away from the focal plane.

Suppose, however, that your lens were of about 1¾ in. focal length instead of 2 in. and that it were still 2⅛ in. away from the focal plane. The lens extension has increased in relation to the focal length and the lens therefore focuses closer. You can actually alter the focal length of your lens in this way by adding another lens to it. The additional lenses so used are known as supplementary, close up or, occasionally, portrait lenses. These simple, one-glass lenses can be fitted onto any camera. They are normally attached to the camera lens in a mount similar to that of a filter. Inexpensive close-up lenses may be purchased without mount. They can then be fitted into any filter mount of the right size. Lenses and mounts are all made in a range of standard sizes.

Supplementary lenses

The focal length of supplementary lenses is not usually quoted. They are referred to by their power in dioptres. To find the focal length, you divide the dioptre number into one metre or its equivalent 39·37 in. Thus, a 3-dioptre lens has a focal length of 13·12 in.

When the supplementary lens is attached to a camera lens set to infinity, it focuses objects at a distance equal to its own focal length. This is easily understood. We have already mentioned that light from an object one focal length in front of a lens emerges from the back of the lens in parallel rays. These parallel rays are accepted by the camera lens as coming from an infinitely distant object and are converged to form an image in the focal plane.

This close-focusing ability of the camera lens plus supplementary lens combination is explained by the fact that the combination is of a shorter focal length than the camera lens alone, while the separation remains that of the focal length of the camera lens.

In the example already quoted, for instance, a 2-in. lens becomes about 1¾ in. focal length when a 3-dioptre supplementary is placed in front of it. Thus, when the camera lens is set to its infinity position,

the combination is set to about $\frac{1}{4}$ in. in front of its infinity position (which is usually more than the normal focusing travel of the prime lens) and will focus much closer.

Field size

A common problem is that of the field covered with a given lens extension or supplementary lens. This is another example of practice being worth rather more than theory. The easiest way to solve the problem is to photograph a ruler or tape measure in a strictly vertical or horizontal position. You can then read directly from the negative, the precise dimension of the field in one direction and calculate the other dimension from that. You can photograph two crossed rulers. if you like and save yourself any mental effort.

If you want to be precise, you should even use this procedure when the camera has a focusing screen. The screens of most 35 mm single lens reflexes, for example, show rather less than actually appears on the film. This is a safety precaution to ensure that you do not cut off a vital part of the edge of your picture and also takes account of the fact that the aperture of colour slide mounts is commonly a little smaller than the image area.

There are formulae to give you the field size, but, as with most optical formulae, they assume perfection in all directions and the results they give cannot be relied on completely.

One formula, for what it is worth, says:

$$W = \frac{N\,(u - F)}{F} \quad \text{where} \quad \begin{aligned} W &= \text{width of field} \\ N &= \text{width of image area} \\ u &= \text{object distance} \\ F &= \text{focal length} \end{aligned}$$

You can use this formula with supplementary lenses by first calculating the focal length of the combination. You do that adding the dioptre strength of prime lens and supplementary and dividing into one metre. Then u in the formula is the focal length of the supplementary lens, provided the prime lens is used at its infinity setting.

The following table gives approximate fields covered with 1, 2 and 3-dioptre supplementary lenses used with the standard lenses for 35 mm and $2\frac{1}{4}$ in. sq. cameras.

The distance at which a supplementary lens focuses is independent of the focal length of the camera lens. It focuses at its own focal length when the camera lens is set to infinity and various closer ranges when the focusing movement of the camera lens is used.

FIELD COVERED (in.) WITH POSITIVE
SUPPLEMENTARY LENSES

Format	Camera Lens	Supplementary Lens Strength (dioptres)					
		1		2		3	
		inf	3½ ft	inf	3½ ft	inf	3½ ft
35 mm	50 mm	18½ × 28	9½ × 14	9½ × 14	6½ × 9½	6½ × 9½	4½ × 7
2¼ in. sq.	75 mm	30 × 30	14½ × 14½	14½ × 14½	9 × 9	9 × 9	7 × 7

FOCUSED DISTANCES (in.) WITH POSITIVE
SUPPLEMENTARY LENSES

Dioptre	Camera lens focus (ft)										
	3	4	6	8	10	12	15	25	30	50	inf
1	18¾	21½	25½	28	30	31	32¼	34¾	35½	37	39½
2	12¾	14	15½	16¼	17	17¼	17¾	18½	18¾	19	19¾
3	9½	10¼	11	11½	11¾	12	12¼	12½	12¾	13	13¼

These are approximate figures and if they are used, the lens should be stopped down as far as possible to take care of possible errors. Or, tests should be conducted at full aperture, varying the distances very slightly to find the correct settings for your equipment.

There is a formula for this, too:

It says:

$$d = \frac{vs}{v + s}$$ where d = actual distance focused on
v = scale setting of camera lens
s = focal length of supplementary

Camera lens as supplementary

High-powered supplementary lenses are expensive because they need careful correction of aberrations. That really demands a composite construction. If, however, you have more than one lens for your camera, you have a very good supplementary lens instantly available.

With a 35 mm camera, for instance, you might have a 135 mm lens as well as the standard 50 mm or thereabouts. The 50 mm lens can be placed in front of the 135 mm to form a 20-dioptre supplementary, focusing at about 2 in. and giving about 3 × magnification.

You will have to experiment to find the maximum usable aperture. Lighting is also a problem but the experiments are well worth trying.

Exposure

When supplementary lenses are used for close-range work exposure is calculated in the normal way because lens-film separation is not altered. When tubes or bellows are used, lens-film separation is increased and the greater distance the light has to travel inside the camera has its effect on the exposure required. The inverse square law (page 130) comes into play again. Regarding the lens as a light source, increasing its distance from the plane on which it projects, reduces the intensity of the light distributed over a given area—in this case the image area. Thus, if the lens film distance is doubled, the intensity of the light is reduced to one-quarter and the exposure required is four times that indicated by a normal meter reading.

That is an easily calculated example. Others are calculated from $(\frac{E}{F})^2$ where E = total extension, i.e. focal length plus length of extension tubes or bellows and F = focal length of camera lens. E should also include the amount of focusing travel of the lens where used. The formula gives an exposure factor, i.e. a figure by which the normally indicated exposure must be multiplied.

Thus, where a 50 mm lens is used with a 15 mm extension tube, the formula gives $(\frac{65}{50})^2 = 1\cdot69$. If the normally indicated exposure were $\frac{1}{2}$ sec. at $f8$, the correct exposure for the close up would be nearer 1 sec. at $f8$ or $\frac{1}{2}$ sec. at $f6\cdot3$.

These theoretical calculations give you a base from which to work. Other factors can affect exposure for close range work—particularly the design of the lens. If you use retrofocus or telephoto lenses, the added extension is not in the same proportion to the actual lens-film separation as with the normal lens. The telephoto lens shot may need more exposure than the formula indicates—the retrofocus less. If you use the lens reversed, however—a common arrangement for macro work—the opposite may apply. It is advisable to conduct experiments with each lens—even when you have a TTL meter, because some types of meter can be misled in these circumstances.

Lighting

Problems are often encountered in lighting close-up subjects. In most cases, diffused daylight is by far the easiest to handle and gives the most satisfactory results. This is particularly true when copying documents, prints, paintings, etc. which need completely even lighting and/or where reflections are likely to be troublesome.

If lamps have to be used, they must be very carefully placed. An unevenness of lighting completely undetectable to the eye can produce negatives that are extremely difficult to print satisfactorily. You really need a sensitive exposure meter to measure the light level at each edge of the document.

Reflections can be similarly troublesome. With through-the-lens viewing, they can be seen and eliminated by rearrangement of the lamps, while still keeping an eye on the light distribution. It can sometimes be a very tedious business. With rangefinder cameras, you can only do your best to judge the effect by placing your eye as close as possible to the lens. This type of camera is at a considerable disadvantage when copying objects likely to give reflection troubles.

Photofloods are handy light sources for close range work, owing to their intensity. They allow relatively short exposures on the slow films normally required. But they are by no means essential; ordinary 100–200 watt household lamps are quite satisfactory alternatives, unless you are working in colour. In that case, you must use daylight if at all possible, or photofloods with artificial light film.

Flash, blue-bulb or electronic, is admirable for close-range work in colour (daylight film) or black and white, provided that you have two units or heads to allow even lighting and also that reflections are not likely to be troublesome.

There are special ring flash units which fit round the lens and give even, almost shadow-free lighting but these are totally unsuitable for glossy surfaced subjects. They throw a reflection straight back into the lens. Even with matt but very light toned subjects they may produce a marked flare effect.

At very close range, it is not usually practicable to mount an ordinary flash unit on the camera. First, it may introduce some parallax error, causing the main beam of the light to miss the subject altogether. Secondly, it is likely to be far too powerful. Even a guide number as low as 20 calls for an aperture of $f40$ at 6 in.

An extension cable enables you to take the flash off the camera and use it at the correct distance. Even lighting can be obtained either by using two flashguns or heads or by setting the shutter on B and firing the flash once from each side of the subject. In both cases, you must be careful to avoid directing the flash into the lens.

Either with floods or flash, it may be advisable to restrict the light beam by directing it through a black paper cone. This is particularly useful where directional light is required to show up contours, the weave of a material or an artist's brushwork, for example. A slide projector can also serve as a miniature spotlight, although its power is not very great and it may be necessary to put a home-constructed stop in the slide carrier to narrow the beam sufficiently.

Focusing

Focusing the close range subject which occupies one plane only (documents, paintings, stamps, etc.) poses no difficulties. If the subject has any depth at all, however, really close work involves you in difficulties with depth of field. Although you will normally stop down as far as practicable to take care of possible slight focusing errors and lens aberrations, the depth of field is strictly limited. With a same-size reproduction, for example, even at f16 depth of field from foreground to background is less than $\frac{1}{4}$ in. for a reasonably good quality result.

The depth of field depends on the standards you set, which means the size of the circle of confusion (page 123) you decide is acceptable. The above example is taken from the table below, which assumes a circle of confusion of 1/1000 in.

The normal depth of field calculations apply to close-range work but it is usually more convenient to work on the scale of reproduction. The formula is:

$$d = \frac{fc(M+1)}{M^2}$$

where d = depth of field behind or in front of the subject

M = scale of reproduction (image size/object size)

f = f-number of aperture

c = diameter of circle of confusion

When powerful supplementary lenses are used, an additional

CLOSE-UP DEPTH OF FIELD (in.)

Aperture f	Depth of Field for Scale of Reproduction												
	0·1 (1:10)	0·13 (1:8)	0·17 (1:6)	0·2 (1:5)	0·25 (1:4)	0·33 (1:3)	0·5 (1:2)	0·67 (2:3)	1 (1:1)	1·5 (3:2)	2 (2:1)	2·5 (5:2)	3 (3:1)
2	0·22	0·14	0·084	0·060	0·040	0·024	0·012	0·0075	0·0040	0·0022	0·0015	0·0011	0·0009
2·2	0·24	0·16	0·092	0·066	0·044	0·044	0·013	0·0082	0·0024	0·0024	0·0016	0·0012	0·0010
2·8	0·31	0·20	0·12	0·084	0·056	0·034	0·017	0·010	0·0056	0·0031	0·0021	0·0016	0·0012
3·5	0·38	0·25	0·15	0·10	0·070	0·042	0·020	0·013	0·0070	0·0039	0·0026	0·0020	0·0016
4	0·44	0·29	0·17	0·12	0·080	0·048	0·024	0·015	0·0080	0·0044	0·0030	0·0022	0·0018
4·5	0·49	0·32	0·19	0·13	0·090	0·054	0·027	0·017	0·0090	0·0050	0·0034	0·0025	0·0020
5·6	0·62	0·40	0·23	0·17	0·11	0·067	0·034	0·021	0·011	0·0067	0·0042	0·0031	0·0025
6·3	0·69	0·46	0·26	0·19	0·13	0·077	0·038	0·024	0·013	0·0070	0·0047	0·0035	0·0028
8	0·88	0·58	0·34	0·24	0·16	0·096	0·048	0·030	0·016	0·0089	0·0060	0·0045	0·0036
9	0·99	0·65	0·38	0·27	0·18	0·11	0·054	0·034	0·018	0·010	0·0067	0·0050	0·0040
11	1·21	0·79	0·46	0·33	0·22	0·13	0·066	0·041	0·022	0·012	0·0082	0·0062	0·0049
12·5	1·37	0·90	0·52	0·37	0·25	0·15	0·075	0·047	0·025	0·014	0·0094	0·0070	0·0056
16	1·76	1·15	0·67	0·48	0·32	0·19	0·096	0·060	0·032	0·018	0·012	0·0090	0·0071
18	1·98	1·30	0·76	0·54	0·36	0·22	0·11	0·067	0·036	0·020	0·013	0·010	0·0080
22	2·42	1·58	0·92	0·66	0·44	0·26	0·13	0·082	0·044	0·024	0·016	0·012	0·0098
25	2·75	1·80	1·05	0·75	0·50	0·30	0·15	0·094	0·050	0·028	0·019	0·014	0·011
32	3·5	2·30	1·34	0·96	0·64	0·38	0·19	0·12	0·064	0·036	0·024	0·018	0·014
45	4·9	3·2	1·90	1·35	0·90	0·54	0·27	0·17	0·090	0·050	0·034	0·025	0·020

Circle of confusion 0·001 in. The above is the depth of field at each side of the plane of sharp focus. The total depth is twice these figures. From the *Focal Encyclopedia of Photography*.

calculation is required. The *f*-number for depth of field purposes of the combination of supplementary and prime lens becomes

$$\frac{fs}{F + s}$$ where f = *f*-number of camera lens

 s = focal length of supplementary lens

 F = focal length of camera lens

This has very little effect where the normal 1, 2 or 3-dioptre supplementary lenses are used. Even with a 5-dioptre supplementary on a 50 mm lens, the adjustment indicated is less than half a stop.

Don't trust the theory

Yet again, bear in mind that all these calculations are theoretical. They apply fully only under perfect conditions. In practice, lens aberrations and varying standards of performance can obviously wreak havoc with calculations involving such tiny tolerances. The only practical method of ascertaining depth of field in such circumstances is to take the photograph; take several at various apertures. If you can afford the time required to set up a close-range subject accurately, it is a little ridiculous to economize in the use of relatively inexpensive film.

In close-range work you should distrust all formulae and tables. Use them simply as a rough guide to tell you whether your project is possible or impossible. If they give you hope, go to work—allowing for at least a 100 per cent error either way in the calculated figures. The knowledge gained by experience of your own equipment will soon build up to replace the theory.

You may find, while experimenting, that your lens works better mounted back to front for close-up work. The theory behind this is that the normal camera lens is designed to work at short lens-film distances and relatively long lens-subject distances. In close-up work, these features are reversed, so the lens should be reversed, too. It sometimes works.

Again, diffraction may rear its ugly head. This is said to cause loss of definition at very small stops owing to the effect of light rays deviating from the straight and narrow and creeping round the edge of the stop. Only by actually trying it and critically comparing the result will you find out whether your lens reacts in this way. Even

then, it would not be advisable for you to talk knowledgeably about the effect of diffraction on your lens. Most lenses perform better at a moderate stop than at a very small one, but this is just as likely to be due to the fact that the correction of the lens aberrations is at its most effective at that stop. The difference in performance is, in any case, usually marginal.

By practical work, too, you will find out how accurate your focusing is. The restricted depth of field will show up any inaccuracy very quickly. This may be due to an unreliable tape measure or focal plane mark, wrongly located mirror in a reflex or just plain bad eyesight. You must track down the cause and try to correct it.

Even flash and photoflood guide numbers are suspect at close range. They rely on the inverse square law, which really only applies to point light sources. No flash unit can be regarded as a point light source when used at close range on a relatively small subject.

The rangefinders in reflex screens are unlikely to be accurate at very close range and you should use the screen itself or the ground glass collar if fitted. You may find that fine focusing is very difficult because, although depth of field is so small, depth of focus (tolerance in lens-film distance) is greatly increased. It is often simpler to focus by moving the camera or subject.

Naturally, you will always focus at full aperture but check the focus when you stop down. It can change, although it should not.

Close-range work calls for infinite care and patience and, because you hope for fine detail—a rock steady camera. You need a really stout tripod on a solid foundation—not a deep pile carpet—a cable release and a complete absence of vibration. Wait for the lorry in the road outside to get well out of range. Wait for vibrations to die down after you wind the film on, set the aperture or cock the shutter. If you have a reflex camera which allows you to release the mirror while keeping the shutter closed, do that and wait again for a few seconds before releasing the shutter. Disregard any one of these and all your careful preparations and calculations may be worthless.

14: Photography Without Light

Infra-red film is not easily obtainable
and there isn't much
that you can do with it when you get it.
Nevertheless, it is interesting to experiment with
and needs no special processing.

There are one or two branches of photography which have a fascina
tion all their own, despite the fact that the opportunities for using
them are comparatively rare. One of these is infra-red photography.
Like tele-photography, it occasionally enables you to see what cannot
be seen by the naked eye.

Infra-red film

Pure infra-red photography uses specially prepared film which,
although sensitive to light of all colours is, owing to special dyes
incorporated in the emulsion, far more sensitive than ordinary films
to infra-red radiation. This type of film can be used for ordinary
photography in normal daylight or artificial light and for infra-red
photography if the light source emits infra-red only or if a special
filter is used either over the camera lens or over the light
source.

Ordinary panchromatic film is also sensitive to infra-red rays and
can be used in a similar way, but it has not the extra sensitivity of the
true infra-red film and is therefore rather slower for this type of
photography.

Infra-red radiation

The infra-red rays are heat rays and are provided by most heat-emitting substances. The sun, tungsten lamps and flashbulbs are all rich in infra-red radiation. Domestic electric irons, radiant heaters and similar appliances also emit infra-red rays but usually of a rather longer wavelength than those for which the film emulsion is sensitized. Exposures can be made by this type of illumination but they may run into hours. Electronic flash can be used but the infra-red output is likely to be much lower than for a flashbulb of comparable power.

Exposures with infra-red film are quite a problem. An exposure meter is not too reliable because it is not sensitive to infra-red. Perhaps that would not matter if the infra-red content of various light sources were constant and predictable, but it is not. It varies greatly in different intensities of daylight and there is even some variation in artificial light: high-wattage lamps usually emit more infra-red than low-wattage lamps.

Filters

The effective speed of the film also depends on the type of filter used. If you wish to expose by infra-red illumination only, the correct filter is one that is opaque to visible light because the film is far more sensitive to visible light than it is to infra-red. You can, however, obtain quite satisfactory results with ordinary red, deep red or very deep red filters. In such cases you use not only the infra-red radiation but also a certain amount of visible red light. This gives an effective film speed about twice that obtained with the true infra-red filter. With Kodak's 35 mm infra-red film, for example, the ASA speed to tungsten with the ordinary red filters is about 20 ASA on the normal unfiltered meter or 12 ASA in daylight. With a true infra-red filter, it is about 10 ASA to tungsten and 6 ASA in daylight. Naturally, these figures are intended as a general guide only. Depending on subject, circumstances and result required, the effective speed can be up to two stops faster or two stops slower.

Red and infra-red filters eliminate the blue content of the existing light (and practically all other visible light, too, of course). It is the elimination of blue, however, that gives infra-red its well known but sometimes exaggerated characteristic of penetrating mist. By eliminating the blue light (and ultra violet radiation) it reduces light scatter

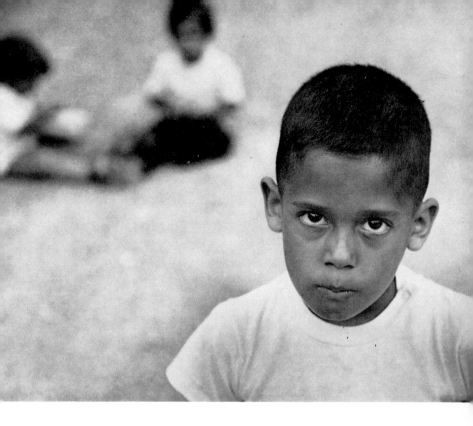

TECHNIQUES

The camera has long outgrown the theory that it cannot lie. In the right hands it can, in fact, bend the truth with considerable skill. The human eye is quite incapable of seeing, in life, most of the pictures in this section. Although the eye has virtually no depth of field, the brain is rarely conscious of the fact. So the camera can isolate subjects by thoroughly defocusing the background (*above*). The eye can adjust rapidly to changes in brightness and would see far more in the shadows than the film managed to put into the picture on page 226.

(*continued on p. 229*)

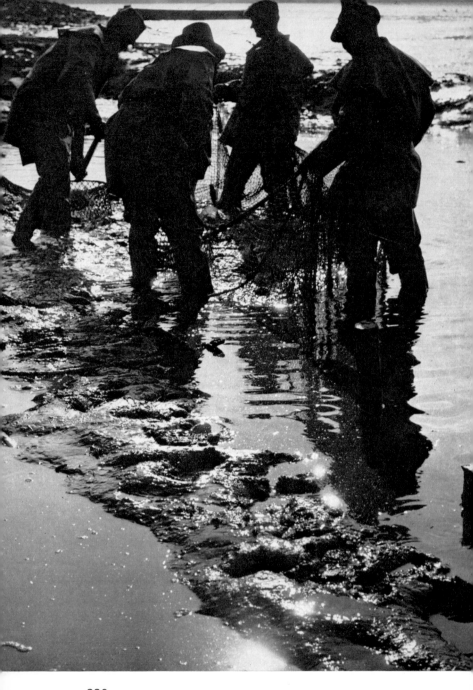

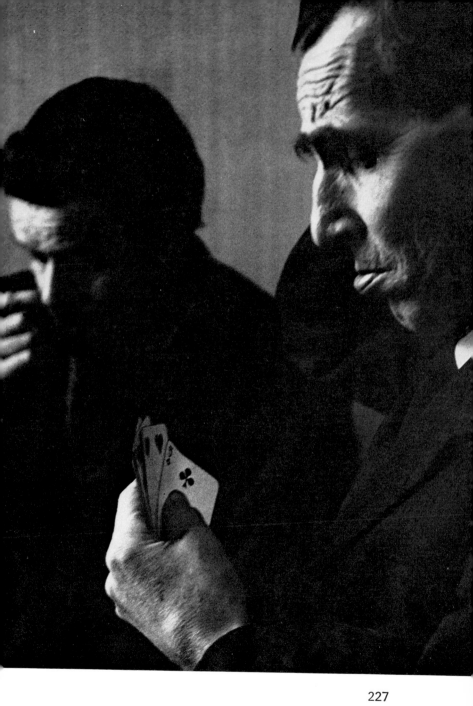

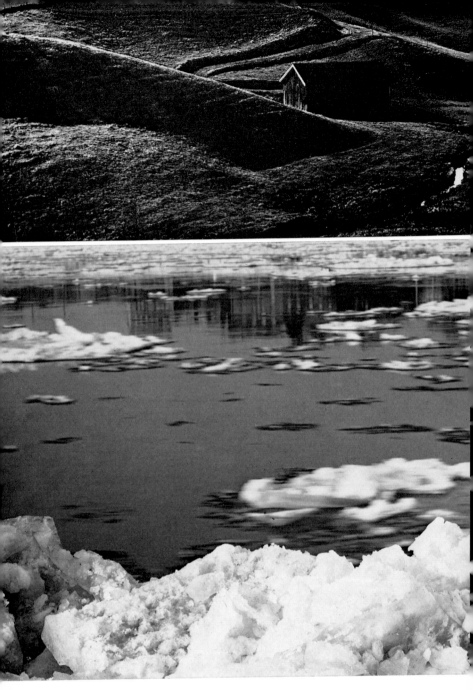

228

TECHNIQUES

(continued from p. 225)

The camera's ability to underexpose a scene (*opposite, top*), to blur movement with a slow shutter speed (*opposite bottom*) or to freeze it by panning (*below*) cannot be paralleled by the eye.

When darkroom techniques are brought in, the photographic process can become an out-and-out liar. Posterisation (p. 230) can turn any scene into a composition of restricted tones and little detail. Reticulation or printing through a screen (p. 231) can provide a texture that is appealing, bizarre or horrific, according to subject and taste.

Solarization (so-called) can put in lines where the eye saw none (p. 232) and re-inforce the effects of tone separation by clarifying some details and subduing others.

All these processes and many more allow the photographer to make pictures rather than take photographs.

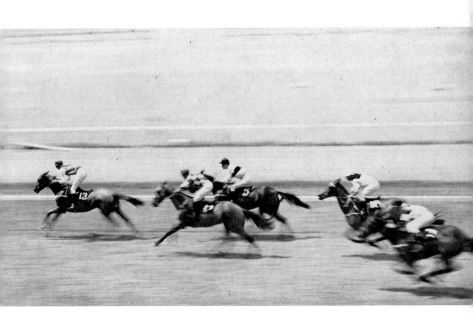

Photos by: Hartmut Rekort (p. 225), Svatopluk Civis (p. 226), Bert Börjesson (pp. 227 and 228, top), I. Janza (p. 228, bottom), Poon Yik-Wo (p. 229), F. Macho (p. 230), Ladislav Postupa (p. 231), Leopold Fischer (p. 232).

to a minimum because it is at these short wavelengths that light is scattered most. Thus, the contrast in distant scenes is increased and more detail is apparent.

Black flash

The uses to which the average amateur can put infra-red film are rather limited. The use that readily springs to mind is the so-called "black flash" technique whereby exposures can be made in the dark without the flash being detectable. For this purpose the filter has to be placed over the light source. In the United States, specially coated flashbulbs are available.

Filters used over the light source need not be of optical quality and there is in fact a filter bag on the British market made from several thicknesses of dyed cellulose film and the light passing through it is almost invisible. The flashgun or flash head is placed inside the bag, which is rather inconvenient in the case of flashbulbs but eminently suited to electronic flash.

Focusing

The problem with this type of photography is in focusing. When photographing a really dark scene, it is unlikely that you will be able to use your rangefinder or reflex screen. You will have to rely on your judgement of distances or on actual measurement. Another fact to be contended with is that infra-red rays are brought to a focus behind the plane for which the lens is normally corrected. With short focus lenses used at reasonably small apertures this is no very great problem because the distance involved is rarely more than about one quarter of one percent of the focal length of the lens. This means that the lens should be racked forward by that amount from its infinity position and a special infra-red focusing mark made against the new infinity position. Many lenses have a small R engraved on their mounts as a focusing index for infra-red lens.

For critical work, the correct focusing adjustment must be ascertained by practical tests. If possible, a practical way out is to focus the single-lens reflex through a tricolour red filter. No adjustment should then be necessary, whereas if you focus before placing the filter in position, you must note the indicated distance on the scale and move it to the infra-red focusing mark.

Exposure

Exposures with flash can be worked out by trial and error. A reasonable starting point with the Kodak film, an AG1 or No. 1 bulb or 80–100 joule electronic unit and an ordinary red filter is to assume a guide number of 70 on X-synchronisation. With the true infra-red filter, a guide number of 50 could be tried.

When using other artificial light sources, the exposure for two 500 watt lamps, one each side of the camera at about 6 ft from the subject and within a 45 deg. angle from the lens axis is likely to be about ½ sec. at $f5·6$ or $f8$. It is preferable to use high-wattage lamps because the higher the wattage the greater the infra-red content. Photofloods are quite suitable and exposures with No. 1 photofloods should be about the same as with 500-watt lamps.

How you can use it

Apart from shooting in the dark, infra-red film can be used to penetrate haze in distant scenes, to produce unusual renderings of landscapes, to emphasize grain in woodwork and to penetrate surface polish, grease, etc. and for a variety of experimental processes.

Infra-red radiation has many strange properties. It is reflected or transmitted by coloured objects in a way that cannot be forecast by reference to the behaviour of visible light. Dark cloth, for example, is often rendered quite light in tone—a feature that can be put to good use in uncovering stains or showing up the weave.

Infra-red rays have strange penetrating powers. They can show the structure of veins beneath the skin, which is helpful for the medical profession but not very encouraging for the orthodox portraitist. They can sometimes penetrate paint to show an artist's technique or ink to show obliterated writing beneath.

Infra-red film has, in fact, many interesting uses for those of an experimental turn of mind. For the average amateur, infra-red work is fascinating to contemplate but rather frustrating to pursue. The film is not easily obtainable; it is difficult to store without alteration in characteristics and considerable experience is needed to use it effectively.

Processing

Processing is straightforward, being exactly the same as that for ordinary black-and-white films. The development time recommended

by Kodak with D76 (which is the same as ID11) is 11 minutes at 68 deg. F. This can be varied considerably according to subject and the degree of contrast required. Practical tests are the only guide to satisfactory results. Development is followed by normal fixing and washing as with other black-and-white films.

15: Develop Them Yourself

Every keen photographer
wants to develop his own films at some stage.
There is nothing very difficult about it
with modern materials and techniques.
All you need to know is here.

Processing your own black-and-white films is such a simple task these days that the greatest difficulty you are likely to encounter is getting the film into the developing tank. That is, if your choice of tank was unfortunate or ill-advised.

The developing tank

The tank is a container that will admit liquid but not light; inside is a form of spiral on which the film is wound. The loading procedure is to wind the film on to the spiral, place the spiral in the tank and put the light-trapped lid on the tank. All that has to be done in total darkness, but from then on you can work in broad daylight if you wish.

Most developing tanks are reasonably easy to load when they are new, if you follow the instructions precisely. Unfortunately most of them are also now made from plastic material of indifferent quality which is highly sensitive to heat, knocks and generally clumsy handling. It only needs a dent or a slight warping of the spiral to make loading a nightmare.

Often, you are advised to practise loading your tank in the light

before trying it in darkness. That is sensible enough if you happen to have a full length of waste film—but who ever has? You have to buy one and deliberately waste it. So you might as well expose it properly anyway. There is no alternative—you just have to take a chance with your first film.

Apart from plastic tanks, there are stainless steel models which are well worth the additional expense. They load differently. Whereas most plastic models load from the outside grooves of the spiral inwards, the stainless steel models load from the centre outwards. You push the film into the centre and then spring it into the grooves while rotating the spiral so that it feeds almost automatically to the outer grooves. It's quite easy really and you do not need the special loader supplied with some tanks.

Nearly all tanks now have a watertight cap to fit over the opening into which you pour the processing solutions. This cap allows you to invert the tank without spilling any liquid. This form of agitation (see page 240) is a part of the actual processing procedure.

Processing has three essential steps—developing, fixing, washing. First you pour in the developer. At the end of the developing time prescribed by the film or developer manufacturer, you pour out the developer. You then briefly rinse the film by filling and emptying the tank several times with fresh water. Next you pour in the fixer and, at the end of the prescribed fixing time, pour it out again. The film is now processed and all you have to do is give it a final wash. That is all that is necessary. You don't see the film while it is being processed as it remains enclosed in the tank until the final wash stage. Control over processing is maintained by time and temperature—like baking a cake.

Choosing the developer

Unfortunately, like everything else in photography, it is possible to complicate this simple procedure almost beyond belief. There are, for example, literally hundreds of formulae you could use for compounding your developer. The majority of these date back to the days when the photographic emulsion left a lot to be desired. Special "brews" were devised (particularly for 35 mm film) to increase or reduce contrast, to minimize grain size and to make the most of the film's then limited speed.

These special concoctions (and some of them were weird in the extreme) belong to history and there is no point whatever in reviving them. Most of them are, in fact, totally unsuited to modern films owing to changes in emulsion chemistry. The trend is towards a compact but not necessarily superfine grain structure designed to produce the edge effects (see page 91) now recognized as essential to true sharpness.

Even now, there are dozens of proprietary brands and the enthusiast can be forgiven for thinking that some of them must have something special. Perhaps they have—and the fervent admirer of any particular brand will swear by his choice—but the effect is marginal.

The most sensible idea is to choose a developer that is readily available in the form you want—powder that you make up into solution or liquid that you dilute for use as required. Stay with the same type so that in time, you can learn how variations in dilution, time, temperature, etc. give slightly different results.

You need only look for special types of developer in special circumstances. For day-to-day photography on medium-speed film, any standard developer can do all you require—even with 35 mm and half-frame material. The days when 35 mm film needed special fine-grain developers are long past.

If, however, you have a special job involving the reproduction of fine detail, perhaps in close-up work, you might well want a slow film to get the best possible result and then there is some sense in using a developer of the high-definition type. Most manufacturers have one and they are usually designed for slow and medium speed films only. That is because they are not particularly fine-grain types. They are what is sometimes known as acutance developers. They are often in a rather weak mixture calling for longish developing times—although the developer type is really somewhat vigorous. Their most significant effect is to produce greater contrast than usual at the borders between areas of different tonal value, thus giving cleaner lines and the impression of greater overall sharpness.

On the other hand, when you need the utmost speed possible, while still retaining some picture quality, the few genuine speed-increasing types can be used with fast films to bring up the shadow detail. These are the developers claiming up to one stop increased

speed (generally rather less than 100 per cent). Treat any others, or special processes, with reserve. You can overdevelop to a considerable degree (steeping the film for hours if you like) to attain an apparent film-speed increase. All you actually do by such methods is increase contrast and grain size. You cannot put more detail into the deep shadows. And that is the only true criterion of increased film speed.

Don't be tempted to make up your own special brew—unless you just like doing it. The manufacturers take tremendous care to compound really reliable products which can be used with the utmost confidence. And they are quite inexpensive in use. If you make up your own, you have to store the required chemicals, often in far from ideal conditions and measure them out (or some of them) with a fair degree of accuracy. It is not impossible or even all that difficult but you cannot rely upon absolutely consistent results and it is just possible that you might make a bad mistake some day. It isn't worth the risk.

Using the developer

If you choose one of the developers recommended by the film manufacturer or a developer made by an independent chemical manufacturer you will find a development time and temperature recommended for your film. If you use one film manufacturer's developer with somebody else's film you won't find any advice with either. In that case, experiment around a time for a film of similar speed rating.

Your tank takes a certain quantity of solution. The quantity is marked on the tank or mentioned in the instruction leaflet. If you picked up the tank second-hand somewhere, measure its capacity before putting it to work.

Pour the required amount of developer at the recommended strength into a graduated measure. Plastic 10 oz and 20 oz measures are readily available.

If you are working with a stock solution that you dilute for use, make it up first in about three-quarters of the required volume of water and then take its temperature. The ordinary spirit type of photographic thermometer costing a few shillings is quite good enough. If the solution is too warm or too cold you can add warm water or an ice cube and juggle it to the correct temperature.

If you store your developer at working strength, then the best way to bring it to the correct temperature is to stand it in a bowl of warm or cold water.

To time the actual development you need a clock or watch with a sweep second hand. You can buy a special timer of course but it is rather a waste of money. Note the exact time you start pouring in the developer in and pour it out again exactly at the end of the prescribed time. The pouring in and out time will then just about cancel each other out.

Using diluted developers

Some developers can be used diluted for a longer time. If you are not one of those who is always in a hurry, there is some advantage in this method because slight errors in timing become much less serious. If the prescribed developing time is 20 minutes, you can run a minute or two over with little or no effect on the film.

If your developing time were two minutes, however, even 15 seconds would be a significant departure from the ideal. With such short development times in fact, it is wiser to develop in darkness, filling the tank with developer first and dunking the film in it. Then you need a luminous or audible timer.

The dilute method has the additional advantage that it frequently entails a once-only use of each solution, so that you have fresh solution for each film and no worries as to whether the developer still has sufficient life in it.

How and when to agitate

At the beginning of and during development, you must move the solution about a bit, first to ensure that air bubbles are dispersed and then to keep the developer circulating. If you do not do this, the developer acting on the film becomes rapidly exhausted, particularly in the highlight areas where it does most work. The solution then becomes less homogenous in character and rather odd things can happen.

Movement of the developer is called agitation and it used to be carried out with a sort of twiddle stick inserted through the top of the tank into the spiral. You twiddled it round and back again to keep the film moving relative to the developer. This was thought not to be very

Film processing equipment is relatively simple: a, b, c, Storage bottles, d, Thermometer. e, Film washer. f, Graduated flasks. g, Funnel. h, Timer, i, Developing tank.

Processing consists of: 1. Load the tank. 2. Bring solutions to working temperature. 3. Pour in developer. 4. Rinse. 5. Fix. 6. Wash. 7. Add wetting agent. 8. Dry. 9. File negatives.

efficient, because it sometimes caused horizontal streaks of uneven development. So the spiral was given a spring bottom so that you could twiddle in two dimensions—round and round and up and down. The same effect was achieved by the spiral being mounted on a slotted bearing so that as you rotated it in one direction it also rose and fell several times per revolution.

Finally came the now almost universal method of fitting a waterproof cap to the tank and providing extra capacity in the lid so that you can invert the tank and allow most of the solution to drain above the film into the lid. You tip it back again to allow an (apparently) complete change of developer, and full mixing.

In practice there is little to choose between the various methods. The old twiddle stick is perfectly adequate provided you don't twirl it round like mad and set up a sort of centrifugal action which leaves the developer virtually stationary. Just a few short sharp back and forth actions every minute are enough.

There is one incidental advantage to the old tanks. Most of them were considerably better made than the new ones. Old tanks are worth looking for if you can't run to a stainless steel model.

Don't become a fanatic about agitation. The manufacturers have to give very precise instructions because all their claims for speed, grain size, contrast, etc. are based on a precise and reproducible processing method. Provided you give sufficient agitation—and two inversions every minute is always enough—you can suit yourself how you work.

Time and temperature

It is not essential to adhere slavishly to the manufacturer's recommended time and temperature. In due course you may favour the type of negative obtained from longer or shorter development. The recommended temperature (for black and white) is usually 68 deg. F. (20 deg. C.). You may prefer to work at 60 or 75 deg. Don't go too far outside those limits because times can become uncomfortably long or short and at very low temperatures you lose contrast. At higher temperatures there is a danger of reticulation.

Reticulation is the breaking up of emulsion caused by immersing it in too warm a solution. It is not often encountered with modern films but can be brought about deliberately with some black-and-white

films by dunking them in water at about 90 deg. F. Don't put them in very hot water or the emulsion will float right off the film base.

It is just about impossible to reticulate processed colour films. Some can be boiled without any sign of reticulating.

Fixing

Fortunately, fixing solutions do not come in such a variety of guises as developers. There are plenty of proprietary brands but they all fall into two main groups—ordinary and rapid. The ordinary fixer is based on hypo (sodium thiosulphate) and fixes films in about ten minutes when fresh. It is rarely used alone, usually containing an acidifying component such as sodium bisulphite or potassium metabisulphite to prevent development continuing during the early stages of fixing.

The rapid type is usually based on ammonium thiosulphate, also acidified, and takes about 90 seconds or less to fix a film fully.

Both types also usually incorporate a hardener to protect the emulsion from damage during washing and subsequent handling. The hardener is advisable but not essential with ordinary fixer. With fast fixers it is usually supplied as a separate solution and is sometimes recommended because of the softening effect of the fixing solution itself.

Over use of fixing baths is one of the amateur's greatest faults. Ordinary fixer dies a rather slow death, fixing time increasing gradually as the bath becomes exhausted. The rapid types have a tendency to exhaust suddenly. In either case, when the fixing time becomes twice that of a fresh bath, it is time to use a fresh solution.

You can easily test a fixer by immersing a small piece of un-developed film in an ounce or two of the fixer and checking its clearing time. It should become clear in about half the recommended fixing time. If it takes twice that time, you need to double the fixing time, but that is about the limit and it would be better to use a fresh bath.

It is only too easy to think that a film is fully cleared and fixed because it looks clean when you hold it up to a strong light. But try looking obliquely at it rather than through it and, if your fixer is getting old you will see a definite veiling or milkiness. That may not affect the printing but it will, in time, affect the permanence of the

image. Don't worry too much about this effect, however, if you are using a high-definition developer. It is characteristic of some of these solutions.

Washing

The final stage of film processing is washing. For absolute permanence this needs to be done thoroughly to wash out of the emulsion the unexposed silver salts converted into soluble compounds by the fixing solution. If left in the film, these compounds may cause staining in irregular patches.

Nevertheless, if you stand the film in its spiral in the tank under a running cold water tap for about 20 minutes it will be as thoroughly washed as makes no difference. If you want to be especially careful you can use a rubber tube to introduce the wash water at the bottom of the tank and wash for half an hour. Or you can buy a fixer eliminator in which you immerse the film for a minute or two after a quick rinse and finish off with five minutes' washing.

Drying

The most important stage in film processing comes last. That is drying. The actual processing is child's play and you really will find it difficult to make a mess of it. When you dry the film however it is so easy to plaster it with dust, scratches, finger marks, etc. that printing becomes a nightmare. It does not much matter if your developer and/ or fixer are full of foreign bodies. They are very unlikely to stick to the film or to have any effect on it at all. When it comes out of the wash water, however, the film must be clean and it must stay clean.

It is unlikely to do that if you wipe it down with a sponge, put it in a cabinet with a lamp at the bottom, or direct a hairdryer at it. The softest sponge can scratch if it has dust embedded in it; any ordinary atmosphere contains dust that rises in currents of warm air; and the hairdryer can really blow all sorts of things on to the emulsion. Just hang the film up somewhere reasonably dry and let it get on with the business by itself. Don't put it in a draught or where people are constantly walking around. A bedroom is as good a place as any.

If you have trouble with drying marks on 35 mm film, i.e. spots on the glossy side caused by impurities evaporating out of the wash

water, add a drop or two of wetting agent to the water in the tank when you turn the tap off. Leave the film to soak in it for one minute before hanging it up to dry.

If that doesn't cure the trouble, don't despair. The marks are easily removed by the old-fashioned spit and polish method, using a lightly moistened, very soft handkerchief.

Another type of drying mark is a comparative rarity, which is just as well because it is often there to stay. This is the mark caused by a droplet of moisture lying on the surface of the emulsion and causing a small area to dry much more slowly than the surrounding area. This is normally only encountered in forced drying or when the film is left lying flat instead of being hung up by end or edge. If it happens, try thoroughly resoaking the film and drying properly—but it may not work.

If you are persistently troubled with drying marks due perhaps to impurities in the water you could carefully wipe the film immediately after washing to remove large patches of water from the emulsion side. This can be done by passing the film once only through a firmly held moistened paper handkerchief. But remember there is always a possibility of surface scratches and with some makes of paper handkerchief small fibres may be left on the film. You must try this method thoroughly before using it on a good film.

Stop bath or rinse

Not many people pass straight from developer to fixer when processing their films. Some use a stop bath, some use a plain water rinse. Neither is an absolutely essential part of the process but they both have advantages.

The idea of rinsing the film is to get rid of most of the developer contained in the emulsion because it is alkali. When the developer saturated film is transferred directly to the fix it tends to neutralize the acidity of the fixing bath, so reducing its useful life. A quick rinse between these stages acts as a safeguard.

Some workers prefer to use a stop bath. This is a weak acid bath, usually consisting of a 2 per cent solution of acetic acid in which the film is immersed for a minute or two after development. It immediately arrests the development by neutralizing the alkali. All the usual developers will only work in a solution that is alkaline. It also

prevents carrying over alkali to the fixer and so prolongs its life.

The choice between rinse and stop bath is a personal one. The stop bath is never compulsory except in the odd cases where it is recommended by the fixer manufacturers. Some of the rapid fixers have a very erratic action and short life if a stop bath is not used.

16: Making the Print

Making black-and-white prints is easy.
Making really good ones calls for skill and practice.
The techniques are fully explained here.
The skill you have to acquire for yourself.

Although processing the film is virtually a routine job, printing is far from that. You can often make an acceptable print from a poor negative, but a poor print is no good to anybody.

Printing takes two forms: contact, which implies a print the same size as the negative; and projection, which generally, but not necessarily, means enlargement.

Contact printing

Contact printing is comparatively rare, owing to the present day widescale adoption of small negative sizes. It has its value, nevertheless, for proof prints. The easiest way to contact print is to place a piece of printing paper and the negative, emulsion-to-emulsion, on a flat surface, negative uppermost. Press the negative and paper into close contact by laying a sheet of glass on top and then hold a "white" light over them. An ordinary domestic bulb is adequate. Work out the exposure in the same way as you do for enlarging (see page 260). The subsequent processing follows virtually the same method.

Special paper is sold for contact printing. It reacts so slowly to light that you can do printing in a room lit by weak domestic lighting.

Enlarging paper can be used for contact printing too, but then you *must* use a safelight (see page 253) because the paper is much faster and any ordinary room lighting or even weak daylight will fog it, i.e. act on the emulsion and cause it to darken all over on subsequent development.

Contact printing can be elaborated by the use of special printing frames or boxes to hold paper and negative. Some of them also incorporate their own safelight. These are useful if you intend to do much printing of single negatives.

When you use contact printing to proof up your negatives so that you can see which ones to enlarge, it is easier to introduce mass production methods. A 10 × 8 in. sheet of paper, for example, accommodates a complete 35 mm or 120 film in strips. The light can then be supplied by the enlarger, which you adjust, with no negative in the carrier, to cover a 10 × 8 in. area on the baseboard.

Contact printing does not give you much control over the final print. For that you have to use an enlarger.

Enlarger principles

The photographic enlarger is not a precision instrument but it has to be carefully constructed. It consists of a lamp arranged to shine through a negative into a lens which projects an image of the negative on to a baseboard.

All modern amateur and most professional enlargers are vertical, i.e. they project their image downwards. The lamp is in a light-baffled housing under which is a slit or opening to take a carrier for the negative. Most carriers accept negatives in strips. Under the negative carrier is the lens, which is mounted in a sub-assembly allowing it to be moved closer to or further away from the negative to focus the image accurately. The complete head can be moved up and down to allow changes of image size for larger or smaller prints or to enable part only of the image to be printed.

The enlarger lamp is not an ordinary lamp. Its envelope is usually opal glass to diffuse and even out its spread of light. Its voltage and other details are printed on the side and not on top where they would interfere with the projected image. It appears to be more robustly constructed than an ordinary domestic lamp, too, because it has a long life with a tremendous amount of switching on and off.

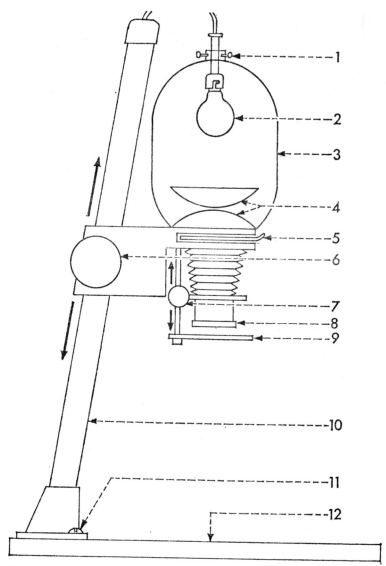

The enlarger takes many forms but is basically a projector arranged to slide up and down a column attached to a baseboard. The main features are 1, Lamp position adjustment. 2, Lamp. 3, Lamp housing. 4, Condensers. 5, Negative carrier. 6, Locking wheel for head height. 7, Fine focusing adjustment. 8, Lens aperture control. 9, Swing filter. 10, Column, which may be single or double, inclined or vertical. 11, Earthing screw. 12, Baseboard.

What the condensers do

In most enlargers the efficiency of the lamp is improved by the inclusion of a condenser or pair of condensers just above the negative. These are simple lenses whose function is to collect the light and direct it in a more or less parallel beam so that it all falls on the negative. This is not indispensable. Some enlargers use only a sheet of opal glass to ensure that the light is evenly spread. But a condenser makes more efficient use of the light and allows rather shorter exposures.

For maximum efficiency, the condenser or condensers should be of a focal length and diameter that allows the light to just cover the negative and no more. Where, for example, you have an enlarger which accommodates more than one negative size, say 35 mm and $2\frac{1}{4}$ in. square, you are offered two sets of condensers, one of about 2 in. diameter for 35 mm and one of about $3\frac{1}{2}$ in. diameter for the $2\frac{1}{4}$ in. square. In practice, you can use the larger condensers for either size. The theory says that a too-large condenser wastes light, but you are not likely to notice any difference. You cannot, however, use the smaller condensers for the larger film. They cut off some or all of the light trying to reach the corners of the picture.

Some enlargers are fitted with an adjuster to move the lamp up and down. The idea here is that the position of the lamp filament (the lamps differ in size) relative to the condensers, is critical, and that you obtain even illumination only at a certain position. With most enlargers you can move the lamp up and down to your heart's content without being able to detect any difference in the illumination on the baseboard. Only with those using very small lamps with clear glass envelopes is the lamp position critical.

Alignment tests

Apart from the lens itself, which we shall come to later, the important features of the enlarger are the alignment of the negative carrier, the baseboard and the lens. Negative carrier and baseboard should be parallel and the lens axis must be absolutely perpendicular to them.

This is where the cheaper enlarger and the home-produced variety often fail to make the grade, with the result that you can never produce a print that is sharp all over. If you feel that your enlarger may be suspect, put a negative with fine detail at edges and centre in

the carrier—or make one by scratching fine lines on an old piece of film with a needle. Focus on the edge and then move the negative in the carrier to bring the edge of the image to the middle. If it is not still in focus, there is lack of parallelism somewhere and you will have to find it. Sometimes it can be cured merely by sticking a piece of thin card under one end of the negative carrier. If all, or two opposite, edges of the image are always out of focus, but you can make them sharp by moving them to the middle, then it is the enlarger lens that is at fault. You might effect some improvement by stopping down.

The trouble is rarely lack of parallelism between negative carrier and baseboard. The tolerance here is quite large because it is analogous to depth of focus (not depth of field) in close-up photography. A very slightly leaning column, for instance, would have no noticeable effect. This is why the often-repeated advice to place a piece of card in the masking frame when you focus your image is rather ridiculous. Quite experienced workers may tell you that you cannot focus accurately without such a card because the masking frame surface is lower than the piece of paper you actually print on. Try it some time. Make a print of reasonable size at full aperture with a coin under one edge of the masking frame!

Negative carriers

Which type of negative carrier you use depends on the construction of the enlarger and personal preference. There are glassless types which grip the negative by the edges. There are glass-sandwich types, usually with a thin glass under the negative and a thicker, heavier glass on top. There are types with one glass only, using the base of the condensers as a top glass.

There are basic arguments for and against each type. The glassless type cannot be guaranteed to keep the film absolutely flat, especially in the larger formats. The glass types act as magnets for dust and, despite the use of anti-static brushes or cleaners, are very difficult to keep spotless. Naturally, the tiniest speck of dust in this position is reproduced, considerably enlarged, in the print.

Glasses also occasionally give rise to the phenomenon known as Newton's rings. These are irregularly shaped concentric markings on the print produced by lack of complete contact between negative and

glass, leading to local variations in the passage of light which are reproduced in the print. The cause is usually that one or other of the glasses is not completely flat. Replacing both might cure the trouble.

Glass-type carriers are not normally required for 35 mm or half-frame work—but they may be. In some enlargers, there is a tendency for the negative to "pop", i.e. the heat of the lamp induces a slight bend in the surface. This can sometimes be very troublesome because the negative may revert to its original position after focusing when you switch off the lamp to insert the paper. When you switch on again to make the exposure, the image may remain unsharp for several seconds and then either gradually or suddenly "pop" back into focus. Dampness is often the cause of this trouble and, if you experience it, the chances are that your negative store is not completely dry. Try placing a bag of silica gel in it or find a different storage place. If the trouble persists, you can switch on the lamp for the exposure but hold your hand in the beam for 10–15 seconds before actually allowing the light to reach the paper. If that doesn't work, then you will have to use a glass-type carrier.

Kinds of lens
Enlarger lenses differ in construction from camera lenses. Their main task is to provide a flat field. That is, they must produce an image that is sharp in one plane right out to the limits of the image area. This they must do under conditions very much different from those usually encountered by the camera lens. In the enlarger, the image plane, corresponding to the position of the film in the camera, is the baseboard. The negative in the carrier is the object. Thus, the enlarger lens is nearly always working with a lens-to-image distance many times greater than its lens-to-object distance. The camera lens does that only when taking extreme close-ups.

Every lens is a compromise. In its construction, various aberrations or faults have to be corrected only as far as they can be without introducing other troubles. These aberrations can only be fully corrected at one working distance. The normal camera lens is corrected to give its best results at mid-distances. The enlarger lens, naturally, is designed to do best at very close range.

Camera lenses, therefore, may not make good enlarging lenses and

enlarging lenses are very unlikely to be much good for ordinary camera work, although they may be very good for close-range work.

The enlarger lens you want depends on the size of negative you use. There is good sense in using the correct focal length, which is, roughly, a little greater than the diagonal of the negative. Thus a 50 mm or 2 in. lens is normal for 35 mm, a 75 mm for 2¼ in. square and so on. You can use the 75 mm. lens to enlarge 35 mm. negatives without losing quality but you need a greater separation between lens and baseboard than with the 50 mm. lens to produce the same size image. That limits the maximum size of enlargement you can make with a given column height.

There is no need to pay the earth for your enlarging lens—but there is no sense either in pressing any old lens into service. The well known moderately priced lenses are as good as most people require. Expensive lenses are generally only marginally better, and then in contrast rather than in resolving detail. They usually give better results at full aperture. Indeed, a first-class lens should approach its best performance at full aperture whereas the cheaper variety invariably needs to be closed down by one or two stops.

For first class results, you must have a high-quality lens. For day-to-day work at enlargements up to at least six times at moderate apertures, the only difference between prints from a good average priced lens and the most expensive should be the marginally cleaner and crisper result produced by the better contrast characteristics of the higher quality lens.

Safelights

The paper on which you make contact prints or enlargements is, of course, sensitive to light. It can produce images because, by interposing a negative between the paper and the light source, light can be allowed to act differentially on various parts of the emulsion. If you expose the paper to light without the intervention of a negative, subsequent development brings up a grey or black tone wherever the light strikes.

Thus, during printing and processing, you must make sure that light reaches the paper only when you want it to. Fortunately, ordinary printing papers are not fully panchromatic. Their sensitivity to light is mainly confined to the blue end of the spectrum.

They are virtually insensitive to red, yellow and yellow-green. Thus, your darkroom can be reasonably well lit, provided the light is "safe". Contact papers may be handled safely in fairly dim domestic lighting owing to their very low sensitivity. The usual safelight is a quite bright yellow or orange. Enlarging papers need a light brown or yellow-green light. The latter is preferable. The brown light tends to make a print look much darker than it does in white light. Here it is less easy to assess the correct density and tone relationships under the safelight.

Safelights are made in various forms, the most useful being the simple box-like affair with an ordinary lampholder and provision for changing the safelight screen, which usually consists of a glass-gelatine sandwich plus an opal diffuser.

When you first put a safelight into use, you need to make sure that it is really safe. You may have seen the recommendation that you should place a peice of printing paper on the workbench or enlarger baseboard with a coin on it and leave it for a few minutes. If, when you develop the paper, you see no light patch where the coin was, the safelight is safe. This is not really a satisfactory test because, in actual practice, your paper is not exposed only to the safelight but to white light as well during the printing exposure. It is possible for the safelight to have an effect on the exposure that does not produce a tone in itself. When, however, the subsequent white light exposure is added, a slight fogging results and reduces the contrast and brilliance of the print.

It is better to place the coin on the paper as before but, after a few minutes exposure to the safelight at normal working distance, to remove the coin and give a quick flash of light from the enlarger before processing the paper. The white light exposure should be sufficiently brief to produce an even light tone on the paper after processing. Then, if there is no trace of where the coin stood, you can be sure that your safelight is really safe. If it were not, the place where the coin stood would show up as a lighter disc.

Enlarging papers

The paper for making photographic enlargements by orthodox methods comes in two forms: bromide and chlorobromide. The bromide is the normal paper. Chlorobromides can give warmer

tones and are mostly used by exhibition workers, amateurs and portraitists. Their point of view is that the paper should be chosen to suit the subject and that a sunlit scene looks best on warmer-toned and perhaps tinted base paper, while a snow scene looks best in pure black and white.

Certainly a snow scene on tinted paper would look a little odd but there is also a school of thought that prefers to see all black-and-white photography as black and white—the blacker and whiter the better. There are exceptions in commercial and publicity work but the various tones, tints and surfaces seem a little superfluous for everyday photography.

The tints and surfaces are available in both bromide and chloro-bromide papers. You can get paper with a white, ivory or cream base. In each range, there may also be several surfaces under such names as glossy, matt, stipple, lustre, rayon, silk and so on.

The stipple, lustre and rayon types have a surface broken up into a regular or irregular pattern of formations. It can look attractive but it is a little puzzling sometimes to hear photographers talk of the superb resolution of their lenses and the remarkably grain-free negatives they produce when they make all their prints on papers which break up fine detail and hide grain very effectively.

If you want clean, clear prints to show everything that is in the negative, use glossy bromide paper. You needn't necessarily glaze it but glazing certainly does improve its appearance. Keep the special surfaces and tints for special occasions, if you can think of any.

Contrast grades

Apart from surface and base tint, papers also come in various grades. The grade of paper indicates the nature of the tonal range it is designed to reproduce, i.e. its contrast. Grade one is soft. It can reproduce and differentiate between a considerable number of tones. It generally needs a long exposure to produce a deep black and, indeed, some soft papers never do seem to produce a real black at all in practical use.

The grades vary according to make of paper but Grades four, five and six (when available) are hard papers. Their tonal range is short. If you print a soft negative with a wide range of mid-tones

on such paper, some tones are lost because the paper cannot differentiate between them.

In the middle, we have Grades two and three, which are about normal. They are designed to reproduce as closely as possible the range of tones in the average well-graded negative.

These variations of paper grade are invaluable. No matter how careful you are, you will inevitably produce some negatives with an ill-balanced arrangement of tones. A slightly overexposed negative of a contrasty subject for example may have dense highlights, rather dense mid-tones and very little density in the shadows. Printed on normal paper, such a negative may produce a too-contrasty image because light just cannot get through some of the denser areas in the time required to produce an adequate image in the less dense areas. A softer paper, however, needs relatively less exposure to produce an image at the highlight end and can handle quite small differences in density between highlights and high middle tones.

You may, on the other hand, *need* extreme contrast, perhaps for a copy of a pure black-and-white subject or for a silhouette. In either case, your film may not be sufficiently contrasty to give full density to the highlights. When you print on normal paper, there is a slight veiling over the parts you want to be clear white. Harder paper solves the problem. Requiring disproportionately more exposure to produce an image at the highlight end, if fails to register anything in the highlights and you have the result you want.

The less extreme results are just as useful. If you find that Grade two does not produce quite the snap you require with a particular negative, then Grade three might make all the difference.

However, nobody really wants to carry the whole range of different grades in stock and this is a great drawback. The more extreme grades may go stale before they are used. Frankly, you don't really need to carry much of a stock. You should be able to use one grade for the vast majority of your work and make minor adjustments by burning in or shading (see page 262). The difficult negatives can be put aside until you go and buy fresh paper to do them.

Variable contrast papers

If you cannot face the prospect of such delays, use one of the variable contrast papers. These have mixed emulsions—varying in contrast

according to the colour of the exposing light. They are exposed through filters.

The idea is that a variable contrast paper gives you several grades in one. So it does, but it needs very careful handling. At the soft end, it generally works very well. A variable contrast paper used with no filter can often rescue even the most drastically overexposed or overdeveloped print. At the hard end, these papers seem rather less efficient and really high contrast is more easily obtained with the normal Grade four or five paper.

Many people even find it difficult to print normal negatives satisfactorily on this paper, with the result that it tends to be used only in emergencies. This is a pity, because the system is versatile and offers enormous scope for control in printing as some outstanding work has proved. Nevertheless, the average person does not get on too well with it, which probably explains Ilford's decision to back out of this particular market.

Stabilization papers

In passing, we must mention the type of paper that may eventually displace the orthodox processing methods. This is the stabilization paper so well known in the field of office copying machines. It does away with the three processing dishes and replaces them with a machine. The paper is exposed in the normal way, fed into the machine and delivered, printed, stabilized and damp-dried in a few seconds. You can, in fact, turn out four or five 8 × 10 in. prints in a minute or so.

The paper is entirely different from other printing papers—and so are the chemicals used to process it. The developing agent is actually contained in the emulsion. When the paper is fed into the machine, a regulated quantity of activator is applied to it by a roller system. The paper itself does not pass through the activator—a caustic solution which activates the developing agent in the emulsion so that it reacts with the exposed silver halide to develop the image completely in 1–2 seconds. The paper is then fed through another solution—the stabilizer—and is picked up by more rollers which take off excess solution and deliver the finished print.

The quality of the resulting print is quite remarkable but it is not permanent. It will fade in time, although the life of prints produced

by the latest methods is believed to be expressed in years rather than the days or weeks of earlier types provided they are not constantly exposed to bright light. The prints can, in any case, be made permanent by fixing and washing in the usual way.

The stabilized print must not be washed unless it is also fixed. That would wash out the stabilizing chemicals and lead to deterioration of the image. For the same reason it cannot be glazed unless first washed and fixed.

The developer, formed by the agent in the emulsion and an activator in the solution, is basically an ordinary hydroquinone-caustic type, normally used to obtain high contrast. With the lowest grade stabilization paper, it nevertheless produces a full range of tones with no tendency at all to excessive contrast. Where contrast is required, there are harder grades of paper and special document or copying papers of extreme contrast.

The machines that produce this form of print are expensive and no doubt will remain so until they are manufactured in greater numbers. They are, however, of very similar design to some wet-process office copying machines, which can be picked up quite cheaply second-hand.

For roller processing the main requirement is that the paper passes first to rollers which pick up the activator and apply it to the paper without allowing the paper to enter the solution. Then the paper must be fed into a bath containing the stabilizer. The speed of the rollers would be such that 10 in. of paper is fed through in about 15–25 seconds. No doubt for reliable results you should use the machine designed for the paper but others do work.

Stabilization papers need careful handling. Exposure must be accurate because the processing time is fixed. You cannot overdevelop. For best results, the solutions—and particularly the activator—must be fresh. In theory, the activator does not deteriorate because it is basically only a strong alkali solution containing no developing agent to cause oxidation. In practice, used solutions soon bring about increased exposure times and lack of contrast. This may be of little importance if you use the machine only for proof prints. Then, according to the degree of imperfection you are willing to accept, the solution can stay in the machine, even the open-tray type, for weeks.

Printing technique

Good printing technique is not easy to acquire. It needs practice and constant study of first-class work so that you know what a good print really is.

It is a simple matter to produce a print of sorts. There are innumerable amateurs, in fact, happily turning out thousands of grey, flat lifeless prints because they have never developed the faculty of self-criticism. They have never passed beyond that first, delirious stage of actually producing an image on paper. For them, the fact that they can do it is enough. They do not stop to think that they can do a great deal better.

There is one thing above all else that would improve many people's prints beyond measure—correct enlarger exposure, coupled with longer development, at least to start with. That may sound a little confused, so let us develop the argument.

Making a test strip

Once you have a negative in the carrier, you have to decide how long an exposure is necessary to print it. The traditional method is the test strip—and it is still the most reliable. Take a sheet of your chosen paper (see page 263) and cut it into strips about $1-1\frac{1}{2}$ in. wide. Place one of the strips on the baseboard so that it will cover as wide a range of tones as possible. Switch on the enlarger lamp and, after five seconds, move a piece of card or black paper into the light beam to cover about one-third of the image projected onto the paper. After a further five seconds, cover two-thirds of the image. After a further ten seconds, cover the whole image and switch off the light.

You now have a piece of paper with three exposures on it—of five, ten and twenty seconds. Be careful when shading the image to give those three exposures that you include as many tones as possible in each strip. There would be little value, for example, in exposing sky, light middle distance and dark foreground separately. That gives three exposures for three different tones. You want, as far as possible, three exposures for each tone.

Processing solutions

The next step is to process this test strip in exactly the same manner as you intend to process the final print.

As with film processing, the developer you use is relatively unimportant. There are many proprietary brands and there is very little to choose between any of them. The temperature is not so critical for print developer, either. It should preferably be around 60–70 deg. F. but as you develop the paper almost right out, most developers will work at lower temperatures. Different brands may vary in this respect but if you find your prints are looking a little muddy, warm the developer up. Some are a little sluggish when cold. Generally, the best temperature to work at is the one you can easily maintain throughout the session. That ensures consistency.

Again, as with films, you can use a stop bath between developer and fixer if you like. Otherwise, use a plain water rinse to avoid carrying too much alkali over to the fixer.

The fixer can usually be a weaker solution of the same brand as you use for films. The instructions packed with it give full details.

These solutions should be arranged in three dishes sufficiently removed from the enlarger to prevent splashes landing on the baseboard. You can buy photographic dishes which are fairly expensive, or shop around to find substitutes in hardware shops. Plastic dishes are safest but if they are large, make sure they are reasonably rigid. You may need to pour solution back into a bottle and a thin plastic dish can make that a hazardous procedure. If you choose enamelled dishes make sure that the enamel is sound on every part of the inner surface of the dish. Rust coming through from the metal below can cause many troubles.

For transferring prints from one solution to another print tongs are most convenient—one pair for use in the developer only and another for use in the other two baths.

Finding the right exposure

And so back to the test strip. Drop it into the developer and push it below the surface so that the whole area is immediately covered with developer. Turn it over once or twice and then leave it face upwards for at least three minutes. The developer manufacturer usually says two minutes but any good bromide paper will stand at least five minutes in the developer without ill effect.

The point of leaving it for three minutes or more is that you want to develop the paper almost right out—to ensure that you get a real

full-bodied black where the image demands it. If you stick to the specified two minutes for the test strip, you can be deluded into thinking that a rather longer exposure than is really necessary gives the best print.

The right exposure gives you a print that changes very little, if at all, when development is prolonged beyond the two minutes. More exposure may give a reasonable looking print at the end of two minutes but if it goes appreciably darker in the ensuing minute or so then you have not got the best print possible.

Do try this technique! You will almost certainly find that it gives richer looking prints than you have been used to getting and it will certainly cure any tendency you may have to produce muddy over-exposed and underdeveloped prints.

After your test strip has had its three minutes, lift it out of the developer with the tongs and drop it into the stop bath or rinse. Do not let the tongs touch any solution but the developer. Whisk the strip through the rinse with the other tongs, drain it, and transfer it to the fixer. The second pair of tongs can enter the fixer and should indeed do so to keep the print moving for the first 15 seconds or so. You can then switch on the light and see what you've got.

You don't want the exposure that looks near enough right. You want the one that shows bright highlights, but with detail in them if appropriate and real blacks where there are supposed to be blacks. Of course, none of the strips may show these qualities. They may be all too light or too dark. In that case you have to start again, giving longer or shorter times or opening up or closing down the lens.

The test strip must be examined in bright light. If it was correctly positioned to include a reasonably wide range of tones, there should be little difficulty in deciding which exposure is best. If you are in some doubt, make another test within a narrower range of exposures and, perhaps, concentrate on the most important tones.

Dodging and shading

Ideally, having determined the correct exposure, you then make a "straight" print. In fact, few negatives can be printed absolutely straight if the best possible result is required. Nearly always, some part of the image needs a little more exposure and another part needs

a little less. The former calls for burning-in or printing-up and the latter for dodging or shading.

A similar result could be obtained by using a softer paper but that often has unwanted side-effects. Soft papers tend to reduce contrast throughout the print and that means some loss of detail contrast and a generally soft and perhaps unsharp-looking print.

The expert printer can work apparent miracles by simply placing his hands in the light beam of the enlarger. By a series of mystic movements he directs light in varying proportions to different parts of the image, bringing up the detail in the highlights and preventing shadow details from disappearing into unrelieved blackness.

Most of us have to rely on pieces of black card or stiff paper cut to various shapes and held in the beam on the end of a piece of thin wire. The idea of the thin wire is that very slight movement of it during printing prevents the shadow it casts having any effect on the print.

It is always worth examining your test strips carefully to see whether different parts of the negative do need different exposures. It is quite common for an exposure sufficient to print a cloud-filled sky adequately to be too long for the darker foreground. Or light-toned clothing may print stark-white with the exposure required for correct flesh tones. A separate test strip for each area could indicate that, say, 2 or 3 seconds exposure is adequate for the face, while some parts of the clothing need 6 or 7 seconds.

These are comparatively short exposures and, where shading or burning in is necessary, it is advisable to stop down the lens. The exposures can then be made long enough to allow the handwork to be carried out accurately and without undue haste.

This is, incidentally, the only valid reason for excessive stopping down of an enlarger lens. The first-class lens should perform perfectly at full aperture, while the average lens should never need to be closed more than two stops from the maximum on the grounds of definition or image quality. Certainly, there is no need to stop down to the minimum aperture. That usually entails long exposures and encourages you to trudge around the darkroom, possibly shaking the floor and the enlarger column in the process.

The enlarger lens iris provides a control over the length of exposure so that you can open up for large prints and/or dense negatives and close down for small prints and/or thin negatives or, as in the case

we are now dealing with, when a longer exposure is required to facilitate dodging or shading.

When you have decided exactly how you are going to deal with the print, place the paper on the baseboard or in the masking frame and set your timer, if you use one. Initially, you will probably find it best to set the timer first to the basic exposure and then to treat separately the areas needing extra exposure. When you are more used to it set the timer to the maximum exposure required and introduce your dodgers or your hands into the light beam at the appropriate times.

Using paper grades

You may find that, despite local shading or printing-in, you cannot reproduce adequately the tones of the original. A contrasty subject, for example, may have provided you with a negative particularly dense in the highlight areas and rather thin in the shadow areas, with some of the mid-tones also uncomfortably thin. Controlled printing of such a negative is sometimes very tricky and it may be better to choose a less contrasty paper.

Wedding shots are frequently of this nature. Light-coloured gowns and dark suits in bright sunshine provide an extremely high-contrast subject. Straight prints might show details in the gowns and none in the suits or vice-versa. Or, the attempt to print up the overexposed gowns may make the grain of the image obtrusive. A softer paper, still perhaps with a little control, can bring about an improvement.

You may find, on the other hand that no matter what care you take with a print it lacks the brilliance and snap you would expect from the subject. This could be caused by underexposure or under-development resulting in loss of contrast in the negative. A harder grade of paper might give better separation of tones.

Long-exposure risks

If your exposure is very long, turn off the safelight unless you are absolutely certain of its efficiency. And if the long exposure means that you are enlarging only part of the image, beware of the enlarger beam striking reflecting surfaces and casting light back on the printing area. The often-cited enlarger column should not be a problem in this connection because it should not be possible in a correctly-

constructed enlarger for the beam to strike the column. In cramped conditions, however, the wall may take part of the image or you may even leave a piece of paper or glass leaning against the wall. If the enlarger light reaches that it could reflect enough light back on the print to flatten its contrast considerably.

Cropping advantages

The ability to enlarge only part of the image is a useful and often creative part of black-and-white photography. For one reason or another you may find that your negative contains more than is really necessary to put across the idea you originally envisaged.

To take a simple example, a head and shoulders portrait may actually turn out to be a half-length portrait on the negative. The extra area of chest is often superfluous and can be distracting. Trim it off!

Sometimes, too, a portrait can be more effectively presented if the image is tilted to give an upward or downward gaze. The diagonal so created can impart a little more life to a relatively static subject.

Most pictures benefit by trimming or cropping unimportant detail. Don't be afraid to crop drastically where necessary. Perhaps you grabbed the shot quickly. In the darkroom you have plenty of time to reconsider the composition. You don't have to fit your picture into one of the standard paper sizes, either. On the other hand, there is no particular merit in producing long, narrow prints just because they look unusual. Study the baseboard image or, better still, a trial print and decide on the best composition and format for that particular picture.

The exception to this rule is where pictures are submitted for publication and you don't know exactly how they are to be presented. Then, if you trim your picture right down to essentials, you tie the picture editor's hands. He sometimes has to compromise to fit the pictures into the available space and he likes to have enough on the print to give him some choice of presentation. He may also take them right out to the edge of the page (technically known as bleeding off). Then, he needs a little excess to be trimmed off in the final presentation.

Print developing

Processing the print is carried out in the manner already described for the test strip (page 259), except that you have to take a little more

care at all stages. The larger the print, the more careful you have to be. If you drop a large print into the developer carelessly, it may take time to bring every part of it into contact with the developer. Any part that is significantly late develops more slowly than other parts. The result is irregular patches of only partially developed image.

That is another advantage of developing the print right out. You can leave it in long enough for the underdeveloped patches to catch up.

The correct procedure, however, is to flood the print with developer immediately you put it in the dish. The most reliable method is to tilt the developer dish away from you, slide the print into the deeper pool of solution so created and immediately lower the dish again so that the developer flows swiftly over the whole print. You can then gently push each corner of the print down alternately with your print tongs until it has absorbed enough solution to remain submerged by itself.

Owing to the natural curl of the paper, it is often convenient to slide it into the developer face down. But turn it over as soon as the developer covers it and leave it face up. It is only too easy to trap air bubbles under the print and so prevent developer reaching some parts of it.

Use fairly deep dishes and don't stint the developer. It is not easy to keep a large print submerged in solution a mere $\frac{1}{4}$ in. deep and you might get uneven development.

If you adhere rigidly to the manufacturer's $1\frac{1}{2}$ or 2-minute recommendation, you need careful timing and you should preferably use a stop bath between developer and fixer. A print can go on developing for a surprisingly long time in a water bath.

If you use the longer time that we recommend, it is still advisable to use a timer to check that you do not develop for *less* than two minutes (or $1\frac{1}{2}$ minutes for chlorobromide papers). You can watch the image coming up, but never snatch the print out if it appears to be going too dark before the recommended time. All you will get for that is empty highlights and muddy shadows. Leave it in for at least the recommended time. At worst, it will do as a reference print.

It is likely, however, if you are not very experienced in printing, that you have been fooled by the safelight. Having made your test strip and examined the result in white light, you do not remember how

each strip looked while it was still in the developer. In fact a correctly exposed and developed print looks much too dark under an orange or light brown safelight. You get used to that in time and learn to watch for the appearance of adequate detail in the highlights or lighter middle tones rather than in the shadows, which often look completely blocked up.

When the print is fully developed, lift it out of the solution and allow surplus developer to drain back into the dish. Transfer it to the rinse or stop bath, remembering to drop it in and not to allow the print tongs to come into contact with the solution. This applies even if you use only a rinse, because you transfer the print from the rinse to the fixer with the other pair of tongs and they put fixer into your water rinse. The developer needs very little hypo contamination to ruin the quality of prints entirely.

Fixing the print

The print needs to stay a few seconds only in the rinse or stop bath—just sufficient to wet it thoroughly—before passing on to the fixer. Again, drain it off first.

Move it around in the fixer for the first 10 seconds or so or rock the dish for a similar time. You can then switch on the white light if you are impatient. There is no danger of further development once the fixing solution has covered the whole print.

Don't be in a hurry to take the print out of the fixer, especially when the solution is not fresh. It is said to be possible for too lengthy a fixing to bleach the image but quite a lengthy time is required for such an effect to be detectable in the average print. Where there is fine detail in the highlights, however, the bleaching effect might just make a difference. Avoid prolonged fixing with these.

Don't allow prints to pile up in the fixer unless you use a very large dish and keep the prints moving in a fair volume of solution. Otherwise, some may stick together and be inadequately fixed even after a much extended time in the solution.

Final wash

If running water is available, transfer the prints from the fixer to the wash immediately. Alternatively, drop them into a bucket or dish of clean water and leave the washing until the end of the session.

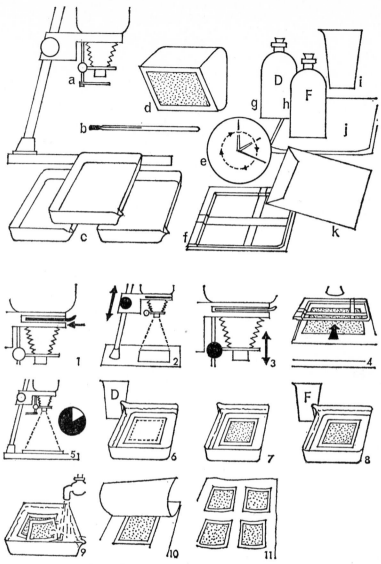

Printing equipment can be elaborate but the items shown here are enough for most people: a, Enlarger. b, Thermometer. c, Dishes. d, Safelight. e, Timer. f, Masking frame. g, h, Storage bottles. i, Flask. j, Photographic blotting paper. k, Printing paper. Processing is as follows: 1, Insert negative. 2, Compose picture. 3, Focus critically. 4, Insert paper. 5, Expose. 6, Develop. 7, Rinse. 8, Fix. 9, Wash. 10, Blot off excess moisture. 11, Dry.

Washing prints is an important step but, as with films, it can be overdone. A reasonably deep dish and a tap are perfectly satisfactory equipment. Run the tap fairly fast and leave the prints in the dish for 20–30 minutes. If you move them around and/or pour the water out of the dish and start again two or three times during that period, the washed prints will last longer than you are likely to need them.

The washing time for both films and papers can be cut by using a hypo eliminator. Commercial products provide for a brief rinse followed by a two minute immersion in the eliminator solution and a final 5 minute wash. Whether this really saves much time depends on individual working conditions and methods. If running water is freely available, the hypo eliminator is not really worth bothering with.

Printing methods

Most prints are made relatively straight. They may call for a little shading here and a little burning in there but the main object is to reproduce a more or less factual impression of the scene recorded by the camera. It is sometimes permissible, however, and occasionally necessary, to add to or subtract from, the negative image. This may involve adjustment of the tonal range or the actual printing in or elimination of detail.

Alterations to the tonal range are effected by the techniques of posterization and tone separation. These are related processes but there are important differences between them. First, tone separation retains some gradation in the tones whereas posterization produces flat areas of tone in well defined steps. The highlights and shadows of a posterized print are completely empty, while a tone separated print gives good highlight and shadow detail. Secondly, although both processes make use of separation negatives printed successively on to a single sheet of paper, the order of printing the negatives is different for each process.

Tone separation

Consider tone separation first. This generally uses only a highlight negative and a shadow negative. These have to be prepared from an intermediate transparency. Thus, the original negative is first printed on a medium-speed film and normally developed to provide a well-

graded positive. The positive is, in turn, printed twice on to slow-to-medium speed film of reasonable contrast and processed in a vigorous developer to provide two new negatives. The first is produced by a short exposure to register reasonably detailed highlights and virtually nothing else; the second is given a rather longer exposure to produce almost opaque highlights and heavily-detailed medium tones and shadows.

Naturally, these two negatives must be of exactly the same size and extra care is necessary at this stage if the opportunity is taken to produce a larger image by printing on sheet film.

To produce the final print, the shadow negative is printed first to show good detail in medium tones and shadows and pure white in the highlights. That is not too difficult if the shadow negative was produced correctly with the required degree of contrast. This negative should, in fact, be rather dense and quite unsuitable for normal printing.

The tricky part comes next. On the same sheet of paper and in exact register, you have to print the highlight negative with a very short exposure that just registers adequate detail in the highlights yet puts no more than the barest trace of tone over all the rest of the image area except the extreme highlights. You will realise that the highlight negative has to be very carefully prepared.

Registration can be achieved by scratching two small crosses at opposite sides or diagonally-opposed corners of the intermediate positive so that they appear on both negatives. These marks can then be lined up at the printing stage by pencilling in on the paper those first projected and then projecting the second set to coincide with the pencilled marks. Projection in each case must be through a safelight filter. A better method is to make more prominent marks, such as large corners or even a complete frame around the positive.

Posterization

The separation negatives for the posterization process are entirely different. This time they are made, again from the intermediate positive, on contrasty material (process or "lith" film) and processed to produce as nearly as possible images composed of completely opaque and completely transparent areas. Aim to produce one negative showing black highlights only and a second negative with

black highlights and midtones and clear film in the shadows. To do this you may have to repeat the process, producing a second, more contrasty, transparency and a third negative with the full contrast required. At this stage you are dealing in opaque areas and clear film, so you can retouch the negative extensively if necessary.

This time, the printing process is reversed. You print the highlight negative first with a fairly brief exposure. The result is blank highlights and an even light grey tone over all the rest of the image area. Then print the other negative which masks the highlights and medium tones but allows you to print an additional tone on to the shadow area. If you give sufficient exposure to render the shadows as pure black, you have a posterized print containing flatly rendered areas of white, grey and black only, just like a poster or silk screen print.

Naturally, you can extend the process by producing three or even four intermediate negatives but the bold three-toned treatment is usually the most effective.

It is not often that the same subject is suitable for both processes. Posterization is designed for bold images with strong outlines and simple design. Tone separation can be used on more intricate subjects with finer detail.

Adding detail

Printing in is a much more difficult technique. It involves the use of two separate negatives. The simplest example is that of printing clouds into a bald sky. Where the skyline is regular, or anything protruding into the sky area is very dark in tone, there are no great problems. You first project the image of the picture on to a sheet of ordinary white paper and draw the horizon across the paper with a sharp pencil, ignoring any small detail encroaching on the sky area. You use this piece of paper as a template to cut a piece of black paper or card as a mask for the foreground while you print in the clouds and also as an indication of the area in which the clouds are to be printed.

Assuming that the sky prints completely white, you then print the negative in the normal way and remove the paper from the baseboard, marking its exact position on the board (a masking frame simplifies matters) and also marking the paper on the back for top and bottom. Place the black mask in the frame or use your pencil-marked white

paper and compose and focus the cloud negative in the sky area. Return the printing paper to the baseboard, position the mask and print the clouds.

Exposure for each negative has to be determined separately and it is advisable to use test strips, printing the cloud negative on to a part of the test strip already exposed for the "bald" sky. This is essential because, although the sky may print completely white with normal exposure and development, the exposure may, in fact, be sufficient to act as a prefogging. The result is that the white clouds print with a decidedly dark tone. If this happens and proves to be unmanageable, then the sky area must be masked while the foreground is printed.

It is often advisable, and is always necessary when intricate outlines are masked, to position the masks an inch or two above the baseboard. In this case you need wooden blocks or books to hold a sheet of glass at the required height above the paper. The image is focused on to the baseboard and a piece of paper then placed on the glass to mark the areas to be masked. The outline is a little fuzzy but is sufficiently clear to make a reasonably accurate mask.

Both negatives should be enlarged to the same degree. If they are not, one mask is inaccurate, because the different angle at which the light passes the edge of the mask causes an overlap of the image or an area of unexposed paper. The only remedy for that is to construct separate masks for each negative.

Advanced work of this nature includes printing figures or other features into the picture. This is effected by masking off a rather indeterminate area of the picture including part of the surroundings of the figure to be inserted. It is rarely practicable to mask exactly to the figure outline. It is a skilled technique, nearly always requiring the inserted feature to be specially photographed in suitable surroundings.

In all printing-in work, you must be careful with the lighting. It would be pointless to insert into a flatly lit outdoor scene a studio-type portrait with evidence of strongly directional lighting. Any clouds inserted in a landscape must not be lit by sunlight coming from the left when the trees show that the sun was in fact on the right.

There are less complicated forms of multiple exposure. If you have subjects photographed against completely white backgrounds you

can print any number of them on the same sheet of paper without masking. Simple masks in contact with the paper can be used to print inserts or to print the left or right side of a subject twice by reversing the negative.

Two negatives can sometimes be printed simultaneously to produce interesting or bizarre effects. Again, these are usually most effective when the negatives are specially produced so that overlap of the images is suitably controlled. "Ghost" images could be produced in this way, whether of human figures or of machinery, showing both internal and external features.

Reflex copying

Printing paper is a more versatile material than is generally realized and there are many other ways in which it can be used in the dark-room. There is no need to use a camera, for example, to produce copies of printed material. Bromide paper can be used for reflex copying.

The method is to place the paper emulsion down on the document to be copied and to press it into close contact by laying a heavy sheet of glass on top. Light shone through the back of the paper is then reflected from the white areas of the document and absorbed by black printed areas. When the paper is developed in the normal way, you have a negative copy of the original.

An essential part of the technique is that the paper should be evenly illuminated. This is easily effected by using the enlarger head as the illuminant. It should be raised to a suitable height to cover the required area and the strength of the light controlled by the lens diaphragm.

The resulting negative can be printed to a positive quite simply. This time, the negative is placed on top of an unexposed sheet of bromide paper (emulsion to emulsion) and the light shone through it as if making a contact print.

With line subjects, hard paper and/or contrasty developer is likely to give best results. Continuous tone subjects may be copied in the same way but the structure of the paper is likely to show through to some extent and loss of definition is inevitable.

With a rough-surfaced paper, you can use the paper negative while it is still damp from processing. A brief rinse after fixing is all

that is needed at this stage. A most suitable paper is the "art" type with a surface resembling that of drawing paper. Damp glossy paper cannot easily be printed on to glossy paper. It tends to adhere and gives a patchy image.

Using paper negatives

The principle of the paper negative may be taken further. You can print a colour transparency on to bromide paper and produce a black-and-white print from the resulting negative. The print may not be as brilliant or as sharp as a normal print because the texture of the paper negative has a slightly diffusing effect. This varies with the make of paper and can be reduced in all cases by making the paper translucent with melted candle wax, paraffin wax, etc.

You can also put bromide paper in your camera and produce a paper negative. Bromide papers have a speed of about 2–6 ASA, allowing exposures in bright sunlight in the region of 1/30 at *f*5·6. With an *f*4·5 lens or faster, you can copy with photofloods at quite manageable exposure times.

Pseudo-solarization

Yet another application of the paper negative produced on the enlarger is the simulation of solarization effects. Solarization (or the Sabattier effect, to give it its proper name) is usually carried out on film. It involves intentional exposure of the film to unsafe light during development. This results in a partial reversal of tones and a characteristic line between well-defined tones.

The principle can be applied to a print but the result is seldom attractive. The print looks dull and contains no clear whites. If, however, you make a paper negative from a straight print by reflex copying and then solarize that negative, you can make prints as attractive as from a solarized negative.

The technique of producing the solarized paper negative varies with the conditions and materials. Generally, however, it involves contact printing an ordinary print to a negative on paper. That negative is then placed in the developer but after about 60 or 70 seconds, white light is switched on for a very brief period. Developing is then continued for a further 1–1½ minutes.

The result should be an extremely dense print with partial tone

reversal and the typical Mackie line edge effect. This is used as a paper negative to produce a positive print.

Further effects are possible if the negative and positive are placed together, slightly out of register and printed as a single negative. That gives a sort of bas-relief solarization. Or you can resolarize the positive from the solarized negative.

It is advisable when experimenting like this, however, to make careful notes of what you do. You may produce a worthwhile result that you want to repeat but the possible permutations are so many that you may well forget what you did.

17: Processing Colour

Doing your own colour processing
is becoming less attractive.
It takes far too long
and manufacturers actively combat the preparation
of substitute formulae.
It is worth knowing the principles involved.
To do more, you need time, patience and money.

Most colour films can be processed by the user but the practice is not really to be recommended. There are several solutions involved, including two developers with not very good keeping properties. The official chemical kits are expensive unless six or more films are processed within a few weeks. Substitute formulae are available but there is a growing tendency for manufacturers to introduce into their formulae chemicals that are not easily obtainable and to modify their films to suit those chemicals. Above all, the process is long and tedious.

None of this discourages the enthusiast, who will quite cheerfully spend several hours making up the solutions and processing a single film of, say, 12 exposures.

Reversal processing
The processing of reversal colour film to produce colour slides varies slightly according to the type of film: manufacturer's instructions are always detailed and should be followed to the letter.

The basic process is: first development to a silver negative image followed by a fogging exposure of the whole film to white light;

colour development to silver plus dye positive images; bleach to remove the silver images; and fix.

The fogging exposure is the essence of the reversal process. The initial exposure of the film in the camera produces latent negative images which the first developer converts to silver images. As in an ordinary negative, the brightest parts of the image are recorded on the film by the heaviest deposits of silver.

When the film is exposed to white light (after a wash to remove the still active developer) the previously unexposed parts of the emulsion receive a latent image opposite in tone to the negative, i.e. a positive. The colour developer goes to work on the silver halides forming this positive image. It works in a different way to the ordinary black-and-white developer, however. Its complex formula makes use of the oxidation by-products of the development process to form the coloured images. As the negative image has already been developed, no oxidation occurs and no colour forms there. This means that colour is formed in proportion to the amount of silver halide left in the emulsion after the first development, i.e. that which is acted on by the fogging exposure.

Kodak have eliminated the fogging exposure in the processing of Ektachrome, which now uses a chemical fogging solution. The principle is the same.

First development and re-exposure

Two things are apparent. The first development must be just right and the fogging exposure must be total.

If the first development is too short, the negative image is too thin. The excess of unexposed halide then produces heavy coloration and a dense transparency. Extended first development leaves a thin positive image which produces a correspondingly thin transparency. In both cases, there is also usually some colour distortion.

Given correct exposure and first development, the required strength of colour is represented by the quantities of unexposed silver halide. It is imperative, therefore, that the fogging light is allowed to act fully on all of the halide. This calls for a quite prolonged exposure to brilliant light. Do not be misled by the fact that ordinary unexposed film is apparently totally fogged by a very brief exposure. The colour film is re-exposed wet and is somewhat desensitized by

the action of the first developer and the presence of the negative silver image. In practice, you cannot overdo the fogging exposure of a colour film.

After the fogging exposure, the film is no longer sensitive to light and all subsequent operations can be carried out in normal lighting.

The really critical part of colour slide development is the first development. This must be as exact as possible, both in temperature of solution and in timing. The latitude in temperature is usually quoted as $\pm \frac{1}{4}$ deg. F.

Time and temperature are far less critical for other solutions, even the colour developer, which is normally allowed a variation of ± 2 deg. F.

Colour negative

The development of colour negative films is basically the same as the process for transparencies without the first development and the fogging exposure, i.e. colour development, bleach to remove the silver images and fix.

This time the colour is formed along with the silver of the negative image. As it is formed in what might be called negative strengths, the developed film shows an image reversed both in tone and colour. The colours are complementary to those actually required in the final result. Greens are red, reds are green and blues are yellow—more or less. When white light is projected through these colours on to colour print material, a print in correct colour can be produced.

When producing prints, however, a certain amount of correction can be introduced to overcome minor deficiencies in the colour quality of the negative. Colour negative development is, therefore, perfectly straightforward and is moderately tolerant of less than ideal conditions.

Colour prints

Colour printing, i.e. 'the production of full colour prints on paper from colour negatives is a task that should not be undertaken lightly. It is not beyond the scope of any reasonably intelligent person but it requires a great deal of patience and the acquisition of no mean degree of skill.

Black-and-white prints of a sort can be produced easily. Even if they are not good, they are still recognizable and the uncritical or inexperienced observer may accept them as adequate. But a poor colour print is immediately recognizable as a distortion of the truth. Where the black-and-white print can only suffer from poor tonal rendering, the colour print may present the most extraordinary rendering of colours that not even the most purblind of home printers will accept as satisfactory.

Equipment for colour printing

Moreover, colour printing requires a certain minimum of equipment. First, you must have an enlarger. Black-and-white prints can be made by contact (page 247). So, indeed can colour prints, but as most are probably made from small negatives, it is hardly practicable.

You need a set of filters. The negative image is projected in the usual way on to a sensitized paper but colour paper has, like colour film, three emulsion layers, each one sensitive to a different colour of light. The filters are needed to ensure that the various mixtures of colour that go to make up the full colour of the print are distributed to their correct emulsion layers.

The tricky part of colour printing is finding the correct filtration. It is largely based on trial and error, at least in the early stages, can take a long time and can result in the consumption of large quantities of materials. Colour printing paper, moreover, is expensive and there is always a temptation to skimp on the test strips.

Additive and subtractive printing

There are two methods of using filters—additive and subtractive. For additive printing, you need only three filters, one each of the primary colours red, green and blue. For subtractive printing, you need a set of at least thirteen filters of various densities of cyan, magenta and yellow. These colours are also known as minus red, minus green and minus blue respectively, because they are the result of extracting those colours from white light.

The additive system sounds simpler and less expensive and, up to a point, it is. There is, however, another important difference between the two systems. Additive printing entails three separate exposures, one through each filter. With subtractive or white-light printing, the

filters are placed in the light-beam of the enlarger together and only one exposure is made.

The disadvantage of the additive system is obvious. You have to be absolutely certain that there is no movement of the enlarger head, paper, lens, etc. between each exposure. And during that time you have to switch the enlarger on and off three times and change the filters. If you can manage that, the end result should be the same whichever method is used. The subtractive method is, however, generally preferred.

Placing the filters

There are two positions in which the filters can be placed—between lens and paper (outside the enlarger) or between enlarger lamp and negative (within the enlarger lamp house). The latter position is preferable. If the filters are placed below the lens, they can affect the quality of the image. They must be of first-class optical quality and must be kept scrupulously clean and free from scratches, finger marks, etc. If they are used inside the lamphouse, they do not interfere with the task of the lens in projecting the image and can be of lower optical quality and thus less expensive.

Many ordinary enlargers can be used for colour printing simply by laying the filters on top of the condenser. It is preferable, however, that the enlarger be fitted with a filter drawer. An existing enlarger can sometimes be adapted while for some models a colour conversion kit is available. There are also special colour enlargers which do a great deal of the work of assessing the necessary filtration automatically—but they are extremely expensive.

Other equipment

Apart from the enlarger and filters, you need several storage bottles for the solutions. Colour prints generally go through about five solutions. Then you need a processing tank, which may consist of a flat, light-tight compartmented dish or one of the various cylindrical models available at moderate prices. These enable you to work in normal lighting once you have inserted the paper, which is, of course, sensitive to light of all colours.

You must have a reliable thermometer so that you can keep all solutions at a constant working temperature over rather long periods

of time. In your early days it might take you an hour or two to find the correct filtration for a print. If, during that time, the temperature of the developers drops by a few degrees, the final print will look rather different from your laboriously produced test.

There are elaborate temperature-control instruments available. You can also buy a voltage stabilizer to eliminate variations in the mains voltage supply which might affect the light output of the enlarger lamp. Neither of these refinements is, however, necessary. Keep your solutions in bottles standing in water at the required temperature, topping up as necessary with warm water. If you are working mostly in the evenings or at week-ends significant fluctuations in voltage are comparatively rare.

Naturally, the professional colour printer has to be very careful about these things because he needs to repeat his results without waste of time. You, on the other hand, are seeking an acceptable result from a particular negative at a particular time. If you should need to make another print later, you can spare the time to make the minor adjustments necessary and will probably not worry if there is a very slight difference between the two results.

You need time and patience

It is not possible to go fully into the subject of colour printing in a general photographic book. The aim of this section is merely to point out that colour printing is a time-consuming pastime: it will only be after considerable practice that you are able to produce a final print within one hour of entering the darkroom.

Colour materials are not cheap and the chemicals used have a restricted life. Nevertheless, colour printing is not basically difficult and if you have the time, the money and the patience to acquire the necessary skill, you will certainly produce better prints than those obtained from the wholesale photofinisher. He has to work on a mechanized basis, and cannot give to any single print the individual care and attention that is the stamp of the competent amateur and, indeed of specialized professionals or processing laboratories whose customers can be charged a very fat fee.

18: Darkroom Accessories

You can make darkroom work easier
by a careful choice of accessories.
Some gadgets, however,
are only for those with money to burn.
Essentials must come first.

There are various items of equipment designed to take the drudgery out of printing. Generally speaking, the inexpensive ones are useful. The expensive ones are often ingenious but of a practical value not fully commensurate with their cost.

Focus finder

Among the most useful items is a focus finder. These all work on the principle of intercepting the image-forming beam on its way to the baseboard and redirecting a part of the image, both magnified and enhanced in brightness, to a more easily visible ground glass surface. In some the magnification is greater than in others, but all are useful for those inevitable overexposed or overdeveloped negatives which make normal focusing, especially at high degrees of enlargement, rather difficult. If you always produce perfectly-graded, rather thin negatives, you need no focus finder. If you are like ordinary mortals, you will often find a use for it.

Exposure timer

An exposure timer is certainly not a necessity but it does make life easier. Timers come in several versions over a wide price range. The

expensive ones are electronically-controlled, and give highly accurate timing. Repeat performances can be carried out without resetting.

The most reliable timer is the simple clockwork type which allows exposures from 1 or 2 seconds to 5 minutes, switching the enlarger lamp on at the press of a button and switching it off at the end of the time you set on the dial. You have to reset it for each exposure. It is easily wired into the lead from the electricity supply to the lamp.

The point about enlarger timers is that their accuracy is completely immaterial. It is their consistency that is important. You want to be sure that, whenever you set the timer to give five seconds exposure it gives the same exposure every time. And if you set it to 10 seconds it must give twice the time it gives at 5 seconds. It doesn't matter if the time it actually gives at the 5-second setting is 4 or 6 seconds, provided it is always the same.

Automatic focusing

An automatic focusing device is provided on some enlargers. It speeds up the work if you are constantly switching from one degree of enlargement to another but you are never absolutely sure about it. Every negative, after all, has an infallible focusing aid built in—the grain. If you have a good focus finder, you can focus the grain sharply and the image must be sharp. The automatic focuser would be fine if it enabled you to focus those awkward images when the degree of enlargement you require is very great and the image on the baseboard is almost too dim to see. But these devices so often allow only a limited degree of enlargement.

Distribution board

One of the most useful accessories is not generally available commercially—a distribution board. In your darkroom, you need at least three electrical supply points: to your enlarger lamp, your safelight and your white light. You may have other items of equipment, too.

You can take all these from one lamp socket, of course, via suitable adaptors and line switches, but it looks a bit of a mess and it can be dangerous. It is much better to make up a distribution board with various sockets, preferably with individual switches, so that each item can be plugged into its own socket. Power is taken to the board by a cable from the nearest supply socket, even outside the darkroom.

On the board, you have a plug with its top taken off and mounted in reverse so that the three pins protrude. The cable has the usual plug at one end and a socket at the other. You can buy completely enclosed sockets of this type or use the ordinary socket screwed to a small piece of wood with a hole through the centre to admit the cable. You could wire the cable into the board but the detachable cable is useful as an extension cable for other applications.

You must not put an ordinary socket on the board and use a cable with plugs at both ends. If you do, the pins are live at one end and can be extremely dangerous.

Such a distribution board can hang on the wall and can easily be taken off and used anywhere else in the house for other purposes—such as plugging in photofloods or copying lights.

Processing timer

For print processing, your timer merely has to indicate the passage of about 1½–3 minutes or so. It need not be luminous because you work in a reasonable amount of light. It can be an ordinary clock or watch with a sweep second hand or it can be an old spring clock adapted to indicate the passage of minutes only, with one hand doing a full revolution per minute. It can be an egg-timer.

If you usually follow the process of developing almost to finality, you hardly need a timer at all. If you have an enlarger timer, you can even use that with the lamp switched off at its mains socket. The clockwork type makes a quite audible click when it switches off.

Exposure meter

For most people an enlarging exposure meter is a totally unnecessary expense—and to be accurate, versatile and easy to use, they have to be expensive. There are, of course, some who use one of these expensive accessories with an enlarger whose total cost, including lens, is less than the meter. That is, indeed, putting the cart before the horse.

Commercial printers who handle amateur work turn out straight prints automatically in strips. For the exposure, near enough is good enough and a form of automatic exposure control is excusable. When you do your own printing, you want the best out of the negative. That very often means a degree of individual control over various

parts of the image. At least, if something has to be sacrificed you want to make sure that it is not something vital.

You may be prepared to lose detail in small shadow areas provided you obtain fully detailed highlights and mid-tones. You can only really see what you are getting if you try it first—and that means a test strip and sometimes even a full test print. There is no other way.

You may often turn out prints—for somebody else, of course—that do not need such careful treatment. They just want adequate prints and the averaging out performed by the meter gives you exposures that will produce acceptable prints. But by the time you are doing this type of work you will find you can judge exposures accurately enough to produce such results—even at different degrees of enlargement. You may slip up here and there and have to do one or two prints twice. But if you compare the price of paper and the price of enlarging exposure meters, it is clear that you would have to waste rather a lot of paper to make the meter appear an economic proposition.

Using an exposure meter for *taking* the pictures is understandable. You can't make test strips and the picture may not be easily repeated. So there is an element of chance that the meter helps to eliminate. In printing hardly the same conditions prevail. You can have exactly the exposure you want. And surely that is why you do your own printing?

Print driers and glazers

Drying prints can sometimes be a bit of a nuisance. You have to spread them out all over the house if you have done many. But there is no alternative short of using a drying machine. They take a long time to dry if they are just piled up and interleaved with blotting paper. So spread out the prints on large sheets of photographic blotting paper, fluffless towels or almost any clean, fairly absorbent surface. Just lay the prints on, blot off excess moisture and leave them to their own devices—preferably face upwards and with nothing overlaying them.

The prints will curl when dry but are easily straightened by drawing them carefully, but firmly and sharply bent, over the straight edge of a desk or table—emulsion up. Larger prints are better taken diagonally if at all strongly curled but hold the part on the table firmly with the

flat of the hand. Otherwise, the edge may curl up and you will put an irremovable crease across the print.

Print driers use an electrically heated metal plate on which you lay the print and hold it down with a canvas blanket stretched over the plate. If you lay a highly-polished, flexible steel sheet over the heating plate before putting the prints on, you can glaze the prints at the same time.

Smaller versions (around 12 × 10 in.) are not too expensive but there are models of greater size and price, sometimes double-sided, which have twice the nominal usable area.

Glazing techniques

Neither dryer nor glazer is indispensable. Drying we have already mentioned. Glazing, too, can be done without a machine. The best glaze is, in fact, obtained from polished plate glass. You simply lay the wet print on the glass, squeeze it into firm contact with a rubber roller or flat squeegee and leave it to dry naturally.

If you are lucky, the glaze is brilliant, far surpassing anything you can do with a metal plate. If you are unlucky, the print sticks to the glass and can only be removed by resoaking, which also removes the glaze.

Unfortunately, sticking on glass is a frequent trouble. It can sometimes be avoided by the use of special glazing solutions. The risk can also be minimized by squeegeeing or rolling the print firmly into contact with the glass but without undue pressure. Keep the glass scrupulously clean—window cleaning fluid works well—and don't use warm water for the pre-glazing soak.

Good glazing, whether on glass or amateur glazing equipment is difficult. A faultless glaze can be obtained only from a faultless glazing surface and only then if the water supply is perfectly clean. Most water, in fact, contains tiny impurities and these are quite enough to blemish the glaze. There is always dust in the air, too, and some can easily settle on the plate before you get the print on to it.

The procedure for glazing is to take the print out of soak, letting it drain only slightly. Hold it by two sides and let the middle sink down into a U. Place the print on to the glazing plate in this position, lowering the sides only after the middle has made contact. Apply the squeegee or roller at the centre and roll out to the edges to squeeze

out excess moisture. Then roll firmly, but not with too heavy a pressure, all over the print a few times.

There is one exception to the rule that the glazing surface must be in perfect condition. One particular form of glazing solution actually forms the glazed surface and this can even be used on glazing plates that are slightly damaged. It must be used on metal, however and is a hot-glazing process. If you use it on glass and leave it to dry naturally, it sticks with a most extraordinary tenacity.

Glossary

A **ABERRATION.** Failing in the ability of a lens to produce a true image. There are many forms of aberration and the lens designer can often correct some only by allowing others to remain. Generally, the more expensive the lens, the more highly it is corrected.

ADDITIVE. Method of colour reproduction originally based on three separate exposures of one emulsion to red, green and blue light. In early colour films, the normal exposure was suitably split up by a very fine mosaic-like filter screen incorporated in the film. No longer used in general photography except as a colour printing method, with three consecutive exposures of the three-layer material used in the subtractive process.

AGITATION. Movement of film during development to maintain homogeneity of developer solution. Now usually effected in small tanks by occasional inversion of tank.

ALKALI. Chemical compound capable of neutralizing acids. Nearly all photographic developers contain an alkali because most developing agents will work only in an alkaline solution.

ANGLE OF VIEW. The extent of the view taken in by a lens in relation to the film size used. Usually expressed on the diagonal. Can be measured for any lens by drawing a perpendicular the length of the focal length of the lens from the centre point of a line, the length of the diagonal of the image area. Complete the triangle and measure the angle at the top of the perpendicular.

This is the angle of view at infinity setting of the lens. It decreases as the lens is focused closer.

APERTURE. The opening in the lens, usually provided by an adjustable iris diaphragm through which light passes. Strictly, this is the limiting aperture. The light-transmitting power of the lens is governed by the effective aperture, which is the diameter of the bundle of light rays entering the lens and passing through the aperture. As this is measured at the lens surface and the diaphragm is usually within the lens, the effective aperture is rarely the same size as the limiting aperture. The numerical expression of the effective aperture—the *f*-number—is calculated from the focal length of the lens divided by the diameter of the effective aperture and is known as the relative aperture.

ARTIFICIAL LIGHT. Light from a man-made source other than flash Usually restricted to studio, photoflood and domestic lighting. When used to describe film also known as Type A, invariably means photoflood.

AUTOMATIC IRIS. Type of lens diaphragm, peculiar to the single lens reflex camera, which is controlled by a mechanism in the camera body coupled to the shutter release. The diaphragm closes to any preset value before the shutter opens and returns to the fully open position when the shutter closes.

AVERAGE GRADIENT. A concept replacing gamma as a means of determining development times for black-and-white films. Basically similar to Contrast Index. Also known as \bar{G} (G-Bar).

B BALANCED. Description applied to multi-layer films to indicate their suitability for use in various types of lighting. The speed and colour response of each layer is balanced to provide correct colour in the conditions of use.

BASIC MINIMUM EXPOSURE. The minimum level of exposure that will give adequate detail in the shadows of an average subject. Film speed and processing recommendations are generally based on this concept.

BROMIDE. Type of paper on which photographic enlargements are made. The light-sensitive constituent is almost entirely silver bromide, giving a pure black tone with normal development.

BURNING-IN. Practice in enlarging of giving extra exposure to part or parts of the image to enable them to print up to the required tone. Also known as printing-up.

C CADMIUM SULPHIDE. Material which offers less resistance to flow of electrical current when exposed to light. Used in exposure meters as alternative to selenium-based photocells which need to be larger for equivalent sensitivity. Needs external power supply such as a battery.

CAMERA SHAKE. Movement of camera caused by unsteady hold or support, vibration, etc., leading, especially at slower shutter speeds, to a blurred image on the film.

CAPACITOR. Electrical component once more commonly known as a condenser. Stores electrical energy supplied by a power source and can discharge it more rapidly than the source itself. A useful component in flash equipment, providing reliable firing even from weak batteries, which simply take longer to charge the capacitor. Used alone, the batteries might not have the instantaneous power required to fire the flash bulb or tube.

CASSETTE. Light-trapped film container used in 35 mm cameras.

CAST. Colouring of an image produced by using wrong combination of film and light source, wrong filter or departure from recommended processing conditions. Also brought about by reflection within the subject as from a hat on to the face.

CHLORIDE. Type of paper on which contact prints are made. The light-sensitive constituent is silver chloride, giving a blue-black tone with normal development.

CHARACTERISTIC CURVE. Curve plotted on a graph to represent the various densities produced in a photographic material by different amounts of exposure to light.

CHLOROBROMIDE. Type of paper on which photographic enlargements are made. The light-sensitive constituents are predominantly silver chloride and silver bromide, giving a warm black tone with normal development.

CLICK STOP. Ball bearing and recess or similar construction used to enable shutter speeds, aperture values, etc. to be set by touch.

CLOSE-UP. Indefinite term sometimes used to describe photography at closer range than the focusing movement of the camera lens allows.

COINCIDENT IMAGE. Form of rangefinder image, doubled so that the two separate images fuse into one only when the correct object distance is set on the instrument or, in the case of a coupled rangefinder, when the lens is correctly focused.

COLOUR NEGATIVE. Film designed to produce colour image with both tones and colours reversed for subsequent printing to a positive image, usually on paper.

COLOUR REVERSAL. Film designed to produce a true colour positive image on the film exposed in the camera for subsequent viewing by transmitted light or projection on to a screen.

COMPONENT. Part of a compound lens consisting of more than one element (single lens) cemented or otherwise joined together. A lens may therefore be described as 4-element, 3-component when two of the elements are cemented together.

CONCAVE. Curved like the inside of a sphere.

CONDENSER. Generally a simple lens used to collect light and concentrate it on a particular area, as in enlarger or projector. Frequently in the form of two plano-convex lenses in a metal housing. Also an alternative term for capacitor.

CONTACT PRINT. Positive image of the same size as the negative from which it is made, produced by passing light through the negative in contact with the printing surface.

CONTRAST. Tonal difference. More often used to compare original and reproduction. A negative may be said to be contrasty if it shows fewer, more widely spaced tones than in the original.

CONTRAST INDEX. A concept replacing gamma as a means of determining developing times for black-and-white films. Developing to a certain gamma required a development time that would produce a characteristic curve with a certain degree of slope to the straight-line portion. This disregarded the toe of the curve, now more extensively used, and the effect of developers producing unusual curve shapes. The Contrast Index concept takes care of this, substituting an imaginary straight line for the straight-line portion of the curve. This line joins two points on the characteristic curve representing the approximate maximum and minimum densities used in practice. Full details are given in Kodak Data Sheet SE-1A.

CONTRAST TRANSFER FUNCTION. Index of image quality produced by a lens or photographic emulsion and its processing. The CTF is the relationship between fineness of detail in the subject (spatial frequency) and the ratio of image contrast to subject contrast. It is a better measurement of image quality than the once customary lines-per-millimetre resolution tests because it can highlight the fact that one lens may provide a higher-contrast image than another when used on a relatively coarse-detailed subject, but lower contrast when the subject has finer detail. Depending on the relationship between the steepness of decline in their performances, either may be regarded as "better" than the other.

CONVEX. Curved like the outside of a sphere.

CROP. To print or otherwise to present in the final picture less than the whole image on the film.

D DELAYED ACTION. Mechanism delaying the opening of the shutter for some seconds after the release has been operated. Also known as self-timer.

DEPTH OF FIELD. The distance between the nearest and farthest planes in a scene that a lens can reproduce with acceptable sharpness. Varies with aperture, focused distance and the standards set for acceptable sharpness.

DEPTH OF FOCUS. Total extent of the distance towards or away from the film that the lens can be moved before loss of sharpness in the image becomes unacceptable. Dependent on lens aperture, lens-image distance and the arbitrarily set standard of sharpness.

DEVELOPER. Solution used to make visible the image produced by allowing light to fall on a light-sensitive material. The basic constituent is a developing agent which reduces the light-struck silver halide to metallic silver.

DIAPHRAGM. Device consisting of thin overlapping metal leaves pivoting outwards to form a circular opening of variable size to control light transmission through a lens.

DIFFRACTION. Breaking up of light rays at edge of opaque object, such as an iris diaphragm. Normally has minimal effect but can affect a large proportion of rays at very small apertures and thus worsen definition and colour rendering.

DODGING. Practice in enlarging of holding light back from part or parts of the image to prevent them printing to too deep a tone.

DOUBLE EXPOSURE PREVENTION. Method now incorporated into most cameras for providing a lock on the shutter release which can be released for one operation only by advancing the film.

DRYING MARKS. Blemishes on film caused by solids in water supply or by uneven drying.

E **ELECTRONIC FLASH.** Light source based on electrical discharge across two electrodes in a gas-filled tube. Usually designed to provide light approximating to daylight.

ELEMENT. Single lens used in association with others to form a compound construction.

EMULSION. Suspension of light-sensitive silver salts in gelatin.

ENLARGEMENT. Print larger than the negative from which it is produced.

EXPOSURE. The act of allowing light to reach the light-sensitive emulsion of the photographic material.

EXPOSURE FACTOR. A figure by which the exposure indicated for an

average subject and/or processing should be multiplied to allow for non-average conditions. Usually applied to filters, occasionally to lighting, processing, etc.

EXPOSURE METER. Instrument generally containing light sensitive substance which transmits power to a pointer moving over a scale. For general photography the scale indicates aperture and shutter speed settings required in given light conditions for a film of the speed set on the meter. The speed setting can be varied within wide limits.

EXTENSION BELLOWS. Device used to provide the additional separation between lens and film required for close-up photography. Consists of extendible bellows with mounting plates at front and rear to fit the lens and camera body respectively. Rigidity and adjustment of length is provided by a rod or rods attached to the rear plate and passing through holes in the front fitted with a lock.

EXTENSION LEAD. Electrical cable usually with 3 mm coaxial plug at one end and socket at other to allow flash unit to be used at a distance from the camera.

EXTENSION TUBES. Metal tubes threaded or with bayonet mounts at each end to provide attachment to lens or another tube and camera. Used to obtain the additional separation between lens and film required for close-up photography.

F f-NUMBER. Numerical expression of the light-transmitting power of a lens. Calculated from the focal length of the lens divided by the diameter of the bundle of light rays entering the lens and passing through the aperture in the iris diaphragm.

FILM BASE. Flexible support on which light sensitive emulsion is coated.

FILM SPEED. Guide to the sensitivity to light of a photographic film. Generally expressed as a figure in the DIN (German standard) or ASA (American standard) series. The figure is used in exposure meters and tables as a basis for assessing the shutter speed and aperture settings required in given light conditions.

FILM TRANSPORT. Mechanism for advancing the film after exposure. In its simplest form, a knob directly engaging the film take-up spool and pulling the film through the camera as it is turned. In more complex forms, the film transport mechanism is linked with shutter tensioning, exposure counting and double exposure prevention.

FILTER. Most commonly a dyed-in-the-mass disc of glass attached to the camera lens by a push-on or screw-in filter holder. Generally coloured to absorb light of certain colours and prevent it from reaching the film. Used to adjust tones on black-and-white film or colours on colour film.

FISHEYE. Ultra-wide-angle lens giving 180 deg. view and, therefore, circular image with considerable distortion.

FIXER. Solution, usually based on sodium thiosulphate, in which films or prints are immersed after development to convert the unexposed silver halides in the emulsion to soluble products that can be washed out. This prevents subsequent deterioration of the image.

FLASH. Light source, such as electronic flash or flashbulb.

FLASHBULB. Light source based on ignition of combustible metal wire in a gas-filled transparent envelope. In popular sizes now usually blue-coated to give light approximating to daylight.

FLASHCUBE. Self-contained unit comprising four small flashbulbs with own reflectors. Designed to rotate in special camera attachment as film is wound on.

FOCAL LENGTH. Distance from a lens to the image it produces of a very distant subject. With a compound lens, the measurement is taken from a point within the lens which can generally be taken as the position of the diaphragm.

FOCUS. Generally, the act of adjusting a lens to produce a sharp image. In a camera, this is effected by moving the lens bodily towards or away from the film or by moving the front part of the lens towards or away from the rear part, thus altering its focal length.

FOG. Discernible density in a developed photographic emulsion caused other than by the normal exposure. The cause can be chemical or, more commonly, exposure to unsafe light. Deliberate fogging is used in reversal processing and such treatments as the Sabattier effect (solarization).

FORMAT. Shape and size of image provided by camera or presented in final print or transparency. Governed in the camera by the opening at the rear of the body over which the film passes or is placed. The standard 35 mm format is 36×24 mm; half-frame, 18×24 mm; 126 size (Instamatic types), 28×28 mm; standard rollfilm (120 size) $2\frac{1}{4} \times 2\frac{1}{4}$ in.

FRESNEL. Pattern of a special form of condenser lens consisting of a series of concentric stepped rings, each being a section of a convex surface which would, if continued, form a much thicker lens. Most commonly encountered on focusing screens where it is used to distribute image brightness evenly over the screen.

G G-BAR. Alternative term for Average Gradient which is basically similar to Contrast Index. These are concepts replacing gamma as a means of determining development times for black-and-white films.

GAMMA. The slope of the straight-line portion of the characteristic curve

of a photographic emulsion. Gamma was once used as a measure of the desirable contrast to which a film should be developed for specific purposes. It has been superseded by the concept of Contrast Index or Average Gradient.

GRAIN. Minute metallic silver deposit, forming in quantity the photographic image. The individual grain is never visible, even in an enlargement, but the random nature of their distribution in the emulsion causes overlapping, or clumping, which can lead to graininess in the final image.

GRAININESS. Visible evidence in positive image of the granular structure of a photographic reproduction. Influenced by exposure, development, contrast characteristics and surface of printing paper, emulsion structure and degree of enlargement.

GREY CARD. Tone used as representative of mid-tone of average subject. The standard grey card reflects 18 per cent of the light falling on it.

GUIDE NUMBER. Figure allocated to a light source, usually flash, representing the product of aperture number and light-to-subject distance required for correct exposure.

H HALF-FRAME. Film format half the size of the standard 35 mm still frame, i.e. 18 × 24 mm. Sometimes referred to as single frame owing to its similarity to standard 35 mm cine frame.

HALIDE. Compound of a halogen (fluorine, chlorine, bromine and iodine) with another element. Silver chloride, silver bromide and silver iodide are the light-sensitive substances most commonly used in photography.

HIGHLIGHT. Small, very bright part of image or object. Highlights should generally be pure white, although the term is sometimes used to describe the lightest tones of a picture, which, in that case, may need to contain some detail.

HYPERFOCAL DISTANCE. Distance from the lens to the nearest plane rendered sharply when the lens is focused on infinity.

I IMAGE. Two-dimensional reproduction of a subject formed by a lens. When formed on a surface, i.e. a ground-glass screen, it is a real image; if in space, i.e. when the screen is removed, it is an aerial image. The image seen through a telescope, optical viewfinder, etc. cannot be focused on a surface without the aid of another optical system and is a virtual image.

INCIDENT LIGHT. Light falling on a surface as opposed to the light reflected by it.

INFINITY. Infinite distance. In practice, a distance so great that any object at that distance will be reproduced sharply if the lens is set at its infinity position, i.e. one focal length from the film.

INSTANT-RETURN MIRROR. Mirror of single lens reflex camera

designed to return automatically to viewing position immediately after the shutter closes. The image is thus visible in the viewfinder at all times except while the shutter is open.

INTERCHANGEABLE LENS. Lens designed to be readily attached to and detached from a camera, usually by a screw thread or bayonet mount.

IRIS. Strictly, iris diaphragm. Device consisting of thin overlapping metal leaves pivoting outwards to form a circular opening of variable size to control light transmission through a lens.

IRRADIATION. Extension of effect of light into parts of a light-sensitive surface not directly struck by the light rays. Causes thickening and possible obliteration of fine lines.

L LEADER. Part of film attached to camera take-up spool. Applied particularly to 35 mm film which usually has a leader of the shape originally designed for bottom loading Leica cameras.

LENS. Transparent medium, generally glass but sometimes plastic, with one side or both curved to converge or diverge light rays. The converging lens is positive, the diverging lens negative. Most photographic lenses use both types in a compound construction of three or more elements.

LONG-FOCUS. Lens of relatively long focal length designed to provide a narrower angle of view than the normal or standard lens, which generally has an angle of view, expressed on the diagonal of the film format, of about 40 deg. The long-focus lens thus takes in less of the view in front of it but on an enlarged scale.

M MICROPRISM. Minute glass or plastic structure built in special formations of vast numbers into a viewfinder screen to act as a focusing aid.

MINIATURE. Formerly a description of standard 35 mm still cameras, films and photography.

MODELLING. Representation by lighting of the three-dimensional nature of an original in a two-dimensional reproduction.

N NEGATIVE. Image on film or other surface in which tones and colours, if present, are reversed.

NON-REFLEX. Specifically in this book, a camera not using the single lens reflex principle. Can also, according to context, refer to the twin lens reflex.

P PAPER. Substance on which the photographic print is generally made, consisting of a high-quality paper base coated with a light-sensitive emulsion.

PARALLAX. Apparent change in position of an object due to changed viewpoint. In a camera with separate viewfinder, the taking lens and the viewfinder view an object from slightly different positions. At close range, the image produced on the film is significantly different from that seen in the viewfinder. Various methods of parallax correction are used to overcome this difficulty.

PENTAPRISM. Specially-shaped glass block placed over a horizontally positioned focusing screen to enable an upright and laterally correct image to be viewed at eye level.

PERFORATIONS. Rows of holes along edges of film used particularly in 35 mm size to assist in film transport.

PERSPECTIVE. Size, position and distance relationship between objects. Varies according to viewpoint so that objects at different distances from the observer appear to be closer together with increasing distance. Thus, a long-focus lens used at long range and a wide-angle lens used very close up provide images very different from that of the standard lens used at a normal working distance.

PHOTOFLOOD. Photographic lamp giving more light than a norma lamp of the same wattage, at the expense of filament life.

PLANE. Level surface. Used in photography chiefly in respect to focal plane, an imaginary level surface perpendicular to the lens axis in which the lens is intended to form an image. When the camera is loaded the focal plane is occupied by the film surface.

POLARIZED LIGHT. Light waves vibrating in one plane only as opposed to the multi-directional vibrations of normal rays. Natural effect produced by some reflecting surfaces, such as glass, water, polished wood, etc., but can also be simulated by placing a special screen in front of the light source.

PRINTING-IN. A separate printing into an existing image of an image from another picture. Most commonly used to put clouds into a cloudless sky but can include the addition of a figure or other detail.

PRINTING-UP. Practice in enlarging of giving extra exposure to part or parts of the image to enable them to print up to the required tone. Also known as burning-in.

PROJECTOR. Apparatus for projecting an enlarged image on to a screen, most commonly used for viewing colour transparencies.

R **RANGEFINDER.** Instrument for measuring distances from a given point, usually based on slightly separated views of the scene provided by mirrors or prisms.

REFILL. Length of film, usually for loading into 35 mm cassettes in total darkness. Daylight refills are not now generally available.

REFRACTION. Deflection of light rays passing from one medium to another, i.e. air to glass. It is the ability of glass to refract light rays that enables lenses to be made.

RESOLUTION. Ability of film, lens or both in conjunction to reproduce fine detail. Commonly measured in lines per millimetre as ascertained by photographing, or focusing the lens on, a specially constructed test target.

REVERSAL. Type of film or method of processing designed to produce a positivei mage on the material originally exposed. Now most commonly encountered in colour reversal films for the production of colour slides. The image is formed by fogging and colour developing the emulsion unaffected by the original exposure and black and white development and then removing the silver images to leave a colour positive.

ROLLFILM. Film supplied on a spool with paper backing to protect it from light. Standard rollfilm is now generally used to provide 12 images of $2\frac{1}{4} \times 2\frac{1}{4}$ in. (120 size) but a longer (220 size) version is available to give 24 images of the same size.

S SABATTIER EFFECT. Partial reversal and characteristic outline effect obtained by momentarily exposing a film to unsafe light during the course of development. Commonly, but erroneously, known as solarization.

SAFELIGHT. Light source consisting of housing, lamp and screen of a colour that will not affect the photographic material in use. Safelight screens are available in various colours and sizes for specific applications.

SCALE. Focusing method consisting of set of marks to indicate distances at which a lens is focused. May be engraved around the lens barrel, on the focusing control or on the camera body.

SCREEN. In a camera, the surface upon which the lens projects an image for viewfinding and, usually, focusing purposes. Now almost universally a fresnel screen with a fine-ground surface.

SELENIUM. Light-sensitive substance which, when used in a barrier-layer construction, generates electrical current when exposed to light. Used in exposure meters. Needs no external power supply.

SELF-TIMER. Mechanism delaying the opening of the shutter for some seconds after the release has been operated. Also known as delayed action.

SENSITIVITY. Expression of the nature of a photographic emulsion's response to light. Can be concerned with degree of sensitivity as expressed by film speed or response to light of various colours (spectral sensitivity).

SHADING. Practice in enlarging of holding light back from part or parts of the image to prevent them printing to too deep a tone. Also known as dodging although that term is sometimes confined to work on areas away from the print edges.

SHARPNESS. Clarity of the photographic image in terms of focus and contrast. Largely subjective but can be measured to some extent by assessing adjacency effects, i.e. the abruptness of the change in density between adjoining areas of different tone value.

SHORT-FOCUS. Lens of relatively short focal length designed to provide a wider angle of view than the normal or standard lens, which generally has an angle of view, expressed on the diagonal of the film format, of about 40 deg. The short focus lens thus takes in more of the view in front of it but on a smaller scale.

SHUTTER. Movable part of a camera protecting the film from light passing through the lens. Simple shutters move at a single speed to expose the film for about 1/40 sec. The majority are adjustable to allow various speeds to be set. There are two main types: focal plane and between-lens. The focal plane shutter is situated as close as possible to the film and generally takes the form of two blinds, one following the other across the film and exposing it piecemeal. The time of exposure is governed by the separation between the blinds. The between-lens shutter generally consists of thin metal blades pivoted to open from the lens centre and is generally located within the lens. The speed of the blade movement is constant and the time of exposure is governed by the interval between the fully open and fully closed positions.

SINGLE LENS REFLEX. Camera in which the same lens is used both for taking, and viewing and focusing the picture. Effected by a movable mirror or fixed semi-reflecting surface behind the lens.

SOLARIZATION. Strictly, reversal of tones caused by extreme over-exposure. Now generally used to describe the partial reversal obtained by momentarily exposing a film to unsafe light in the course of development. This is more correctly known as the Sabattier effect.

SPLIT-IMAGE. Form of rangefinder image, bisected so that the two halves of the image are aligned only when the correct object distance is set on the instrument or, in the case of a coupled rangefinder, when the lens is correctly focused.

STABILIZER. Alternative to fixer where permanence is not required. Used in automatic processing machines and can now provide prints that will not deteriorate noticeably over many months if kept away from strong light.

SUBTRACTIVE. Method of colour reproduction based on the simultaneous exposure of three emulsion layers separately sensitized to red, green and blue light. All modern colour films are tri-packs of this nature, using the subtractive method.

SUPPLEMENTARY LENS. Generally a simple positive (converging) lens used in front of the camera lens to enable it to focus at close range. The effect is to provide a lens of shorter focal length without altering the lens-film separation, thus giving the extra extension required for close focusing.

SYNCHRONIZATION. Concerted action of shutter opening and closing of electrical contacts to fire a flashbulb or electronic flash at the correct moment to make most efficient use of the light output.

T TELEPHOTO. Special form of long-focus lens construction in which the back focus (distance from rear of lens to film) is much less than the focal length of the lens.

TEST STRIP. Method of assessing exposure required, usually in enlarging. A strip of photographic paper is given several different exposures under the negative to be printed and the correct exposure is chosen when the strip is processed.

THROUGH-THE-LENS. Type of exposure meter built into the camera body and reading through the camera lens.

U ULTRAMINIATURE. Small cameras and films giving an image format ranging from 18 × 12 mm to 11 × 8 mm. Also known as subminiature.

V VIEWFINDER. Device or system indicating the field of view encompassed by the camera lens. The term is sometimes used as a description of the type of camera that does not use reflex or "straight-through" viewing systems and therefore has to have a separate viewfinder.

VIGNETTING. Underexposure of image corners produced deliberately by shading or unintentionally by faulty equipment, such as unsuitable lens hood or badly designed lens. A common fault of wide-angle lenses, owing to reflection, cut-off, etc. of some of the very oblique rays. Also caused in some long-focus lenses by the length of the lens barrel.

W WIDE-ANGLE. Lens designed to provide a wider angle of view than the normal or standard lens, which generally has an angle of view, expressed on the diagonal of the film format, of about 40 deg. The wide-angle lens thus takes in more of the view in front of it but on a reduced scale.

Z ZOOM LENS. Lens of which the focal length can be continuously varied within stated limits while maintaining the focus originally set.

Index